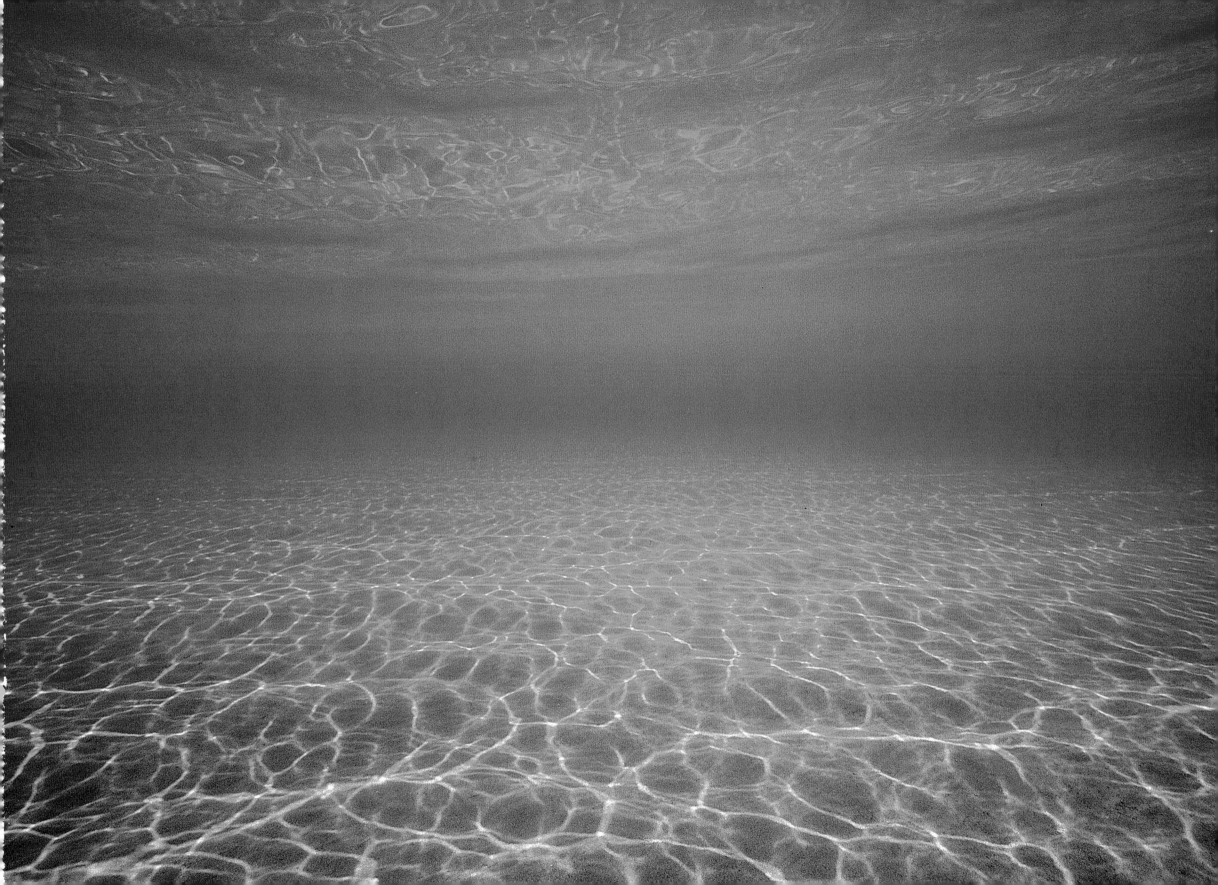

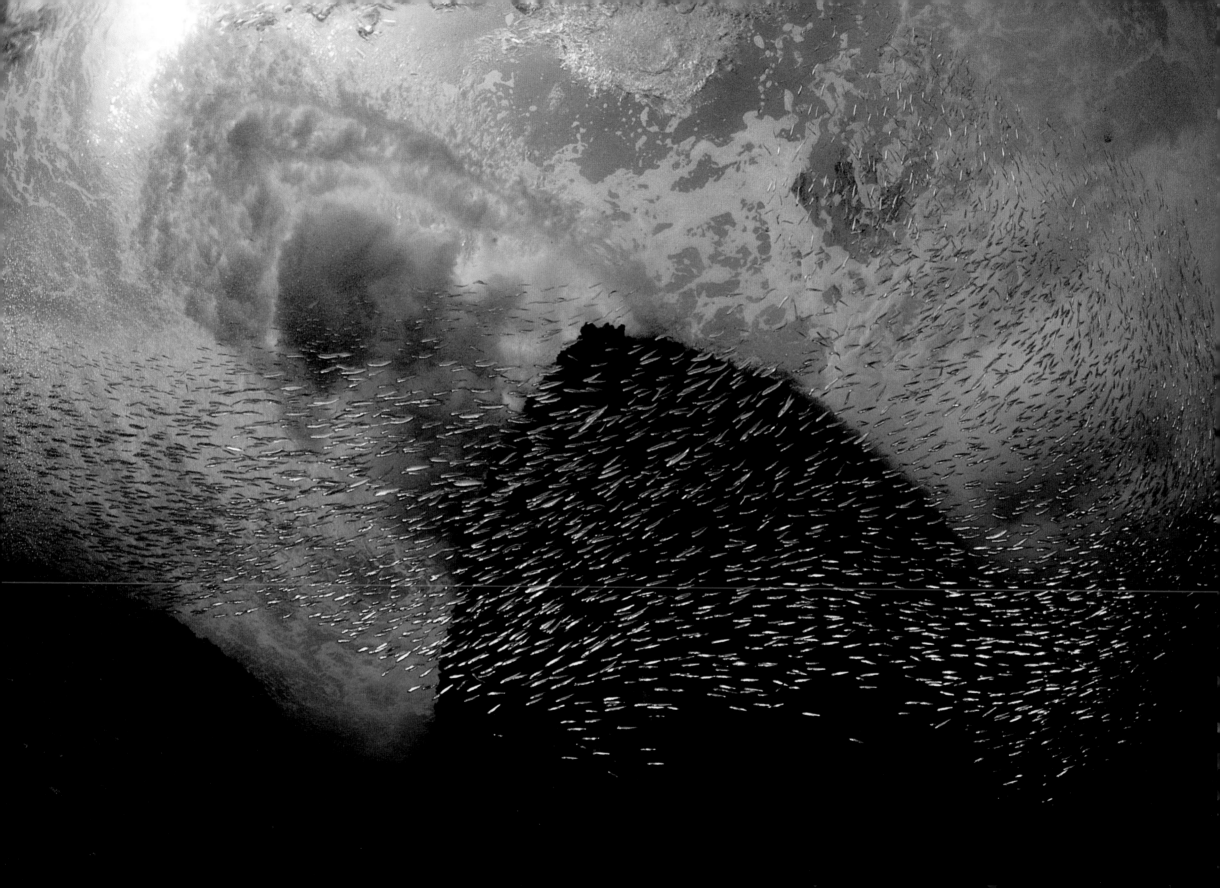

Circle of barracuda, New Ireland, Papua New Guinea, 1987

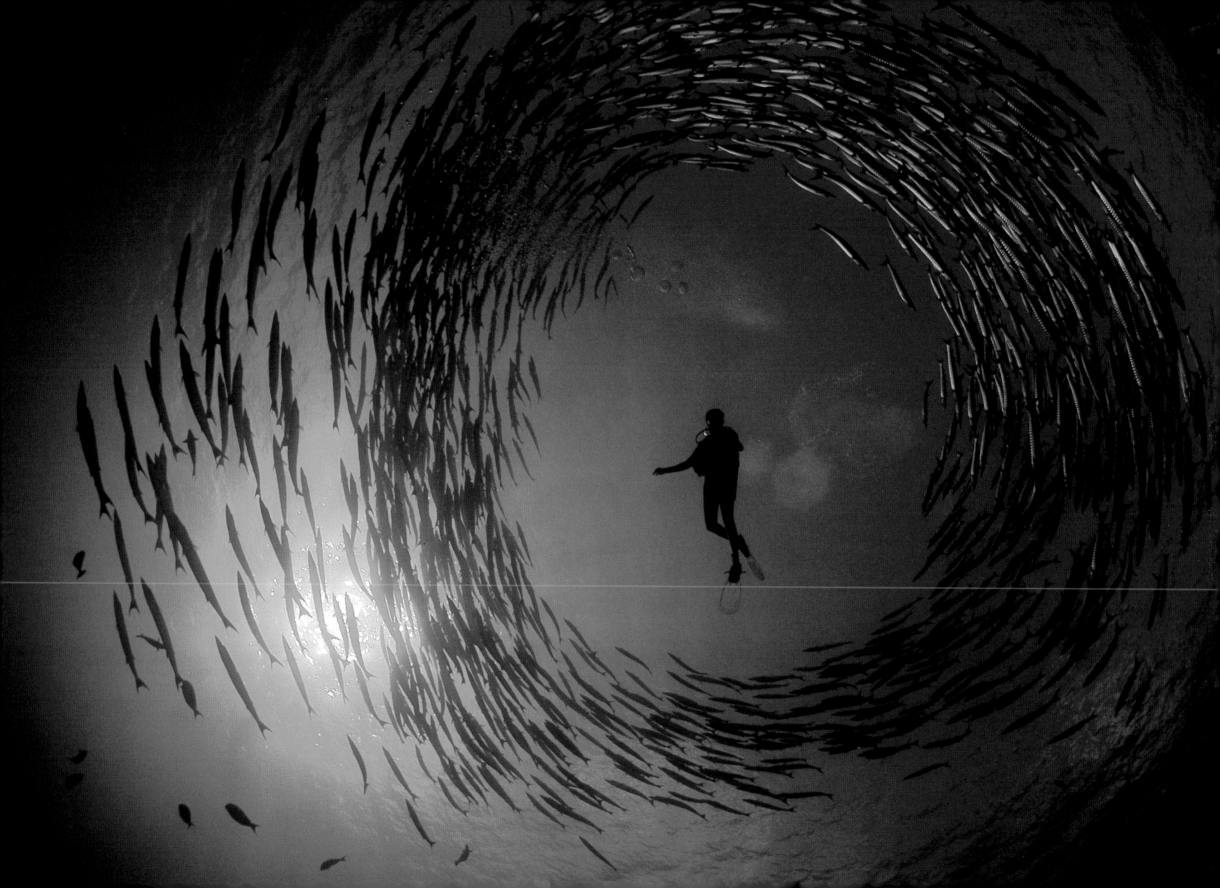

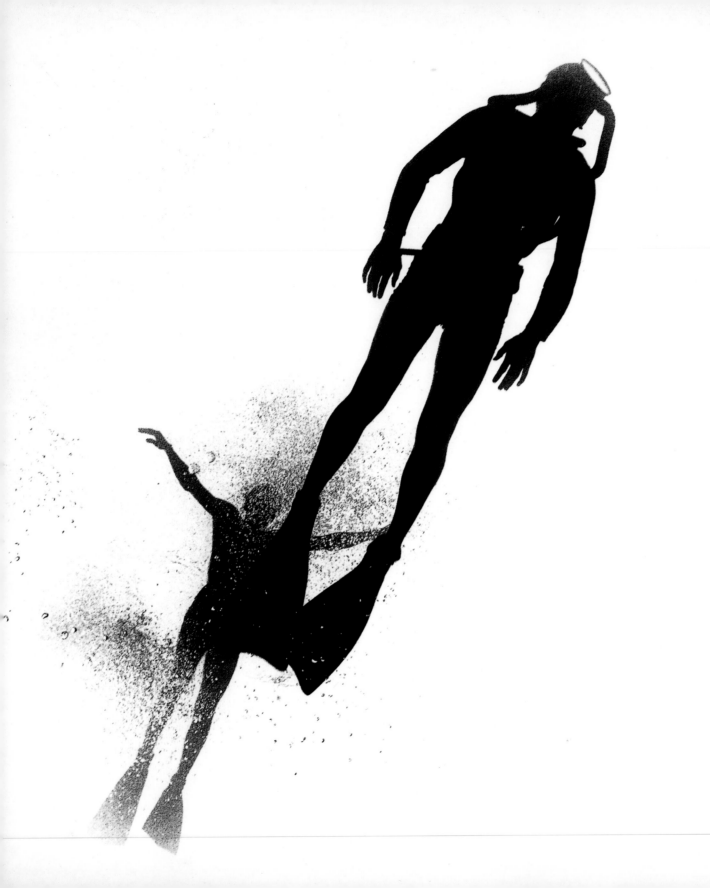

David Doubilet
Water Light Time

Two divers, Andros Island, Bahamas, West Indies, 1962

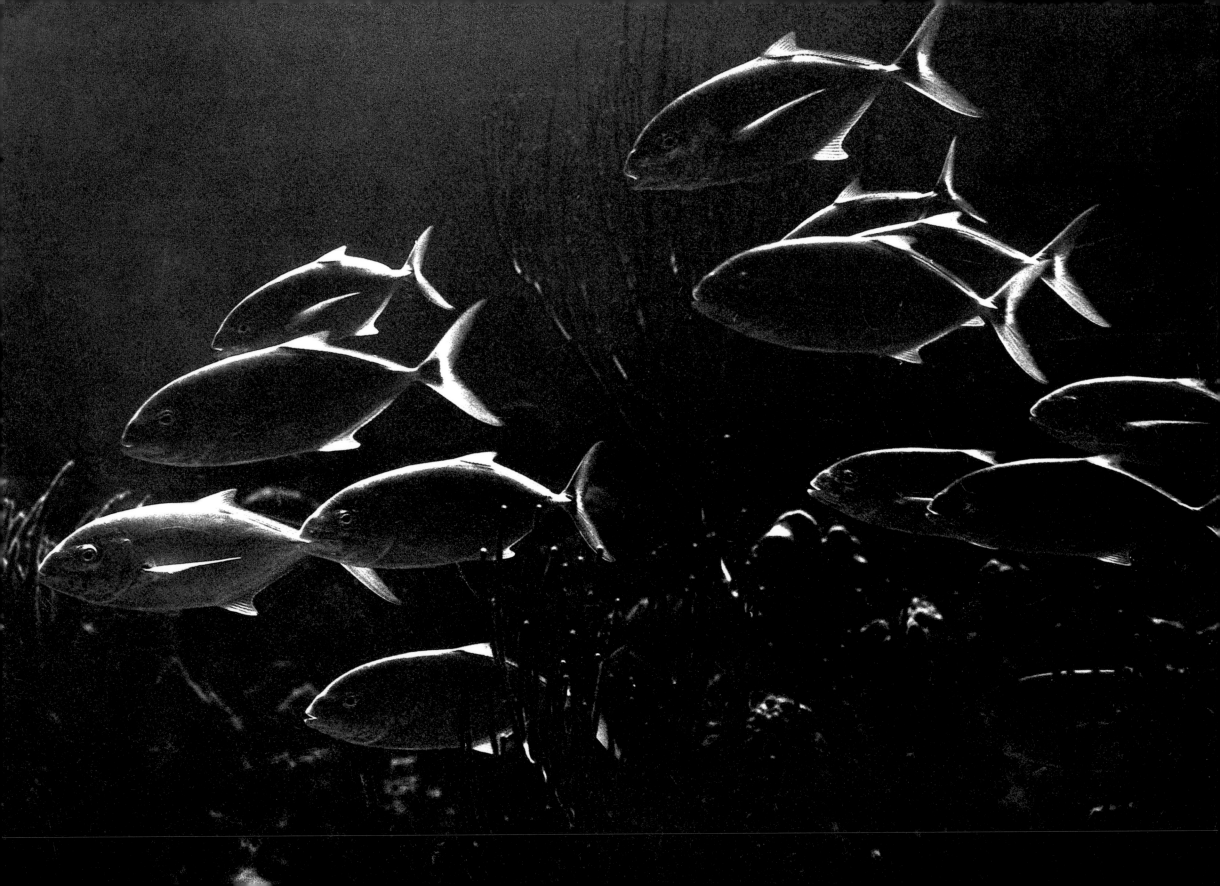

Beneath the surface

By Graeme Gourlay

Miles and miles of film are exposed each year. Millions of people have access to clever and effective cameras. Even in the technically difficult and often physically demanding environment under our seas, a staggering number of photographs are being taken every day. Very few of these images transcend – leap from the page to the heart – or communicate essential truths which add meaning to a complex and often contradictory world. But David Doubilet's work has consistently taken us through that magic window into a barely known world. For more than 30 years Doubilet has brought back images from beneath the seas that are at times profound, often glorious, and always passionate. He has set the standard others follow and opened the eyes of a generation to the wonders of the marine world.

There are two threads here which are closely interwoven: the first is Doubilet's deep affinity and love for the sea and the life which resides in it; and the second is his drive and energy as a master craftsman – an artist who understands his medium intimately and is always trying to push it further. These forces feed and nurture each other and keep 52-year-old Doubilet vital. He is continually challenged by the sheer difficulty of his task: the vastness of the oceans; the complex physics of light travelling through water; the elusive nature of his prey and the mundane problems of working in an alien environment.

It started with an asthmatic child's delight in swimming. He would struggle up mountains and around playing

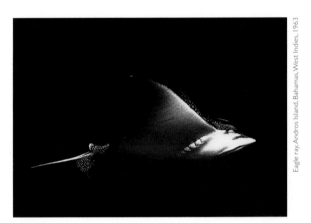

fields, wheezing and feeble; but, as soon as he was supported by water he became an athlete. Freed from gravity his lungs could function. He was a keen competitive swimmer, not quite Olympic standard, but nationally ranked. One day at summer camp in upstate New York, at the age of nine, someone lent him a mask and for the first time he peered underwater.

'As Jacques Cousteau pointed out, look underwater and civilization ends "with one last bow",' Doubilet said. 'The Silent World made an enormous impression on me when I read it in 1956. If you go under the sea and you really look, you see an extraordinary thing, which is the underside of the surface. It really is a looking-glass and it is hypnotic. Light goes through it, sparkling, shafting and moving. It is emotional – I love this view of water. I was talking to Cousteau years later and he told me that the first time he went underwater was in a similar lake to mine just a hundred miles away at a similar summer camp. Peculiar thing.'

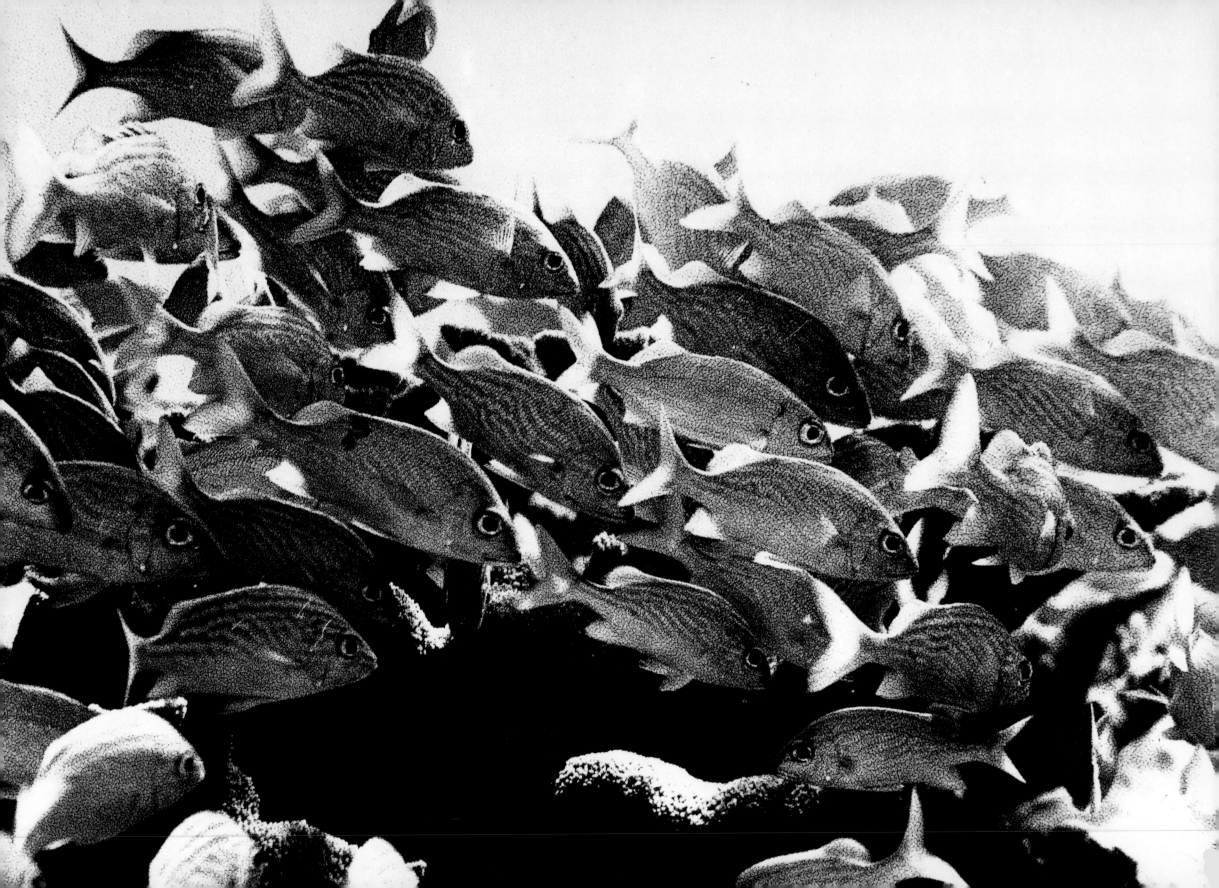

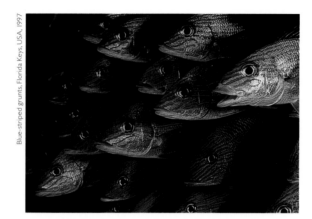

Blue-striped grunts, Florida Keys, USA, 1997

His father died when he was 17 and the rebellious schoolboy, who would only work when the subject matter interested him, quickly decided it was time to focus and achieve something at school. He wanted to go to Harvard but his crucial interview was held the day President Kennedy was shot – not the best moment to make an impression – and instead he ended up at Boston University studying film and broadcasting. He knew already that he wanted to be an underwater photojournalist, emulating his heroes such as *National Geographic* star Luis Marden.

The young Doubilet became increasingly obsessed with jumping through the looking-glass into his own very private wonderland. Born in New York in 1946, the son of a surgeon just back from the war in Italy, he grew up in the city and was later sent to school in New England. But summers were spent at the comfortable New Jersey retreat of Elberon, and there Doubilet could don fins and a mask and explore the bizarre world under the jetties which cut into the murky, green-brown Atlantic Ocean. September brought with it a return to the dull routine of school where, miles from water, all he could do was dream about the fantastic worlds of Hans Hass and Jacques Cousteau, which he read about in *National Geographic*.

Doubilet had been taking underwater photographs since he was 12, starting with a home-made kit and graduating to more professional levels with every new technical development. Photography equipment was becoming more accessible. New York City's second-hand markets were full of Leica cameras brought back from the war and the first Nikons were on the market. Photography was wildly popular and *National Geographic* functioned in the same way as David Attenborough films do today – it brought the exotic and fabulous world, newly opened up by travel and technology, to the comforts of the suburbs. For a bright, artistic child, photography could become an absorbing passion – even more so when the chosen realm was underwater.

After a trip to the Bahamas with his father, Doubilet's bond with the sea was further strengthened. There, he learned to scuba dive and for the next five years he was invited back to Small Hope Bay in Andros, first to fill tanks and later to run the boats and teach diving.

For years the young Doubilet kept a folded and creased copy of a 1956 Marden feature entitled *Camera Beneath the Sea*, where the photographer/writer accompanied

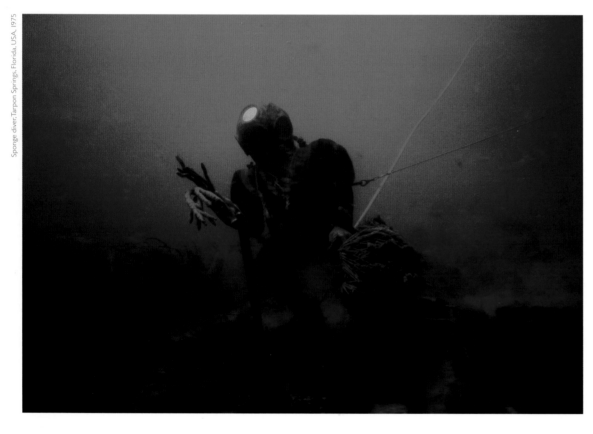

Cousteau aboard the Calypso for a journey to the Red Sea and the Indian Ocean. '*National Geographic* was very important to me then. It was a magazine of adventure and science but most importantly it published interesting photographs. At that time I wasn't trying to shoot reportage. My first really successful work underwater was black and white, not colour. I was making almost fine-art underwater pictures before I did reportage. I was inspired by the work of great photographers like Eugene Smith, Robert Capa and Cartier-Bresson.' As he became an increasingly competent underwater photographer, winning competitions such as one for the Underwater Photography Society of California when he was 14, he realized that his dream of being the next Marden could be a reality.

After leaving college Doubilet went to see Bob Gilka, the famed editor of *Geographic*; gruff, direct and inspirational. He took one look at the eager young man's work and told him, quite simply, that there was nothing new in it. Crestfallen, Doubilet went for some solace to his friend, the *National Geographic* photographer Bates Littlehales, who put his two-and-a-quarter chromes on a light box, sucked his teeth, scratched his head and also said there was nothing new. In hindsight, Doubilet understands what the problem was: 'In truth, my work was derivative, but one of the reasons why it was derivative was because it was equipment driven. The Rolleimarin was the best underwater camera at the time, but it had a fixed

focal-length lens. With a 75mm or 80mm lens, only something the size of a soccer ball or, if you backed away, something the size of an umbrella would fit into its square format. Round objects, square format. So you could shoot a parrotfish but you couldn't shoot a shrimp. And you certainly couldn't shoot the vista, the wonderful vista that you saw underwater.' Littlehales came up with a solution. He designed one of the first underwater housings with a dome that corrected for distortion for the 35mm Nikon camera, which by the late Sixties was dominant in most other areas of photography, and made it possible for Doubilet to make his mark and capture the seascape he knew so well.

His first big break came when Stan Waterman, the famous underwater film-maker, invited him to join the marine biologist, Eugenie Clark on a trip to the Red Sea to study garden eels. It was a *National Geographic* expedition and the staff photographer, James L. Stanfield, very graciously allowed the aspiring photographer to tag along. Using a remote-controlled camera, Doubilet got stunning images of the eels extending into the current from the sandy sea-bed and received a joint by-line when the eventual feature was published in November 1972. Next he proposed an idea to document the lobster fishing industry in North America and through this worked alongside his hero Luis Marden. The feature was published the following year with the charming title, *Delectable Cannibal*. He was starting to make his mark, and the

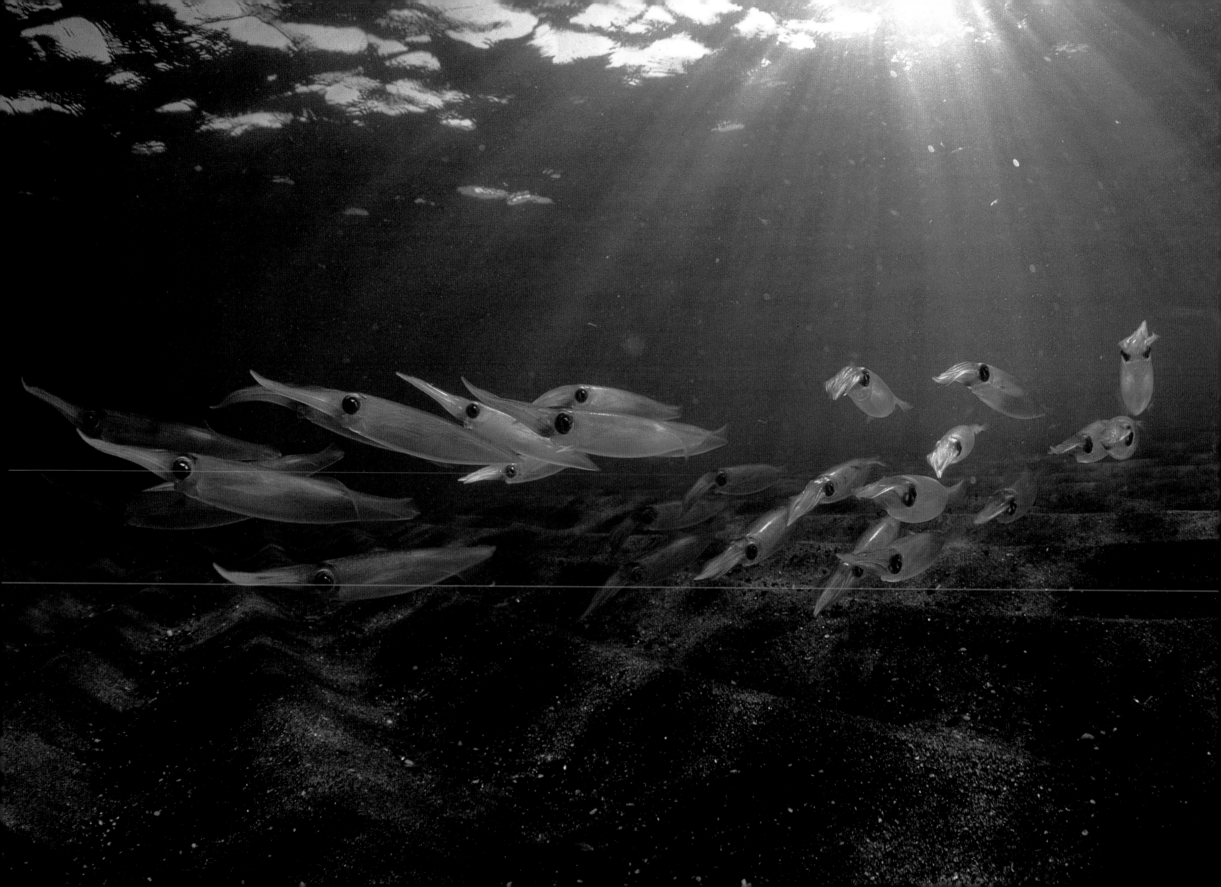

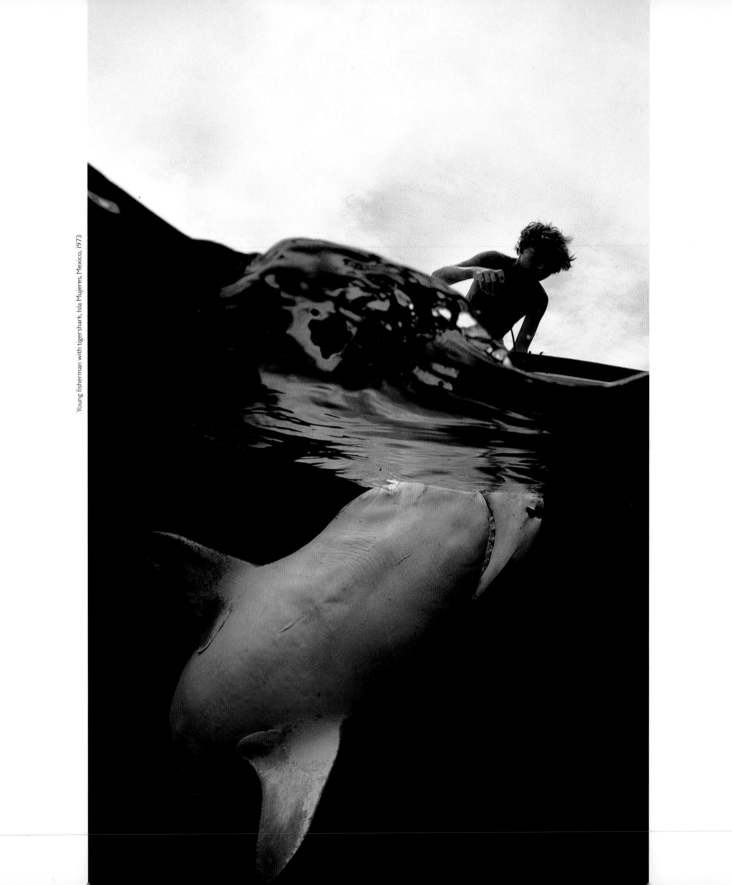

Young fisherman with tigershark, Isla Mujeres, Mexico, 1973

following year he was sent back to the Red Sea and there followed a series of pieces with Eugenie Clark that established him as a major talent. In 1976, Doubilet joined the elite band of *National Geographic* contract photographers. Since then, he has had over 50 major articles published by the magazine and has travelled extensively in the Pacific, Australia, the Indian Ocean and the Caribbean. Though he works as a photojournalist, the driving force for him has always been the art of photography.

'Humans have been going underwater for 50 years. We're still in an age of exploration. There is a tendency for people to go out into this world and discover things, to document it. There is also personal photography and there is magazine photography. I suppose I combine a bit of everything. *National Geographic* is a journalistic endeavour; but it would all be meaningless if I did not secretly push the other side, which I do every time. I never forget I'm a journalist but I am also a storyteller. I examine all the facts, but it is how they are woven together into a cohesive set of images that makes people stop and wonder. In the end, the best thing one can do is amaze people.' And Doubilet has consistently amazed people with a level of journalism that is astounding. 'You go somewhere', he elaborated, 'with a terrific driving responsibility on your shoulders to capture what that place is and bring it back. But it's got to be filtered through your eyes, your mood, your feelings. You have to show the shipwreck underwater. Where's the bow? Where's the stern? Does it steam out of the gloom? Tell me that it is a ship, at least show me a part of it from which I can feel or learn something. And when that comes into focus, important things start to happen: where's the light coming from? What is the person's relationship with the wreck? First and foremost there must be a desire to express the place – its essence – and to give it a quality of seduction. The image itself has to be pretty – whether it is pretty ugly or pretty gorgeous.'

Doubilet is conscious of his political role, but demands more than mere coverage from his work: 'Some say I do not cover the pollution of the seas and the dynamic problems that are relevant. They say I should do more hard-edged journalism, more dead fish on the beach, or the sewage being pumped into the sea. In essence those pictures are news pictures, they belong on the front page of *The Times*. And, a good dead-fish picture can be an important and compelling picture, but for me I need something else. What I've got to say is – why are people interested in this place, what makes it a jewel? A tenet of photojournalism is to illustrate a problem and effect change. All these pretty fish pictures have been *the* most effective journalistic pictures because they have inspired an environmental ethic.'

Today, Doubilet is as enthusiastic and engaged with his work as he was 30 years ago. He continually pushes barriers. A recent piece in *National Geographic* on ultraviolet light and corals is a prime example, both technically ground-breaking and artistically refreshing. He is now shooting more and more in black and white and the results are impressive. In a sense he has come full circle and returned to his monochrome roots. But his new black and white images are the work of a mature artist and they combine all his strengths. They are visual operas telling grand stories about the ocean that combine a mastery of light, an understanding of gesture and a graphically acute eye. 'In the end,' he says, 'they are just moments – the curve of a stingray's wing in the Caribbean, the pulse of life on a Red Sea reef, the weightless gesture of a sea lion in the Galapagos. They all catch the play of light in the sea.'

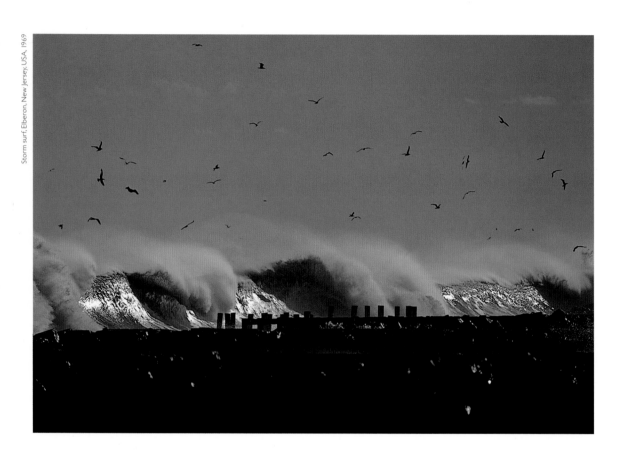

Storm surf, Elberon, New Jersey, USA, 1969

Pompano fish feed in sand, St John, Virgin Islands, USA, 1994

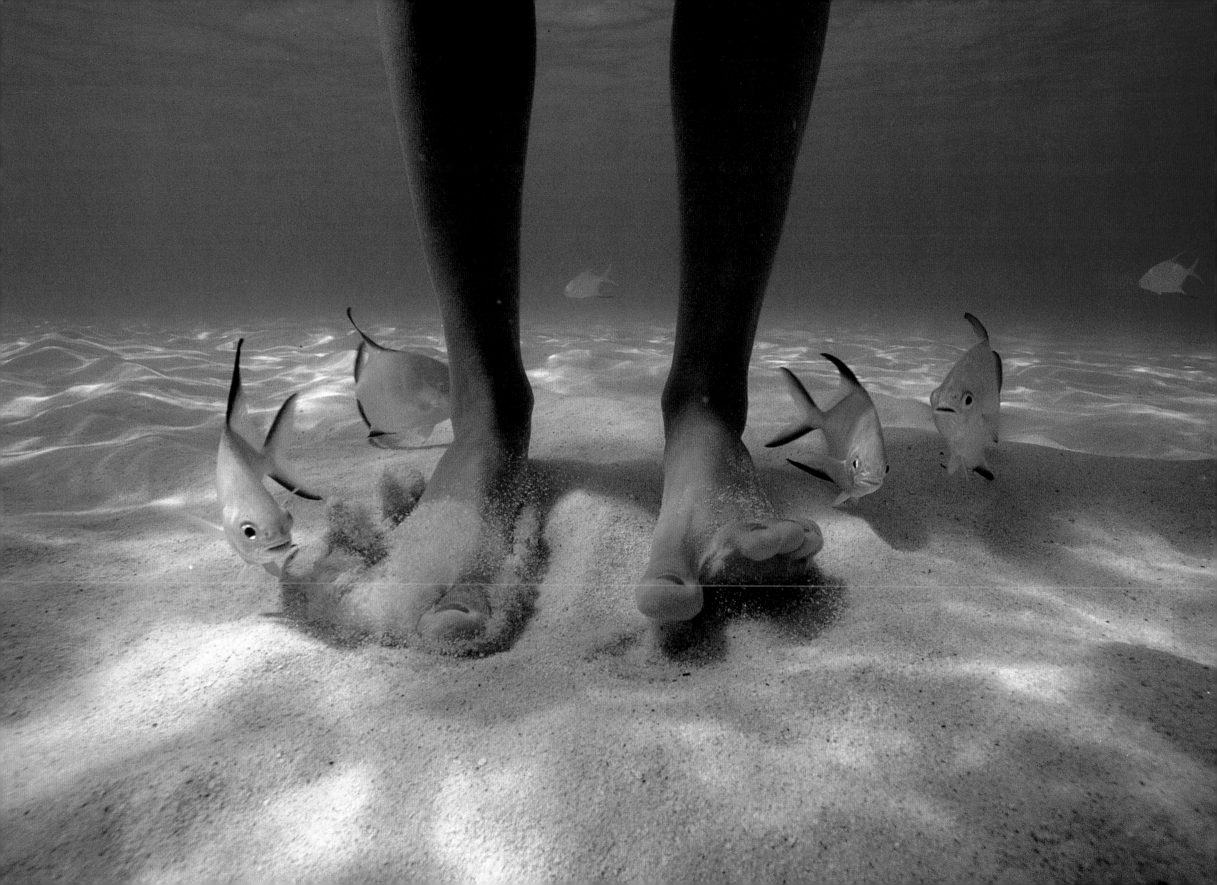

Sea of light

The water was clear, warm and soft. That is my first memory of the Caribbean. I was 12 years old on a first dive. In a clean ocean I remember a shallow reef covered with yellow sea fans and schools of yellow French grunts that flowed within a forest of brown antler corals.

Later I remember rolling on my back, breathing through a double-hosed regulator and looking at how the light came through the underside of the surface. It danced, shifted and pierced into the sea – a vision of light that can only be seen through the window of a face mask.

The Caribbean is a great basin that stretches from the Windward Islands all the way to the coast of Central America. During the Ice Ages the sea level fell and this warm pool of water cooled, killing much of the marine life. Where life did return, this sea became homogenized with little variations of life in thousands of miles of sea. The reefs of eastern Cuba therefore look like the reefs off Honduras.

It is a simple coral sea that can have places of delicate intensity. In the summer, trade winds blowing down the length of the Virgin Island

chain carry the dust of Africa. The seas warm and great schools of two-inch-long silvery baitfish gather off St. John Island. They grow thick and blot out the sun. Tarpons feed on them. Anne and I photographed these schools at night. They swarmed around a powerful HMI movie light. The tarpons slashed through the silver carousel of fish, the light bouncing off their mirror-like scales.

In 1974 I photographed sharks sleeping in caves off Isla Mujeres, an island off the Yucatan Peninsula. In one cave a cloud of silvery bar jacks hovered over a Springer's reef shark's head.

The Gulf Stream born in the Caribbean rushes north past the Florida Keys. Here I photographed the courtship of loggerhead turtles. An indelicate dance that went from a mirror-smooth surface to a sand bottom 60 feet below. Two males fought for the ancient pleasure of the ripe female. At one point a third male arrived. Looking through his rheumy dim eyes, he momentarily mistook me for the female. I politely re-directed his advances.

The Caribbean, from my first memories, was always a classroom and a laboratory where I learned to watch light come into the sea.

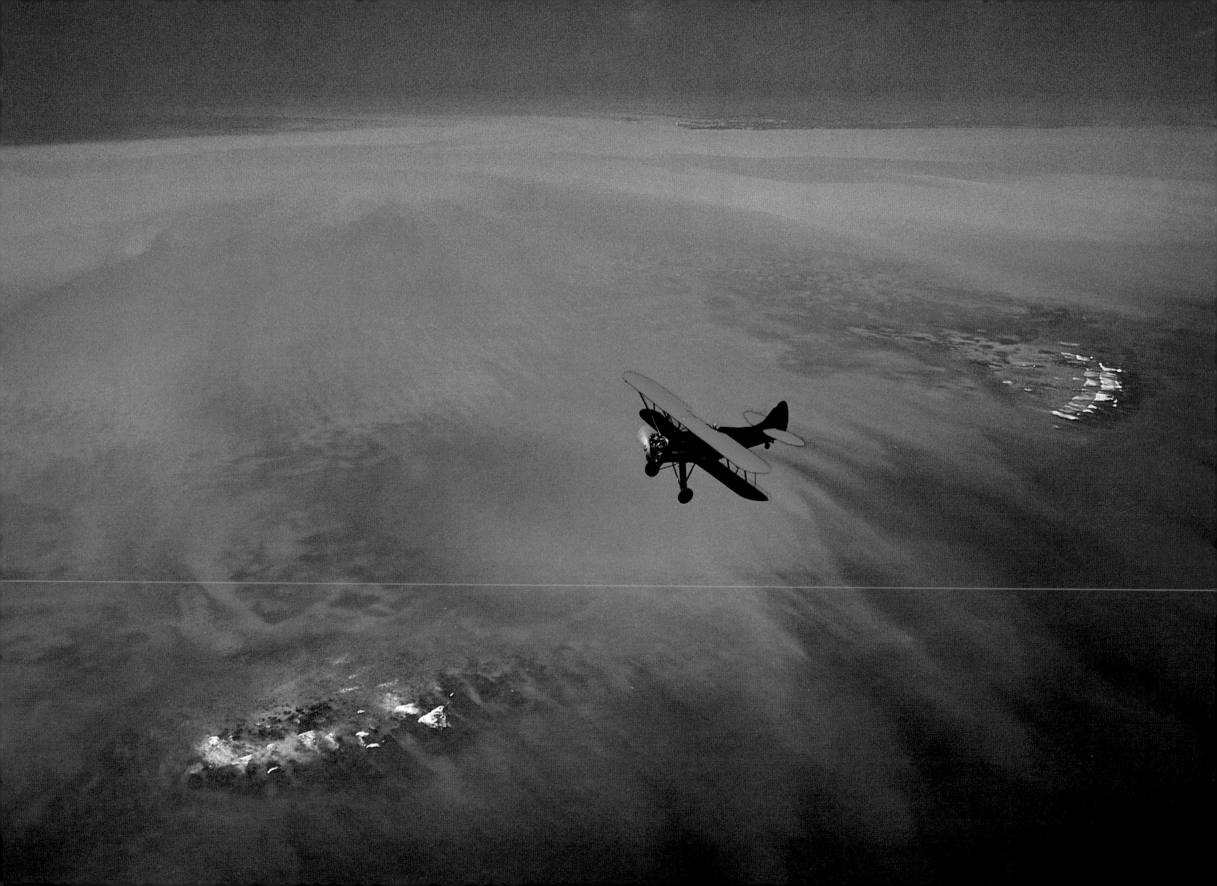

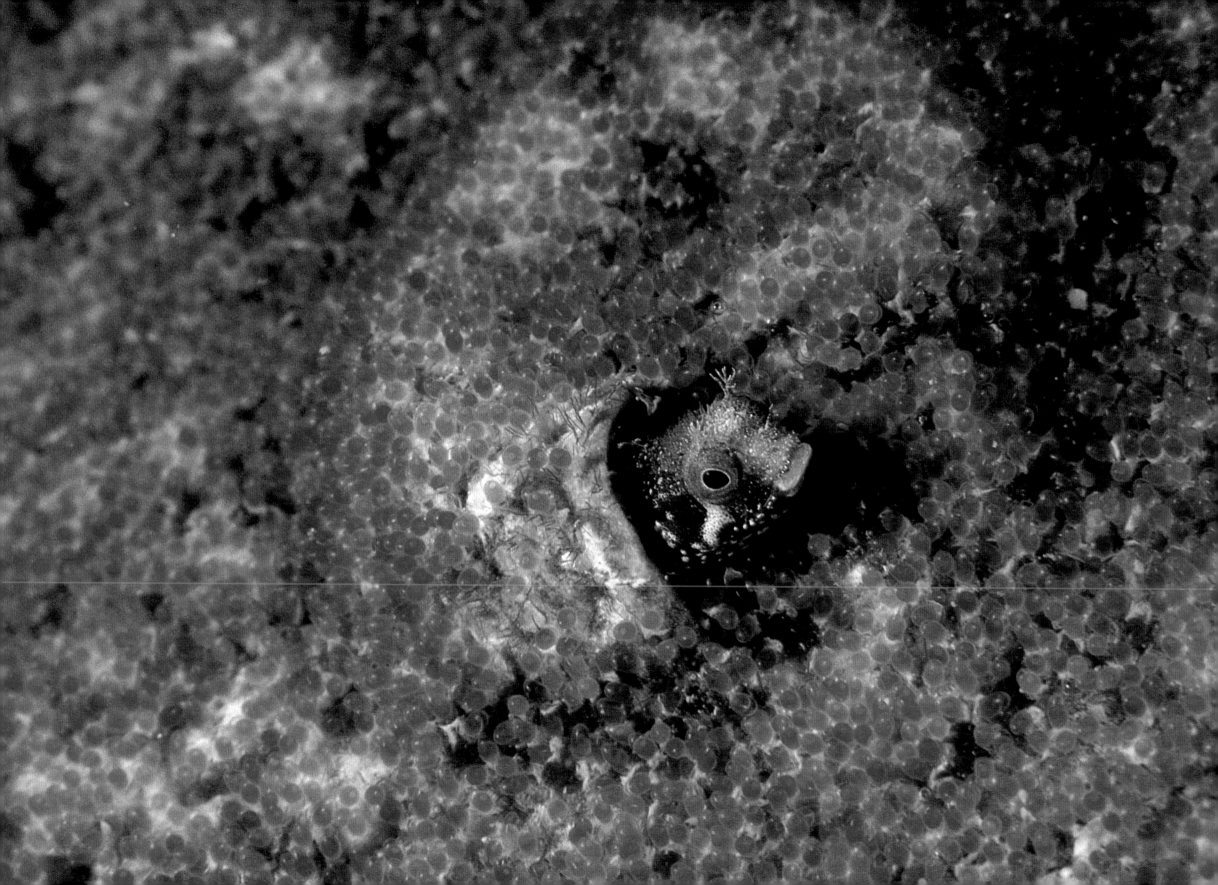

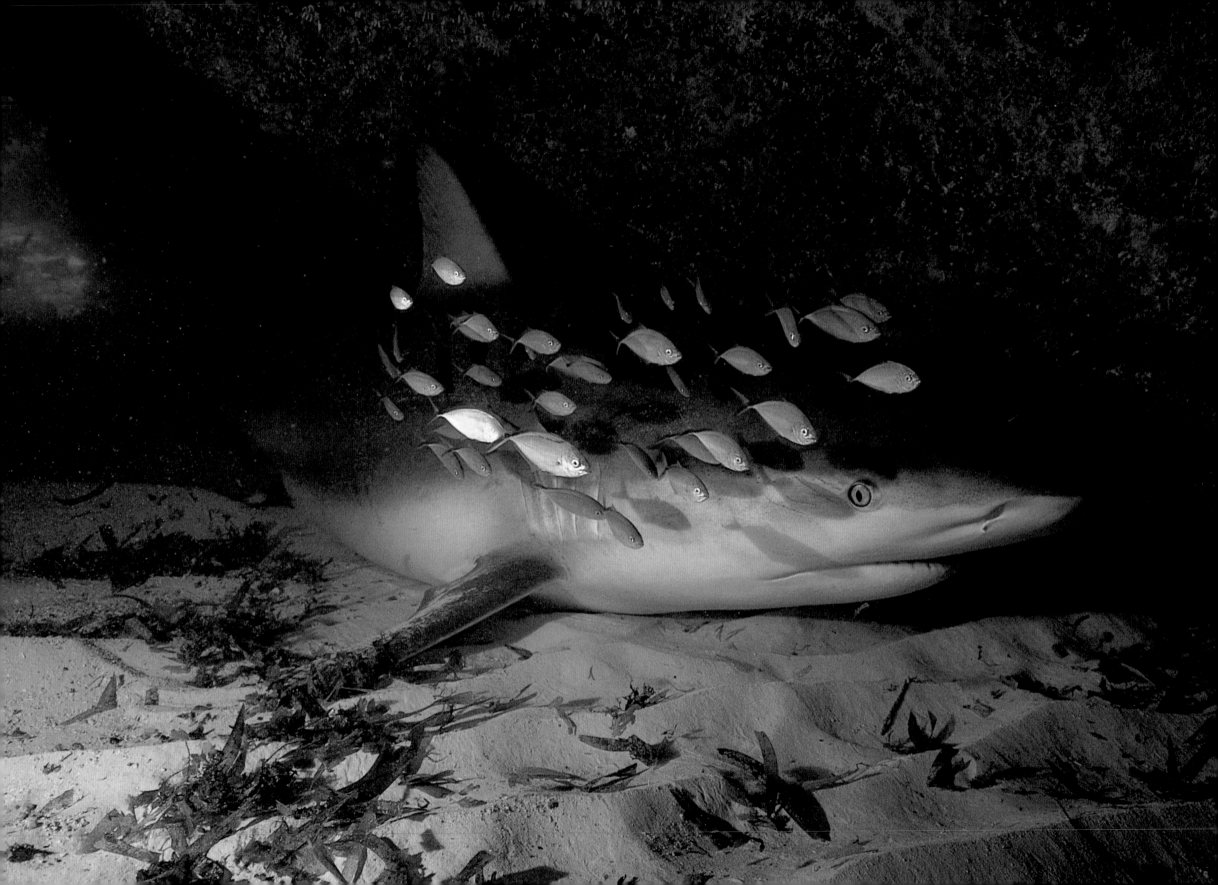

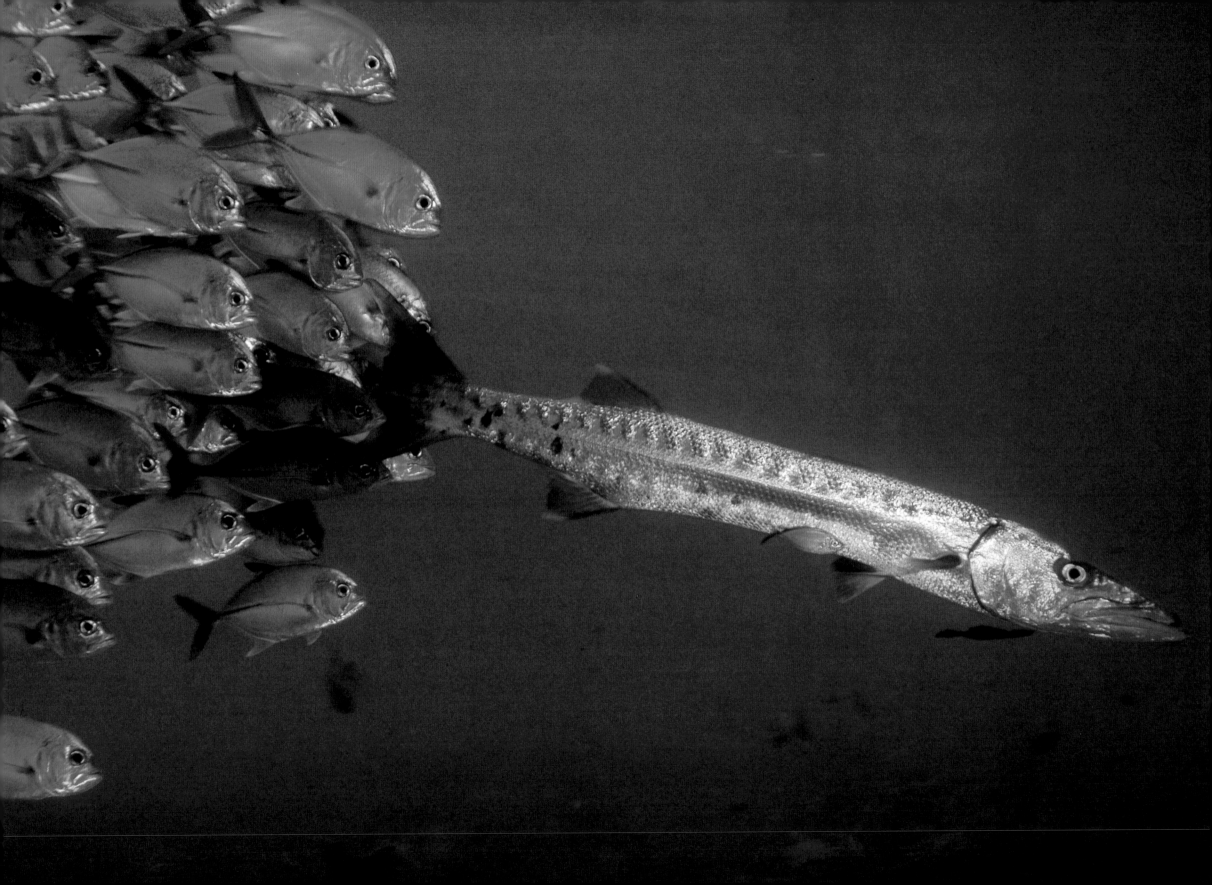

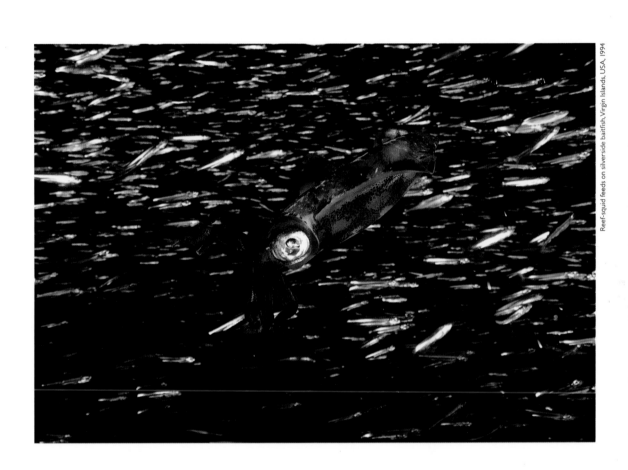

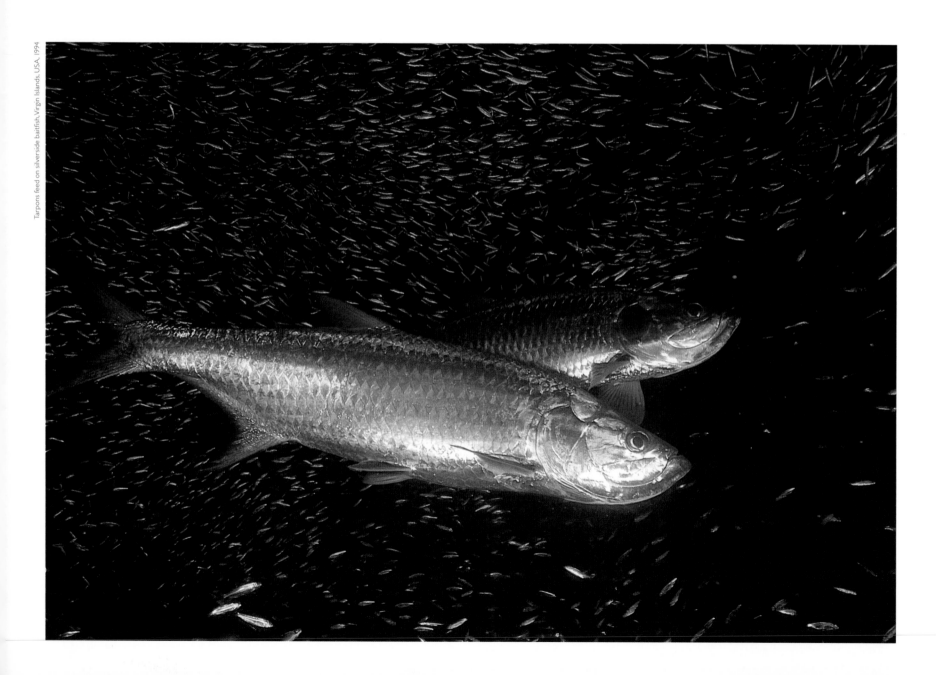

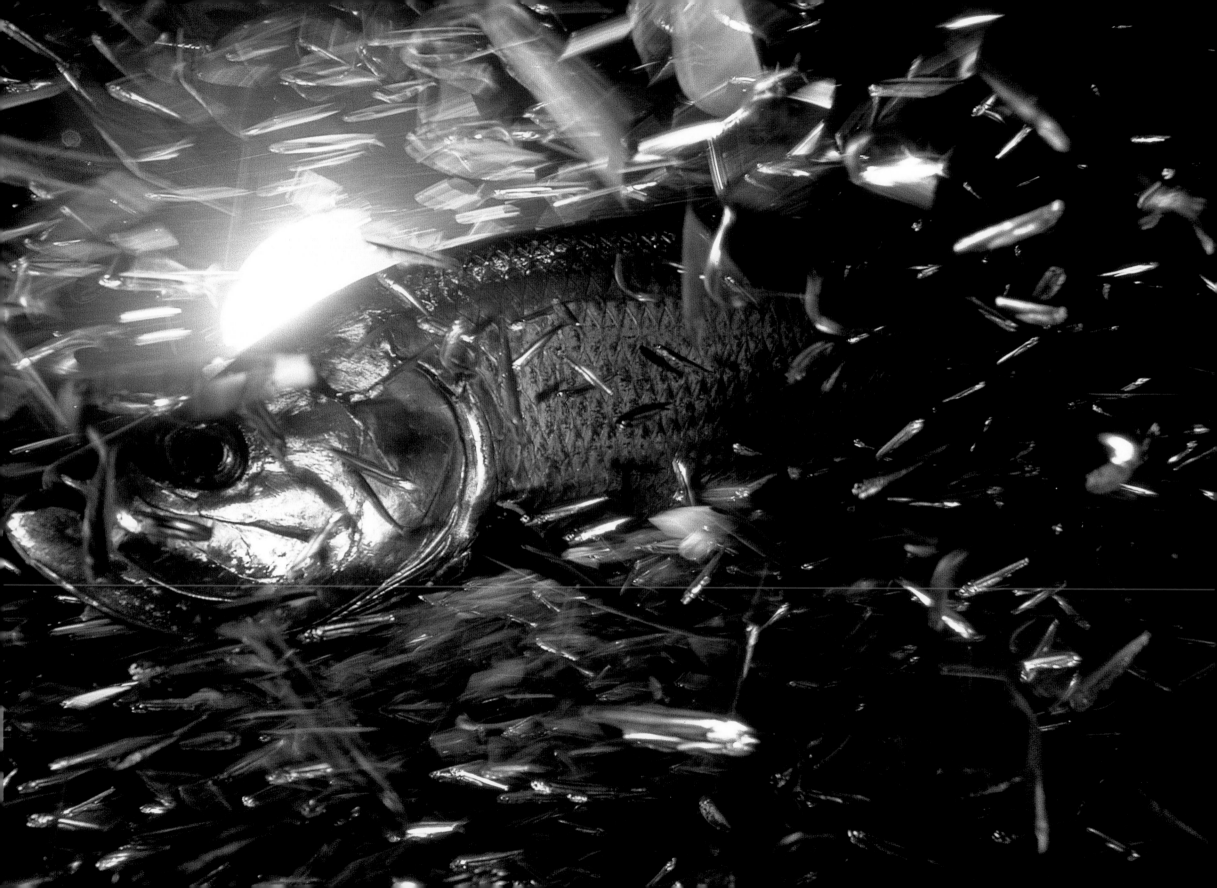

Cool waters

Light enters a Californian kelp forest with operatic grace. The leaves of the kelp filter light to gold. Kelp, the largest of algae, attached to the seabed with special 'holdfast cells', arch towards the surface, sometimes over 100 feet above, like weightless beanstalks. Diving in kelp is like flying around the upper reaches of a forest. Harbour seals slip through this shadowy world. One bit my flipper, turned around, rested its head on an elbow of kelp and winked at me.

Off Vancouver Island I watched a giant octopus fold its tentacles together like a magician's cloak. As the water temperature drops the oxygen level rises – the seas become a rich emerald green.

The colour of the marine life in the cool waters of New Zealand is astonishing. In the Poor Knights Islands off North Island I swam into sea caves where the walls were tapestries covered with jewel anemones. I watched two-inch-long blue-eyed triple-fin fish, found only here, flit over orange sponges.

On New Zealand's southwest coast the sea reaches into the land with fjord fingers. The surface water of Doubtful Sound is green-brown, but this is only a layer of freshwater falling off the 3,000 foot-high mountains into the fjords below. Diving through this layer is like going through a looking-glass into a dark clear world. The murky surface water bathes the steep seascape in green gloom. Storms from the west cross the Tasman Sea and batter this southern coast. When they clear, the mirror-smooth waters of the fjords reflect the complex sky above.

In the cold southern ocean off Tasmania there are kelp forests – of the same species found in California – in deep clear water. But this is the other side of the Pacific. It is a world that looks the same but is wildly different. Gone are the pleasant orange Garibaldi fish. They are replaced by bizarre weedy sea dragons, pot-bellied sea horses and red velvet fish – creatures from the other side of imagination rather than the Pacific. Warm currents mix with cold water and deep water species come up into the shallows. In the constant surge red hand fish with blue eyes hold on to the bottom with pectoral fins that have evolved into hands. The sea changes here within a moment – rain, wind, snow, sun – and amazingly it is a far different underwater country than New Zealand just on the other side of the grey rolling Tasman Sea.

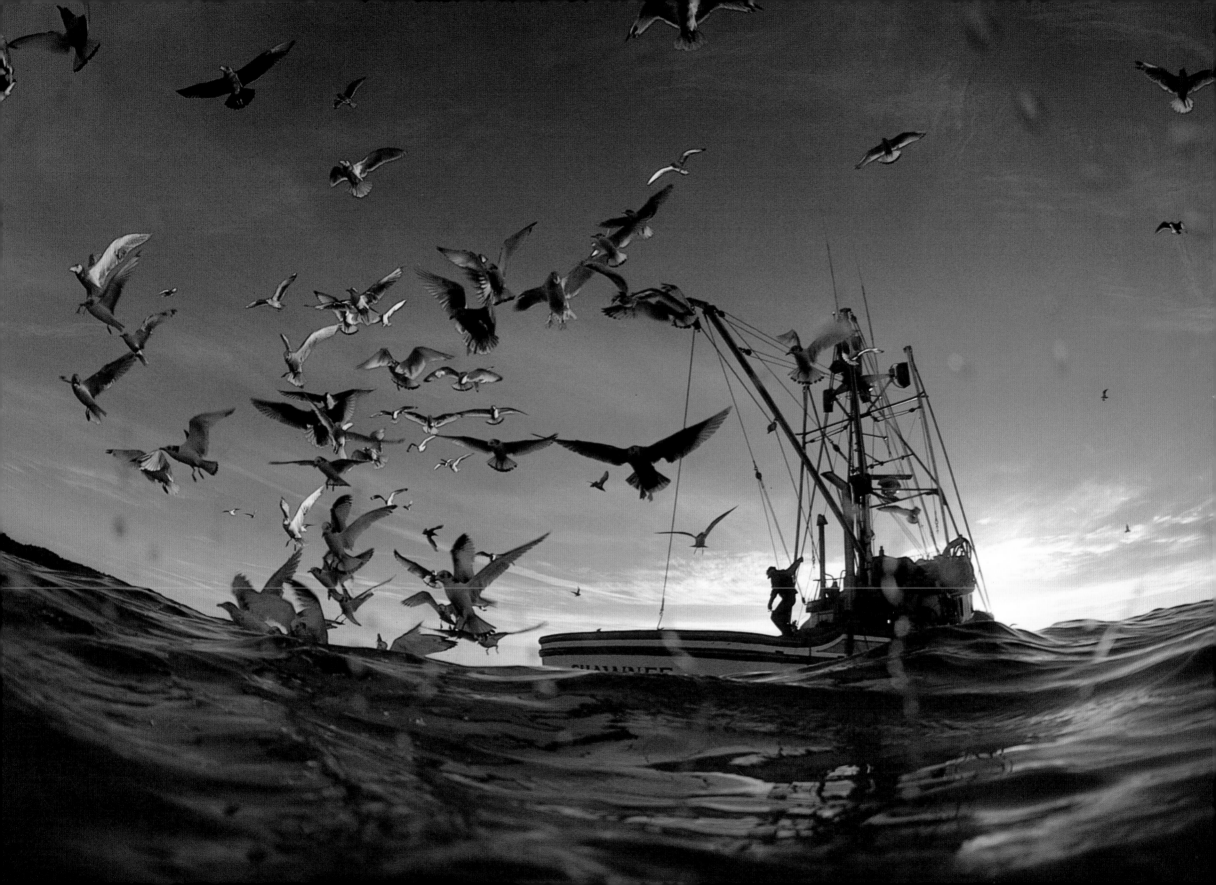

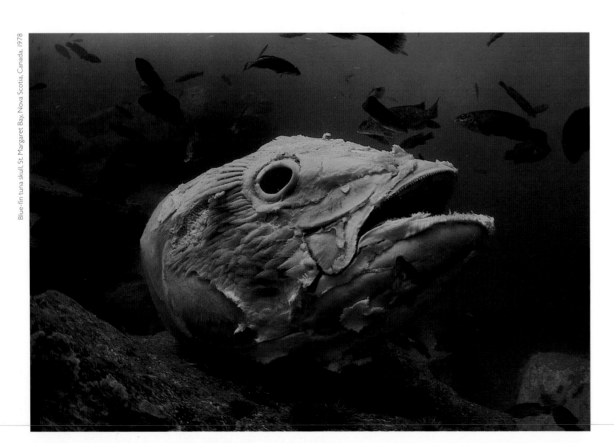

Blue-fin tuna skull, St. Margaret Bay, Nova Scotia, Canada, 1978

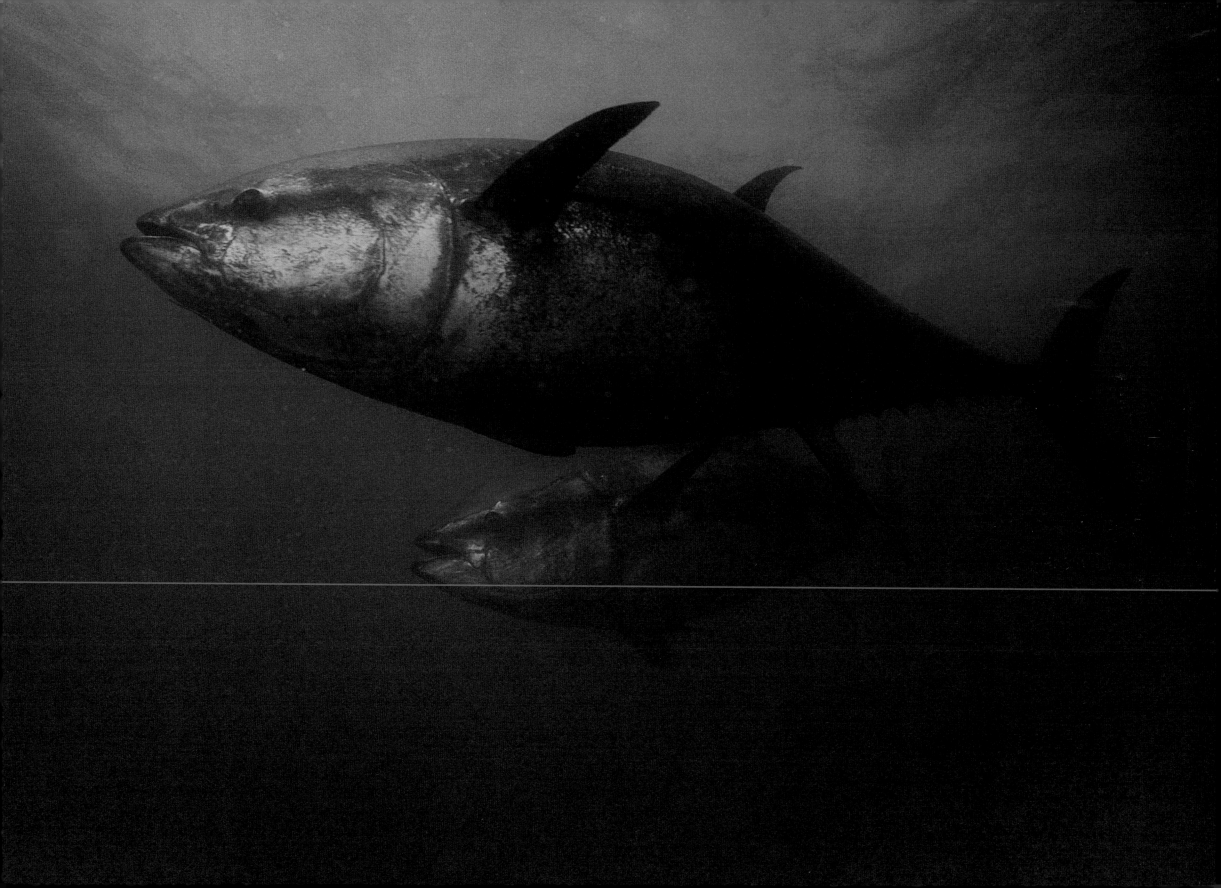

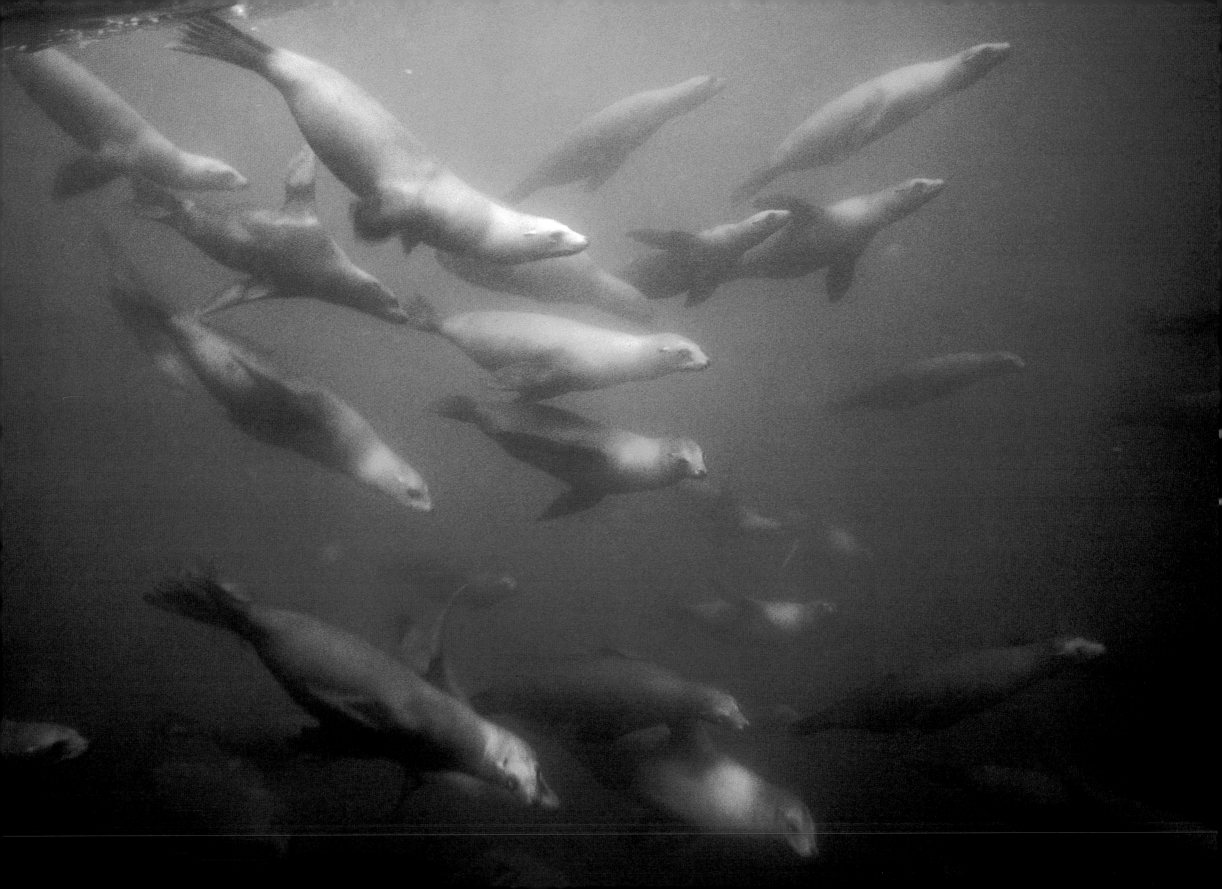

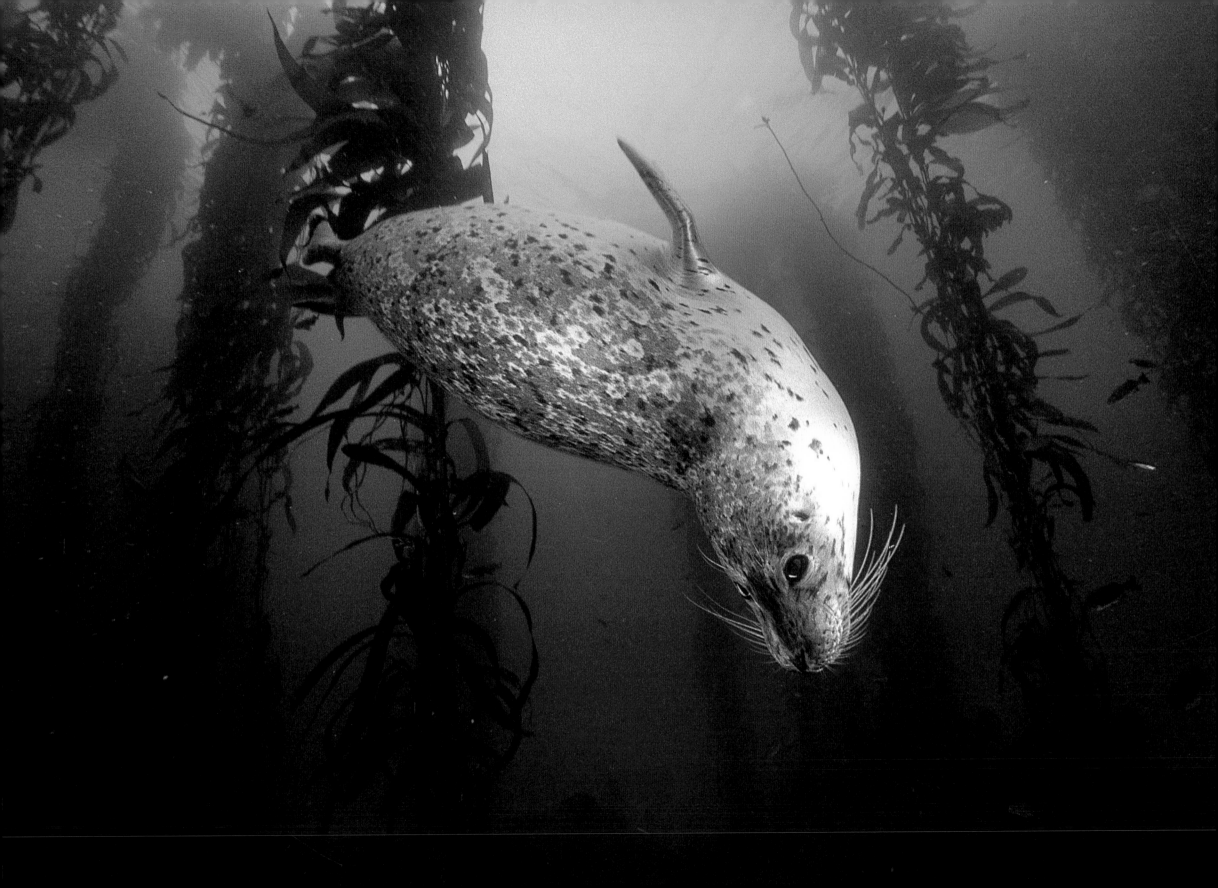

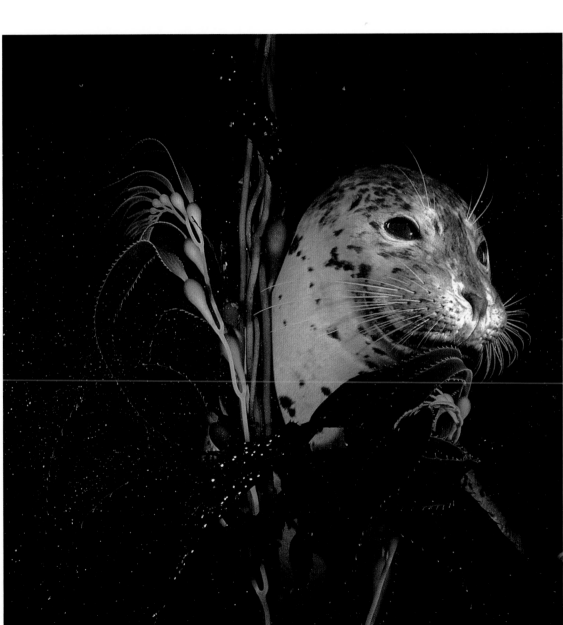

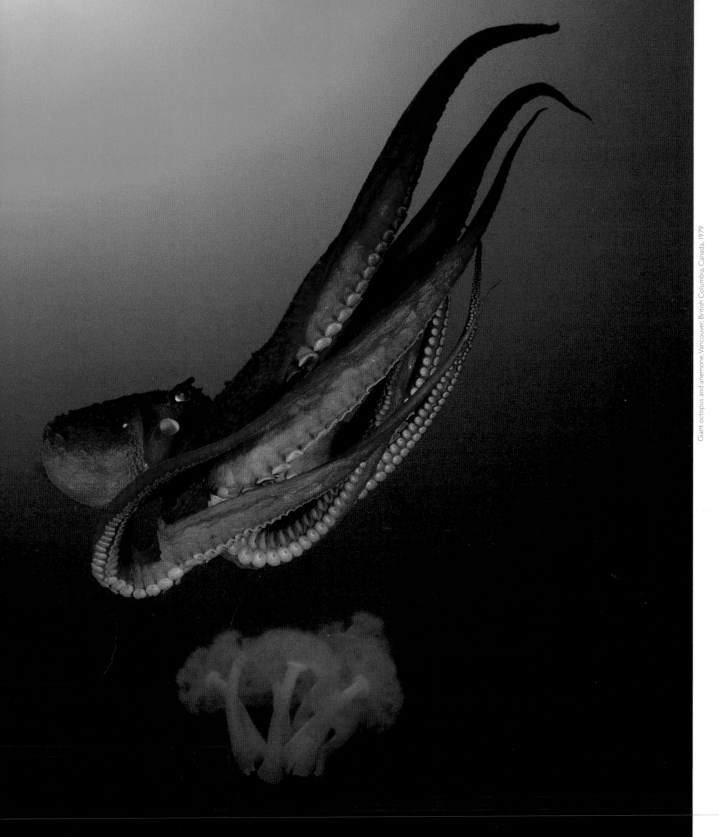

Giant octopus and anemone, Vancouver, British Columbia, Canada, 1979

Senorita and Garibaldi fish in kelp, Channel Islands, California, USA, 1997

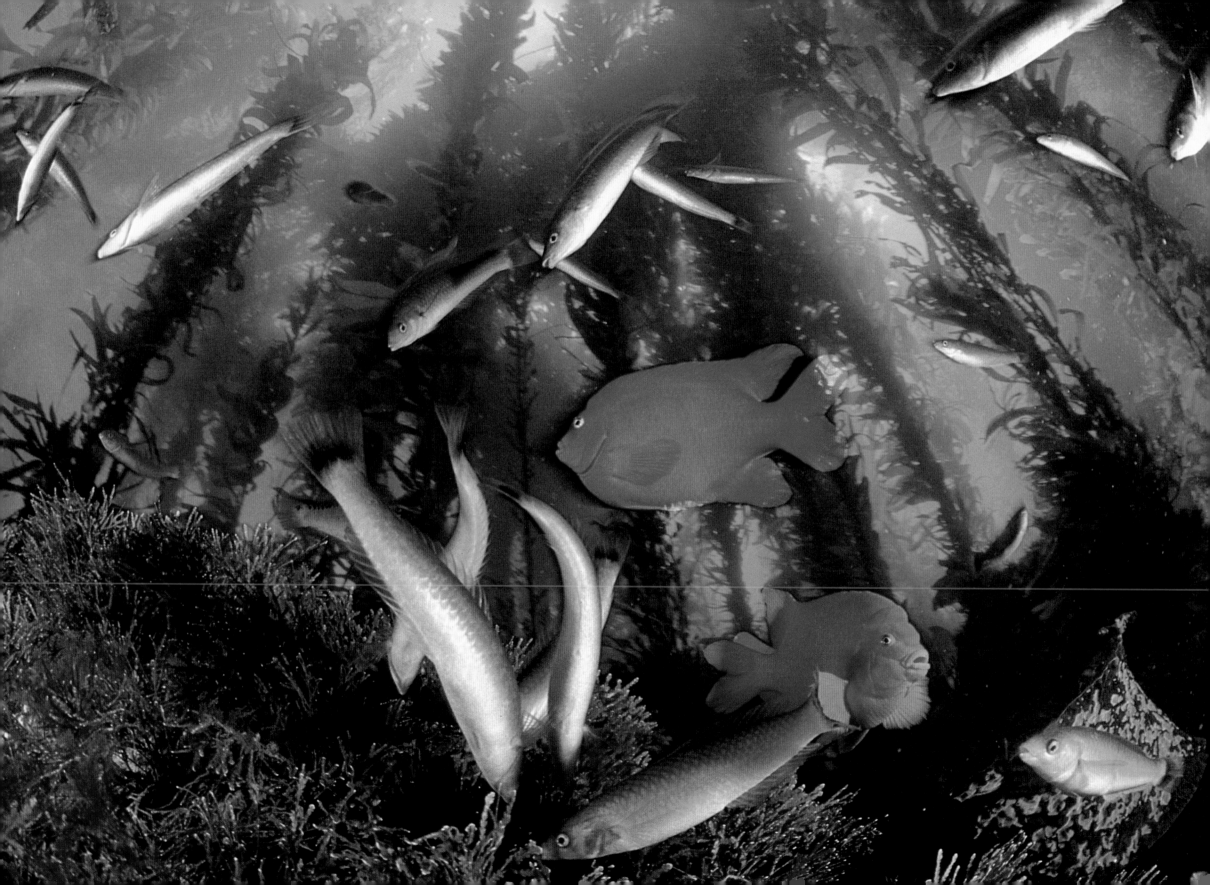

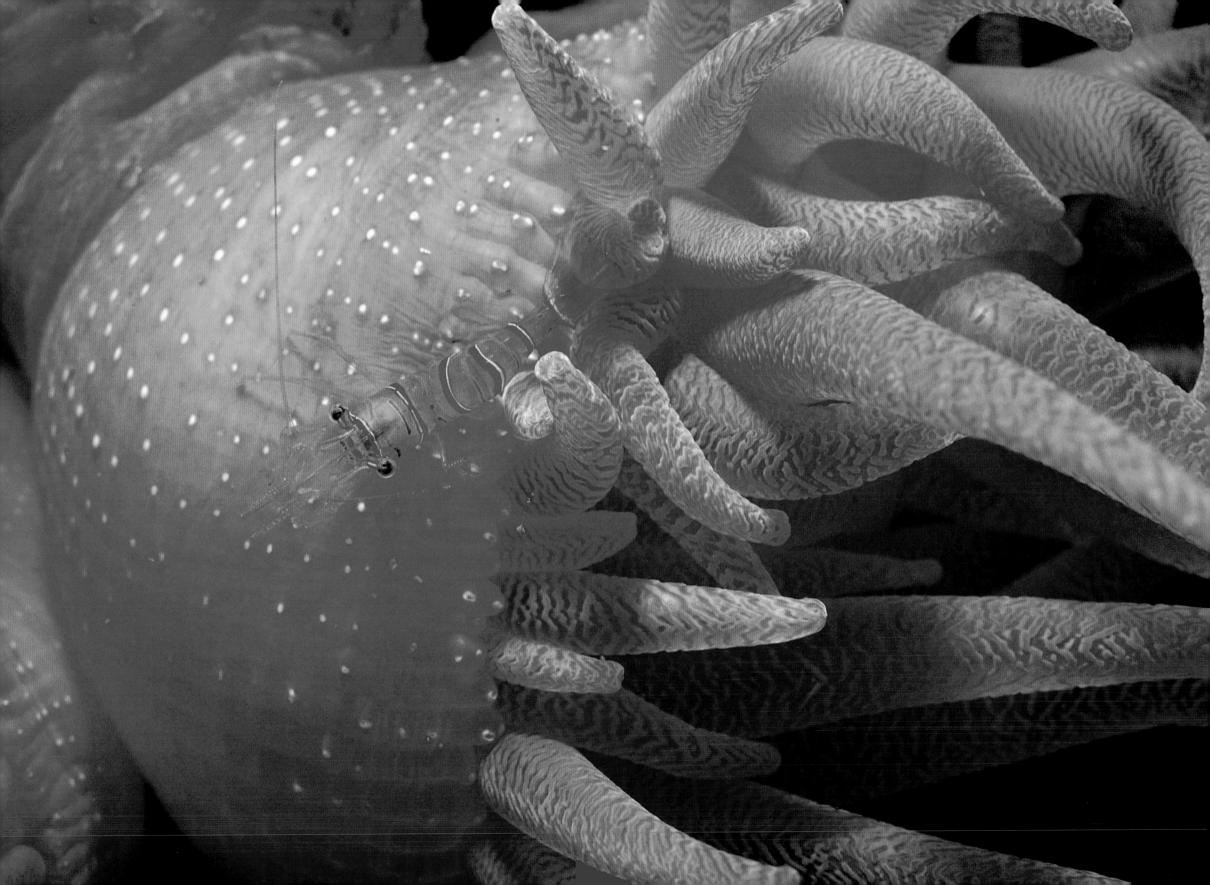

Clown shrimp and pink anemone, British Columbia, Canada, 1979

Pacific moray eel and red cleaner shrimp, Channel Islands, California, USA, 1985

Old wolf eel, Vancouver Island, British Columbia, Canada, 1979

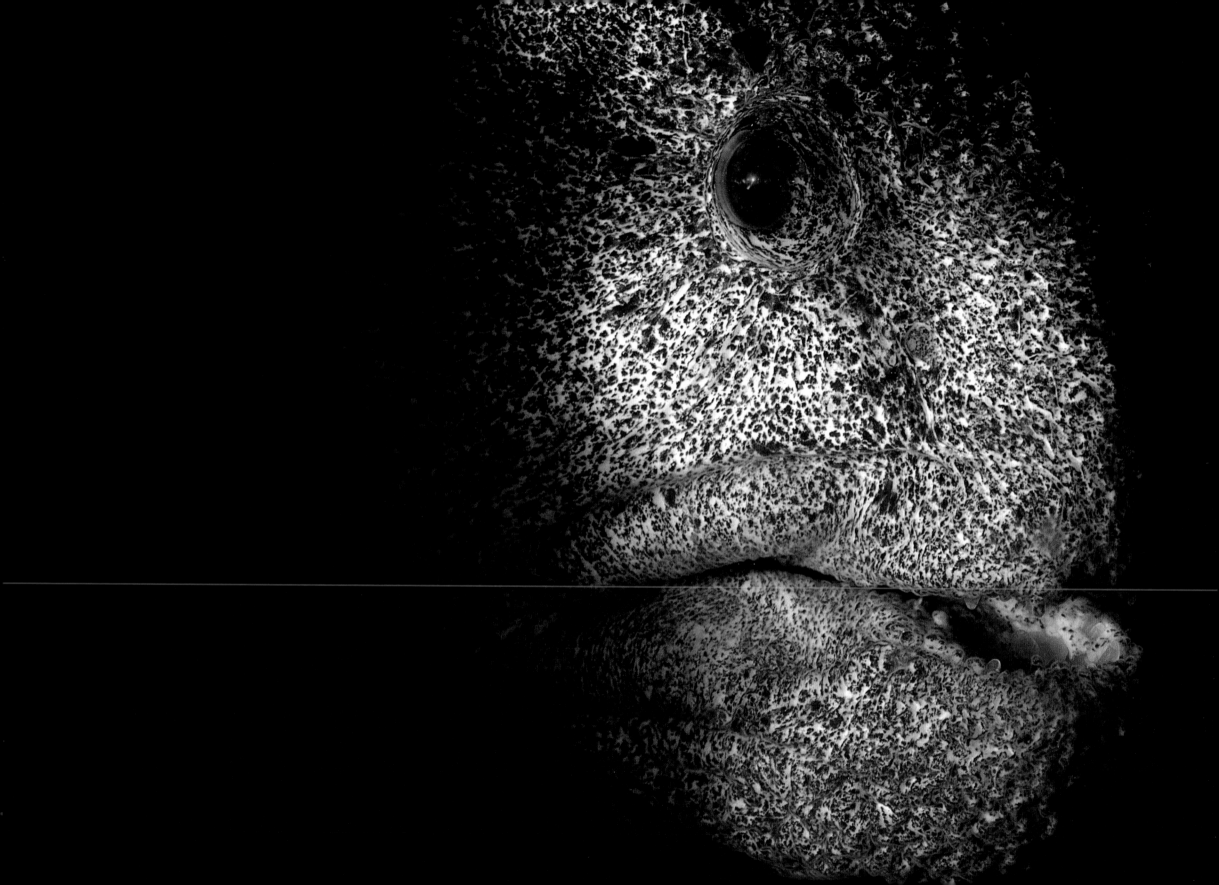

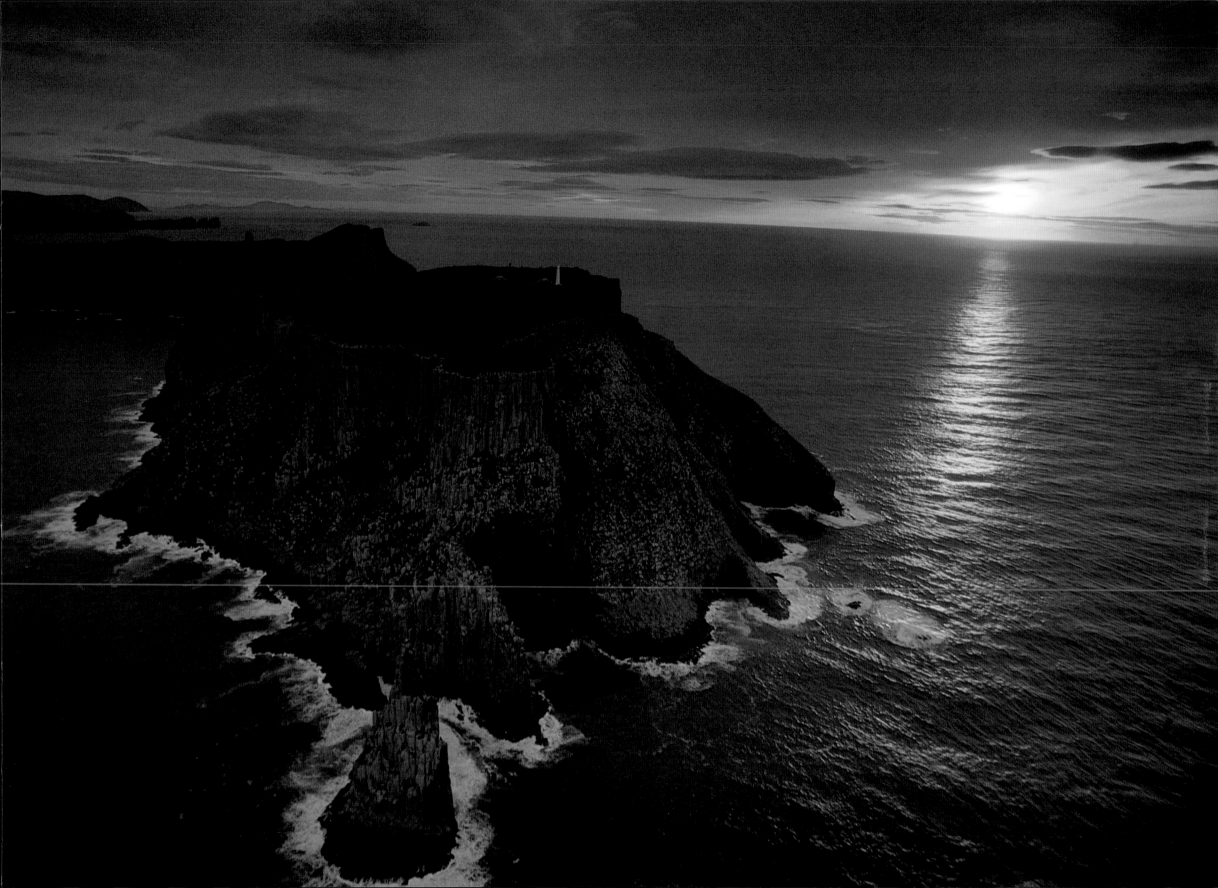

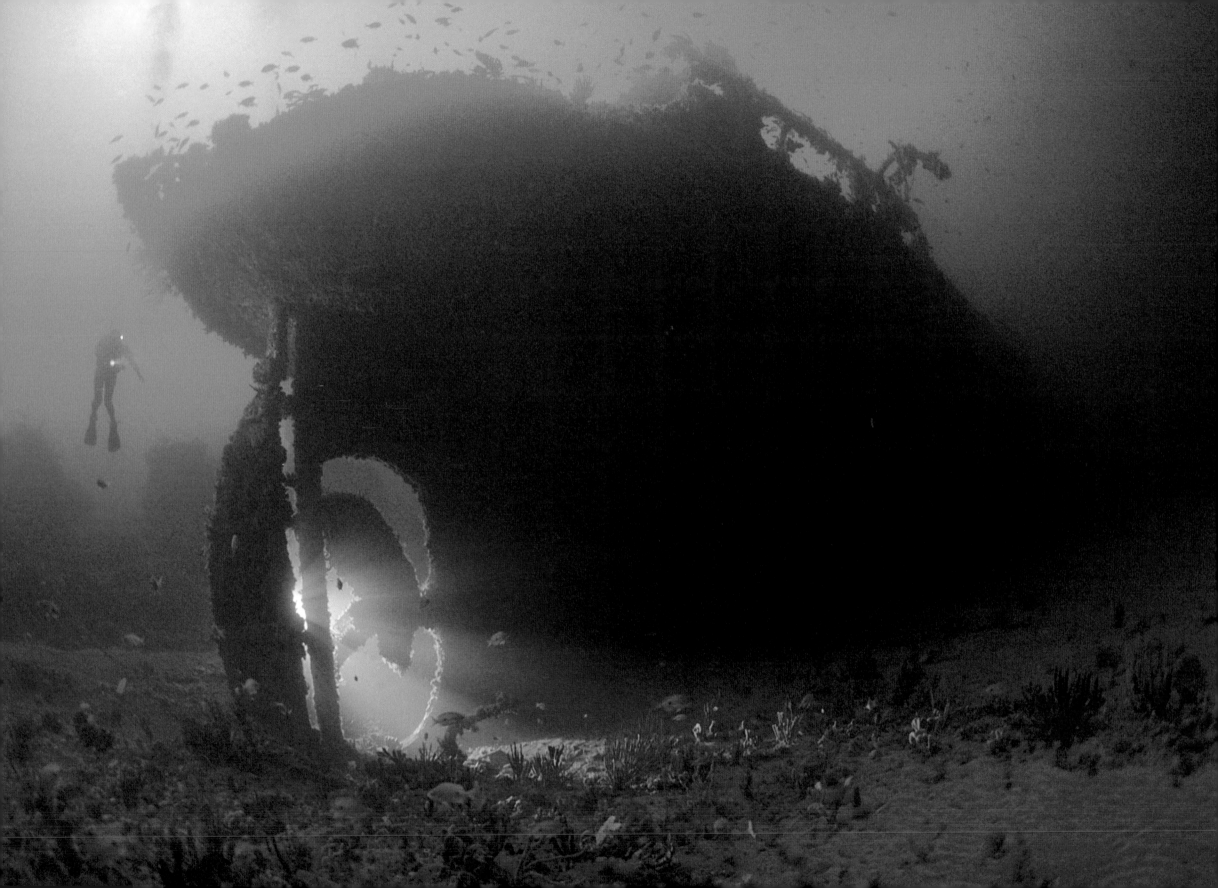

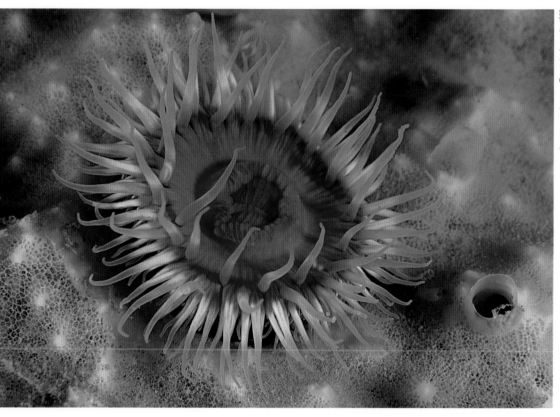

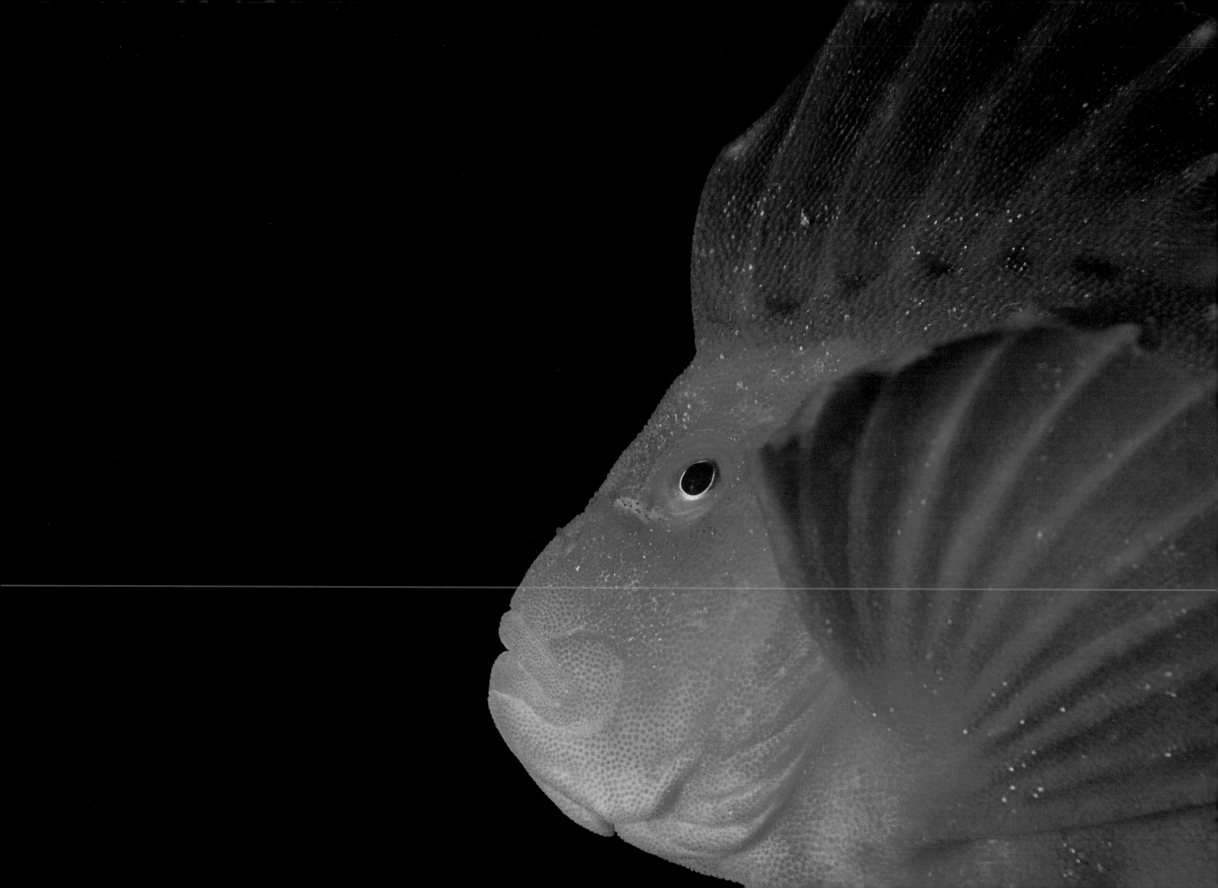

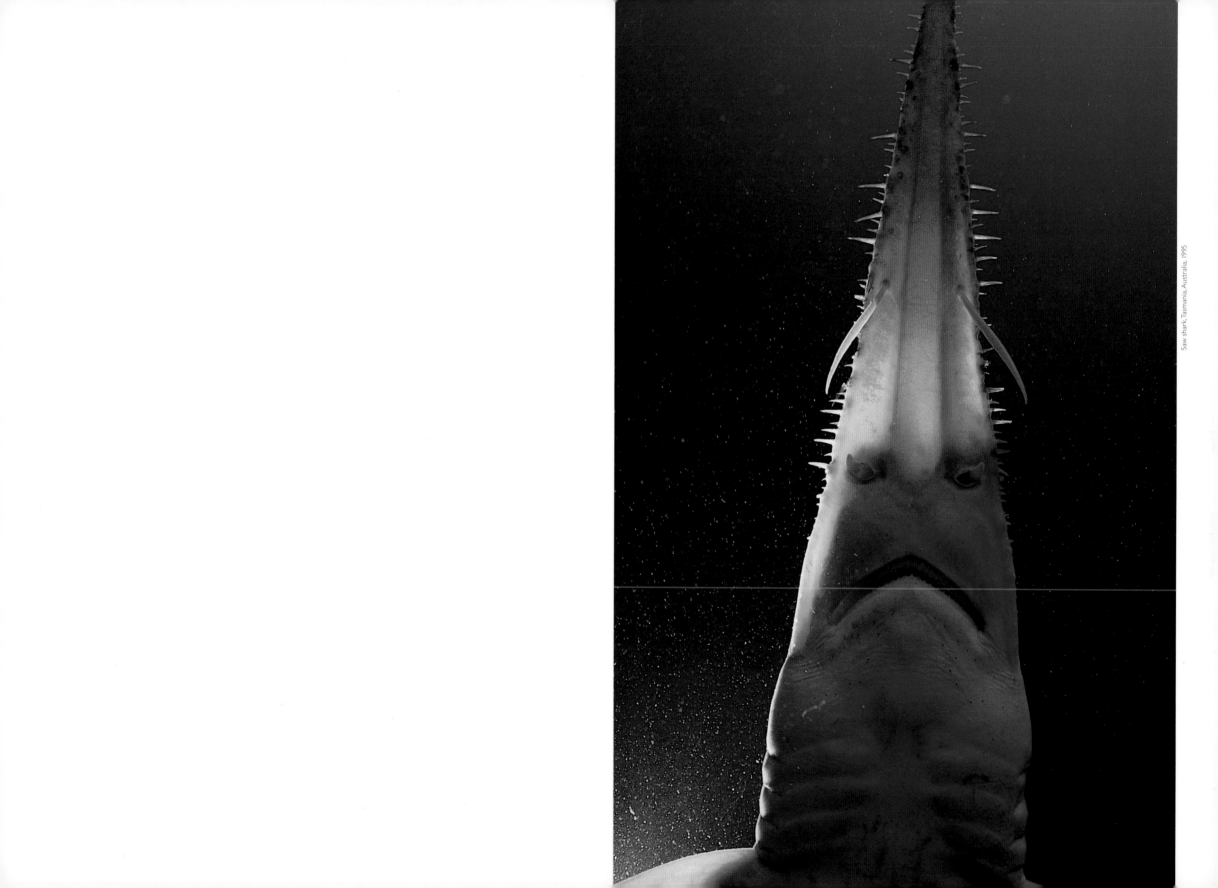

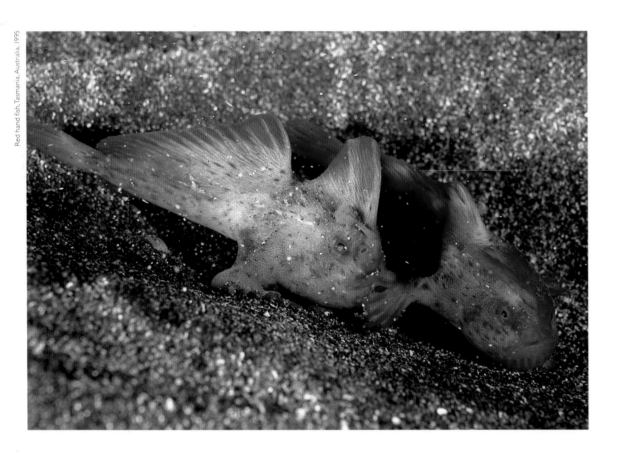

Red hand fish, Tasmania, Australia, 1995

Weedy sea dragon and kelp forest, Tasmania, Australia, 1995

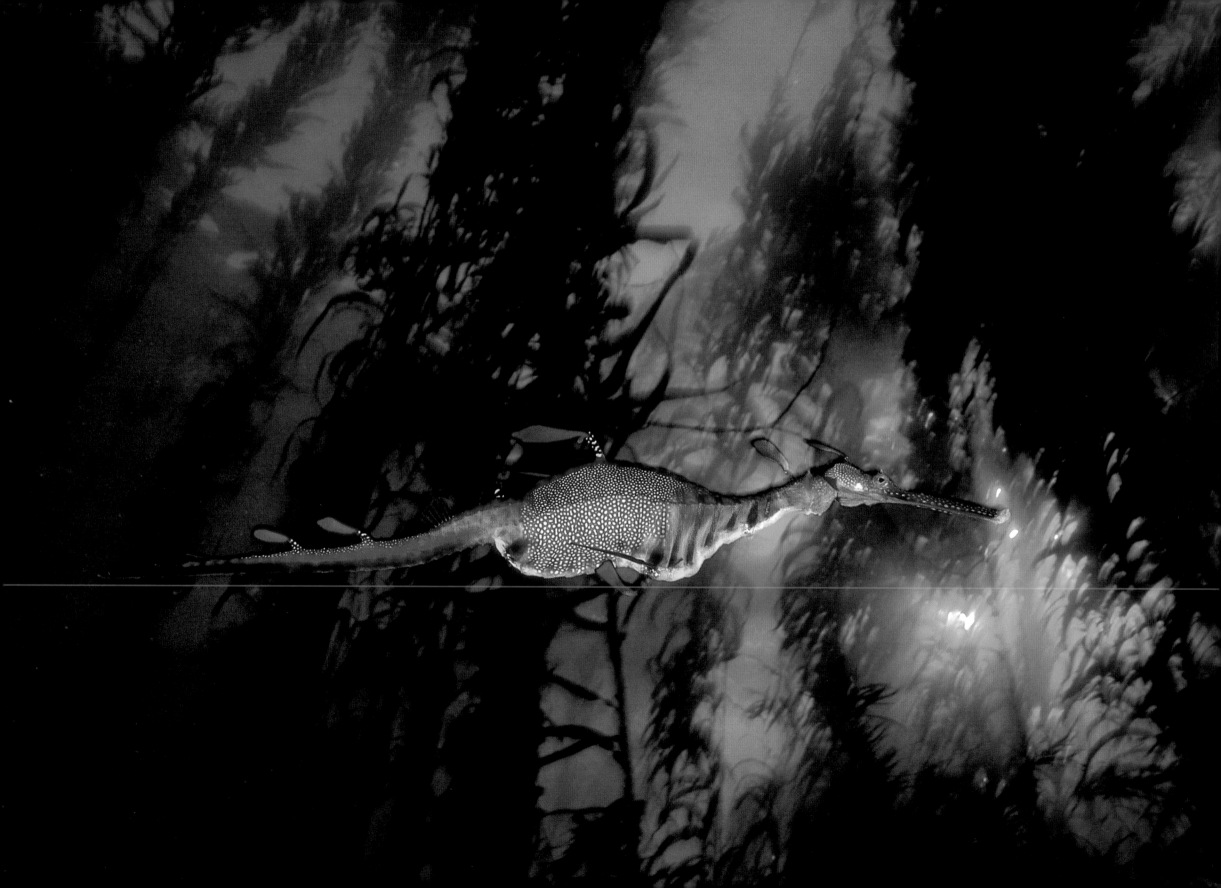

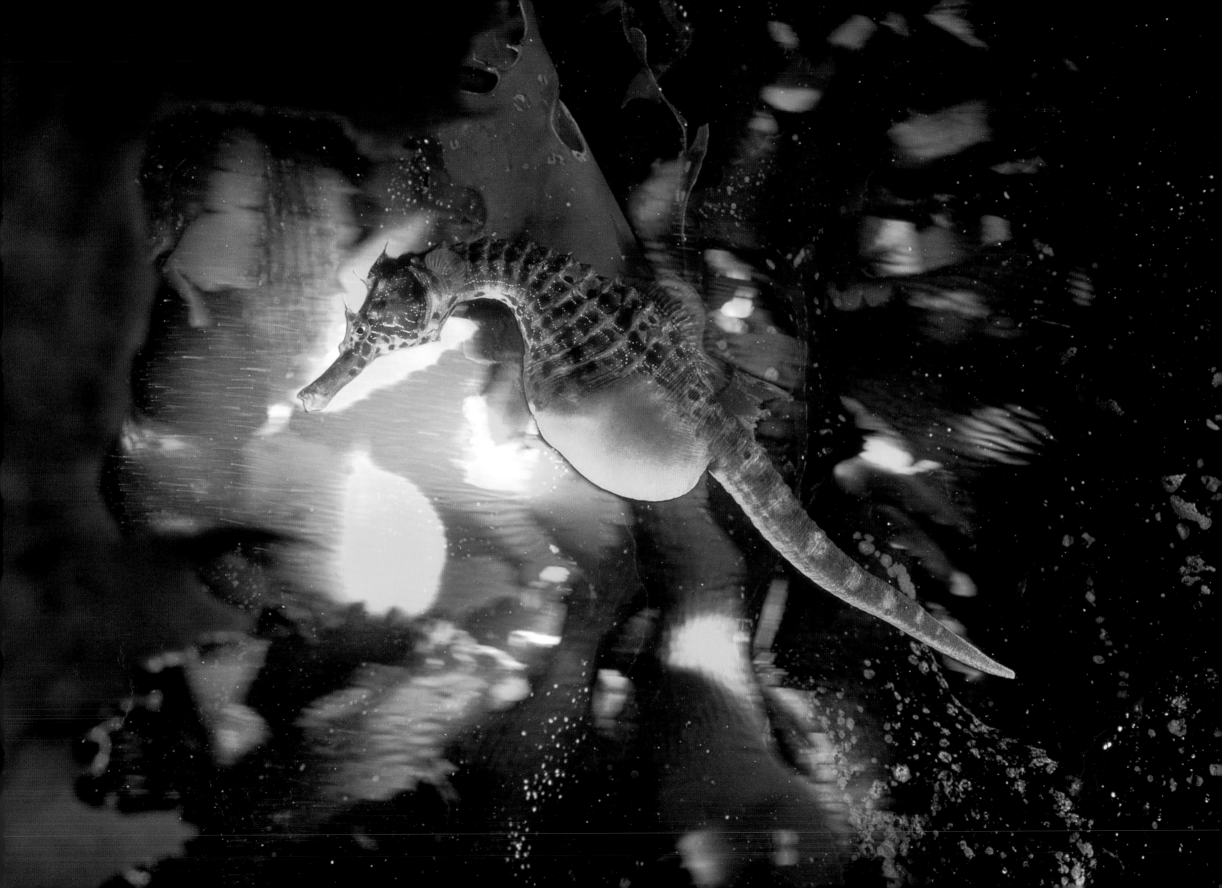

Big-bellied sea horse, Tasmania, Australia, 1995

Long-nosed weed fish, Tasmania, Australia, 1995

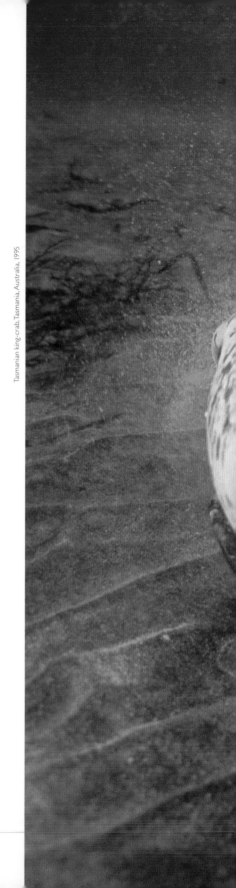

Giant cuttlefish, Tasmania, Australia, 1995

Tasmanian king-crab, Tasmania, Australia, 1995

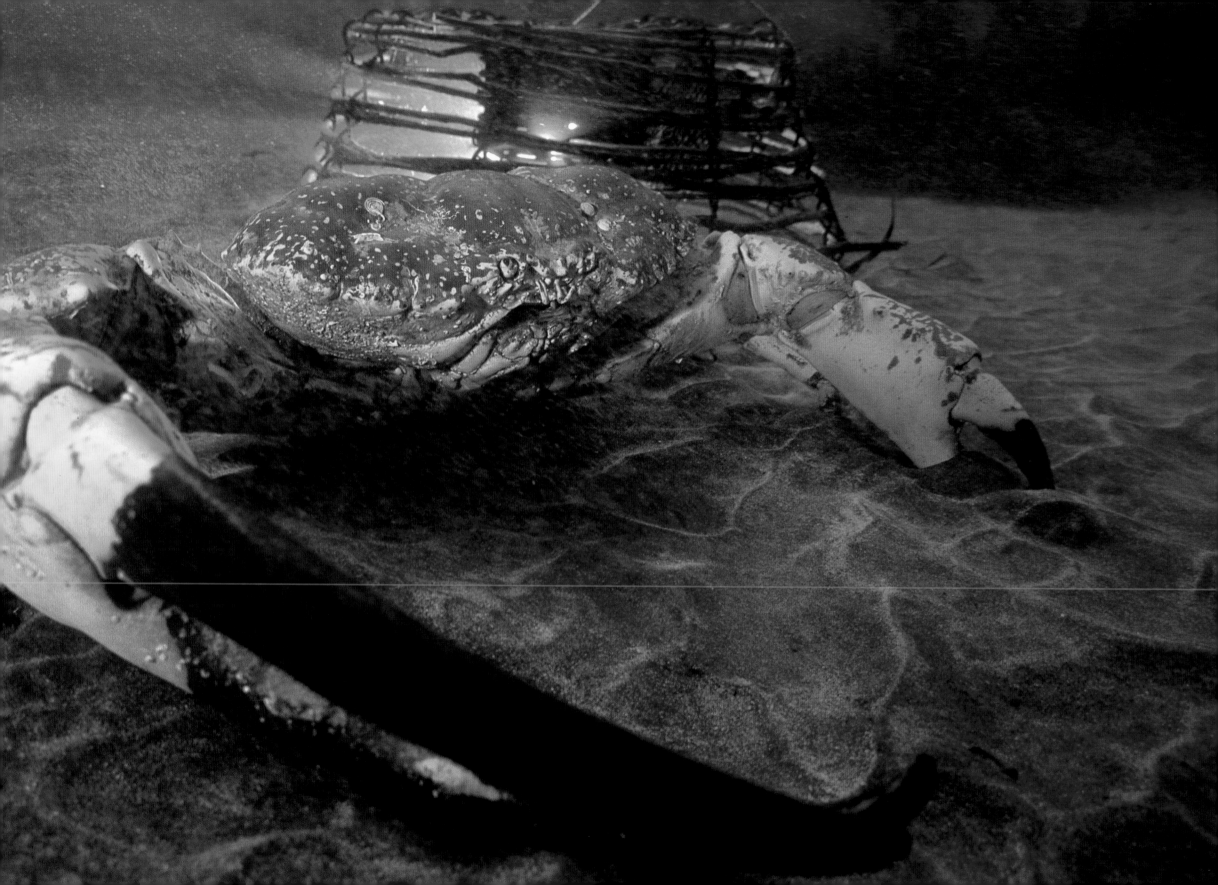

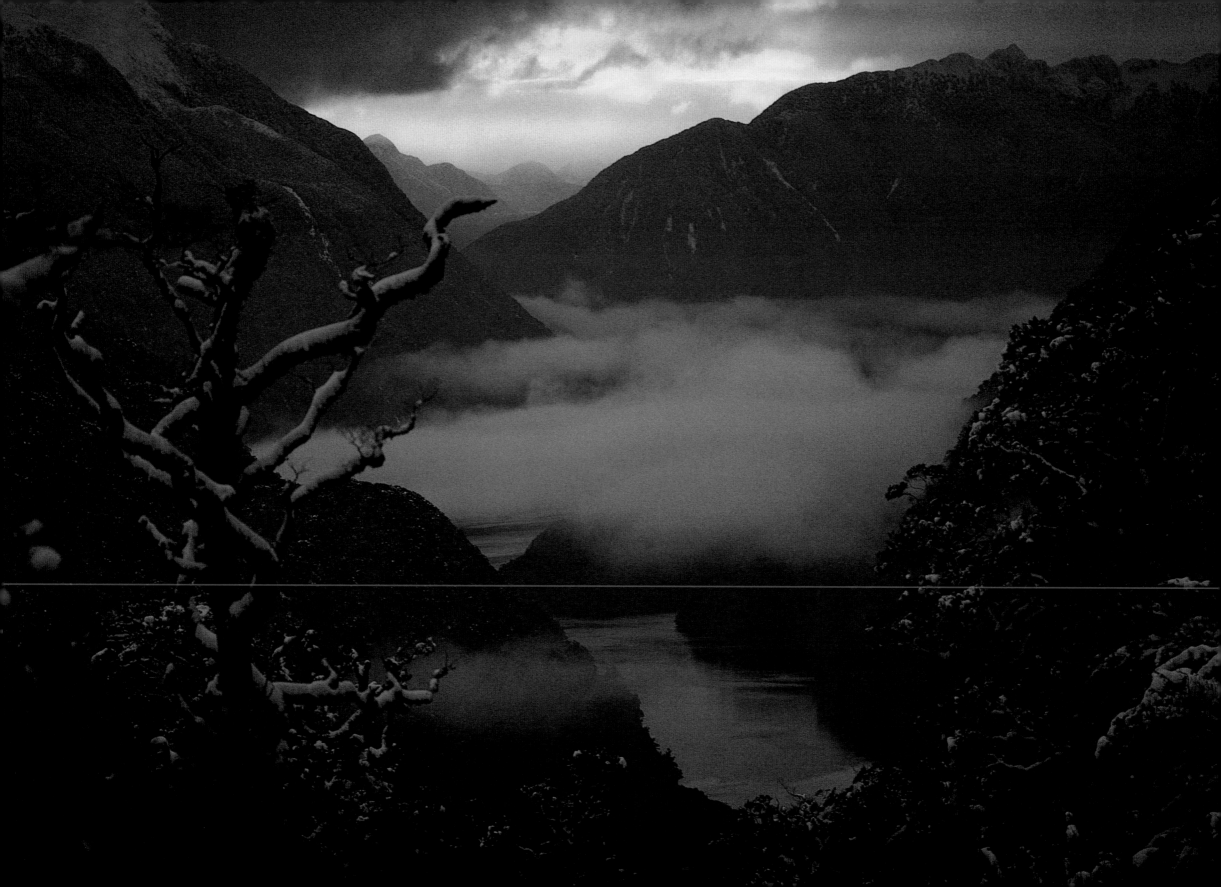

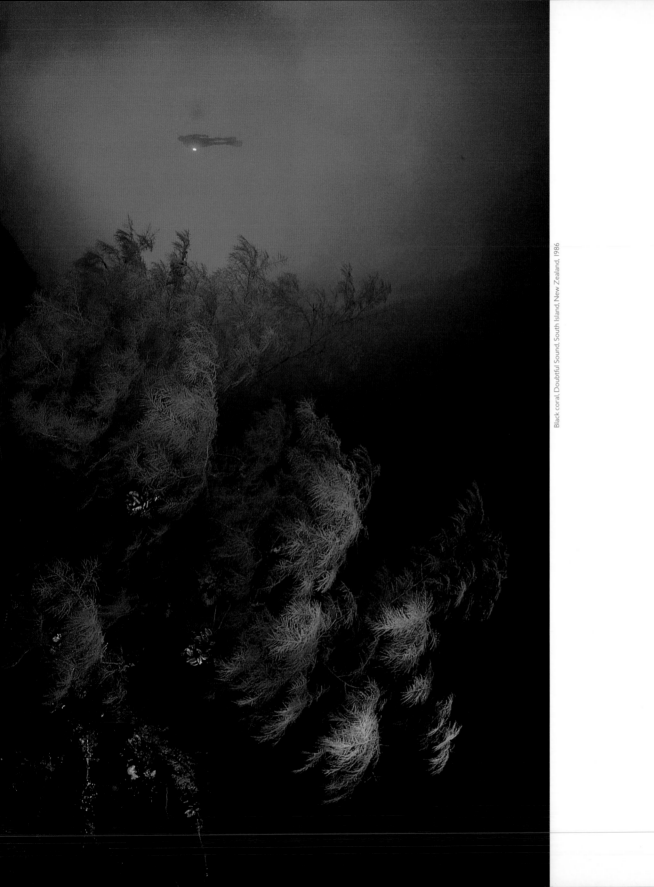

Black coral, Doubtful Sound, South Island, New Zealand, 1986

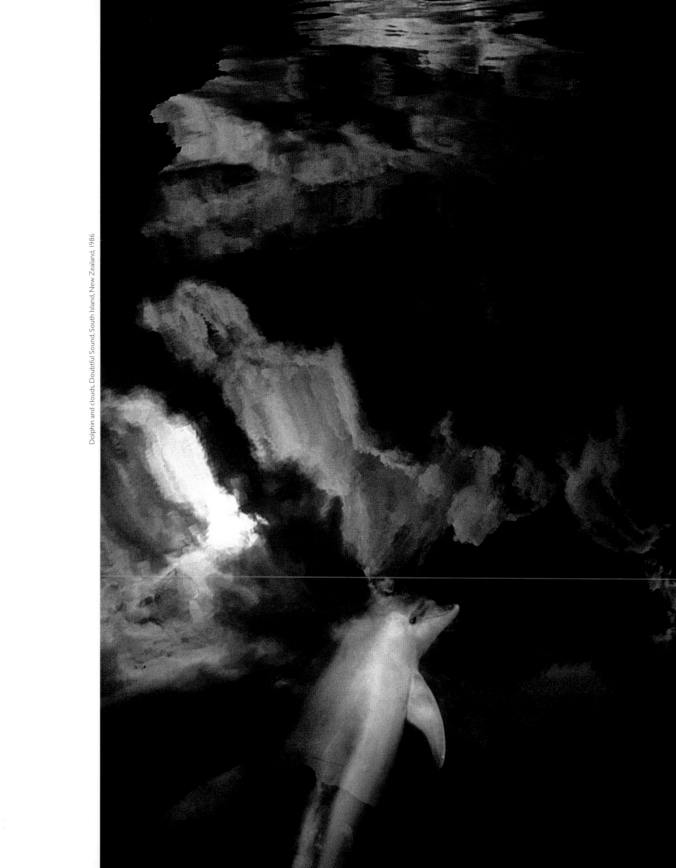

Dolphin and clouds, Doubtful Sound, South Island, New Zealand, 1986

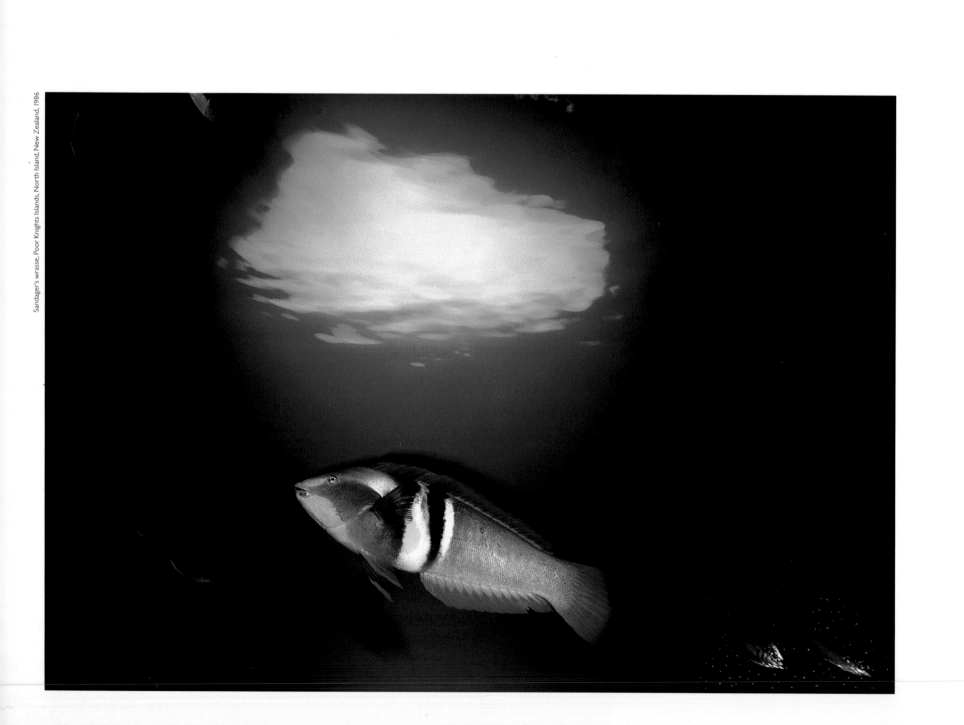

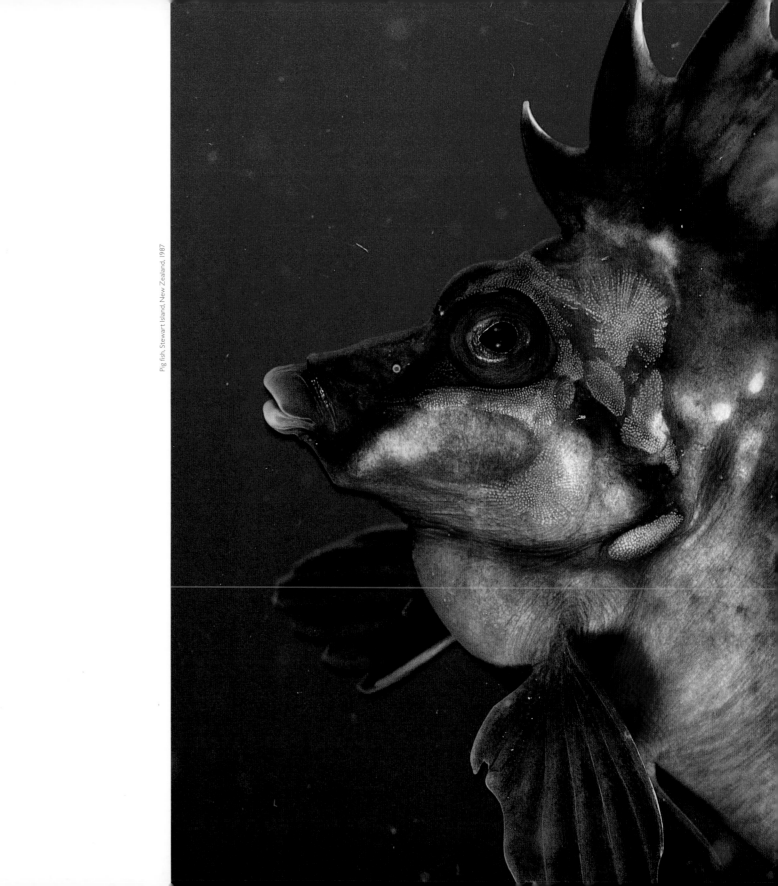

Pig fish, Stewart Island, New Zealand, 1987

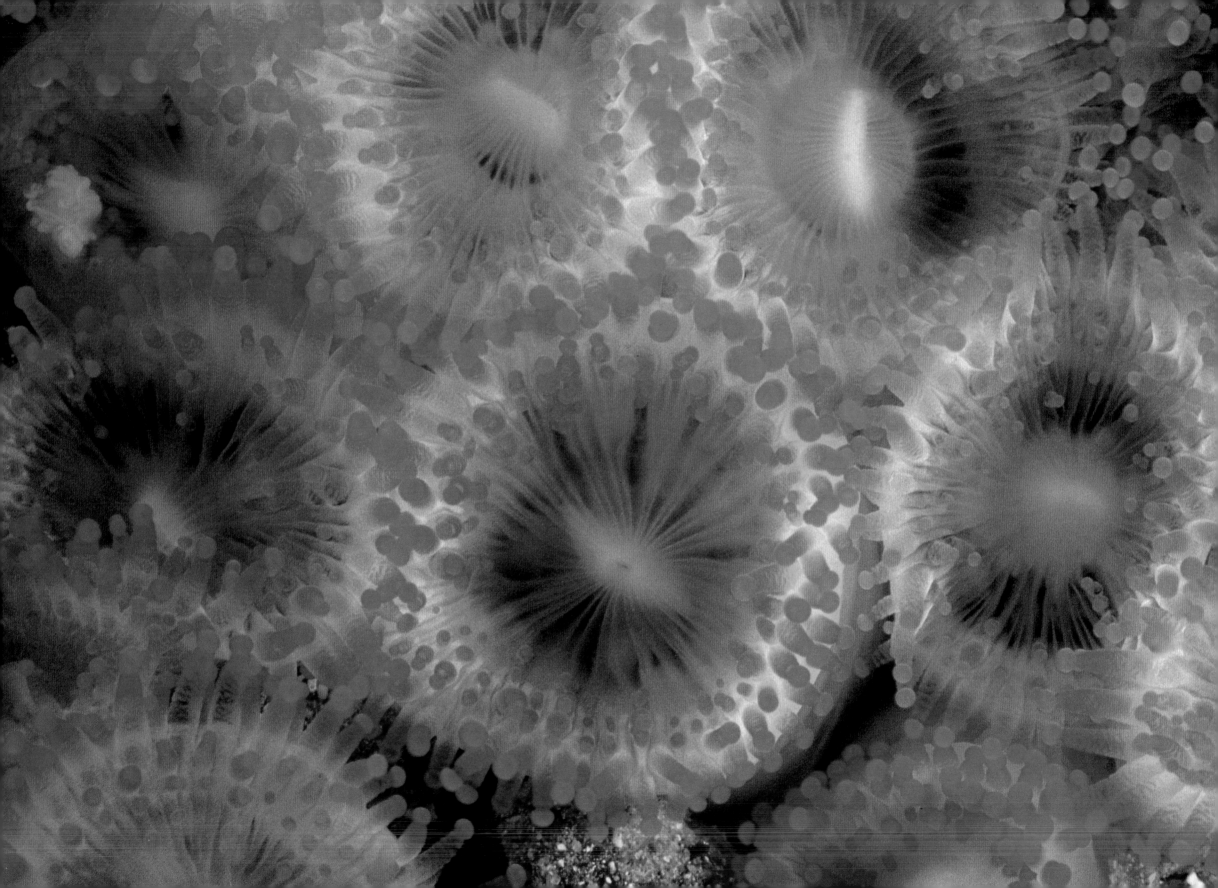

Jewel anemones, Poor Knights Islands, New Zealand, 1986

Blue-eyed tripplefin, Poor Knights Islands, New Zealand, 1986

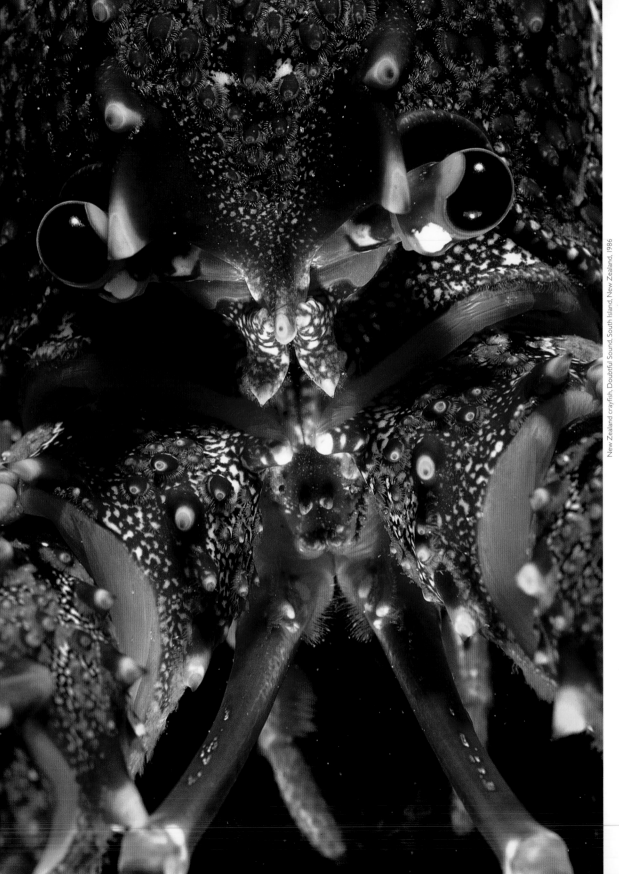

New Zealand crayfish, Doubtful Sound, South Island, New Zealand, 1986

Scorpion fish in algae, Poor Knights Islands, New Zealand, 1986

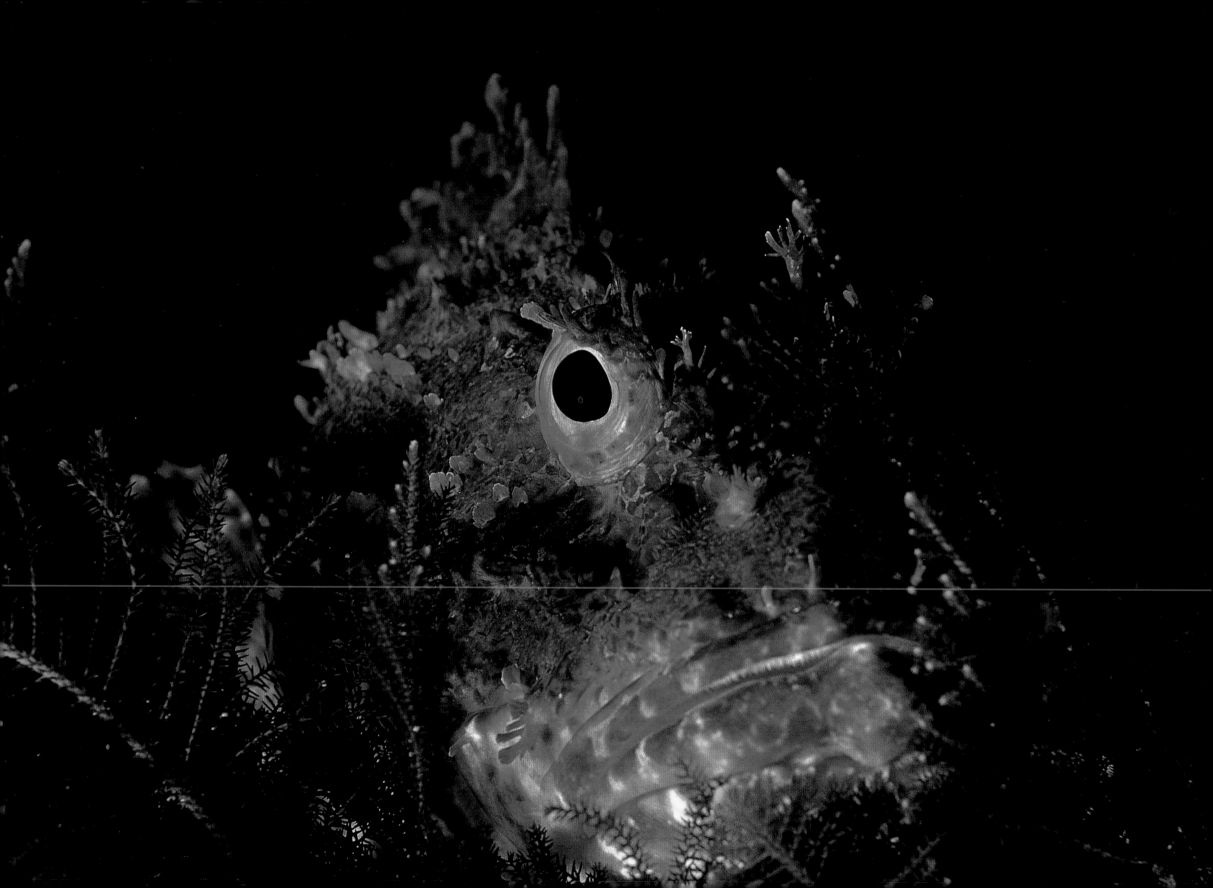

During the summers in New Jersey, when I was growing up, I would sometimes lie on the bottoms of swimming pools and, looking up, photograph swimmers coursing overhead. The best, the most athletic, looked like tin toys compared to sea lions, sharks, manta rays or turtles. Humans swim with individual movements, as if governed by primitive clockwork mechanisms. Sea lions, however, flow and shift with weightless grace. Their bodies follow their eyes. Stingrays fly. They can beat their wings to accelerate, or ripple them to hover.

Fifteen years ago divers began to feed the stingrays in the shallow waters off Grand Cayman Island. They proved to be gentle creatures, sometimes totally enfolding the divers. This shallow sandbar became an extremely popular dive site, attracting up to one thousand divers and snorkelers per day. But the tourist boats stay only an hour. I remained the whole day, watching the light change and the stingrays fly across an endless stage of clear water, sand and shifting clouds – stingrays and clouds. At the end of the day the stingrays reverted to their normal behaviour, snuffling in the sand for small fish.

In Hawaii, for 30 years, the patio lights of the Kona Surf Hotel have splayed into the water. The lights attract swarms of plankton which in turn attract manta rays – simply the strangest creatures on our planet. Originally, they were called devil fish because their rolled-up cephalic fins looked like horns. They grow to enormous sizes, up to 20 feet in wingspan, yet feed on plankton by filtering this microscopic broth of the sea into their mouths like silent vacuum cleaners.

To photograph the mantas I mounted an HMI light on the boat so it shone into the water like a stage spotlight. I sat on the dive boat waiting for the sun to set. We anchored so close to shore I could hear ice clinking in the customers' glasses at the patio bar. As the sun set, we turned on the generator and I went into a dark sea punctuated by a single column of white light.

The manta rays came from the open ocean attracted like giant moths to the light. They feed on swirling plankton in a remarkable ballet of aerobatics, looping endless loops with wingtip turns. It is a scene of shadows against silhouettes in a night sea. Shafts of light illuminate the plankton like snow. With open mouths four-feet wide the mantas feed inches from my camera. The night sea sparkles and I imagine for a moment that they are feeding on stars.

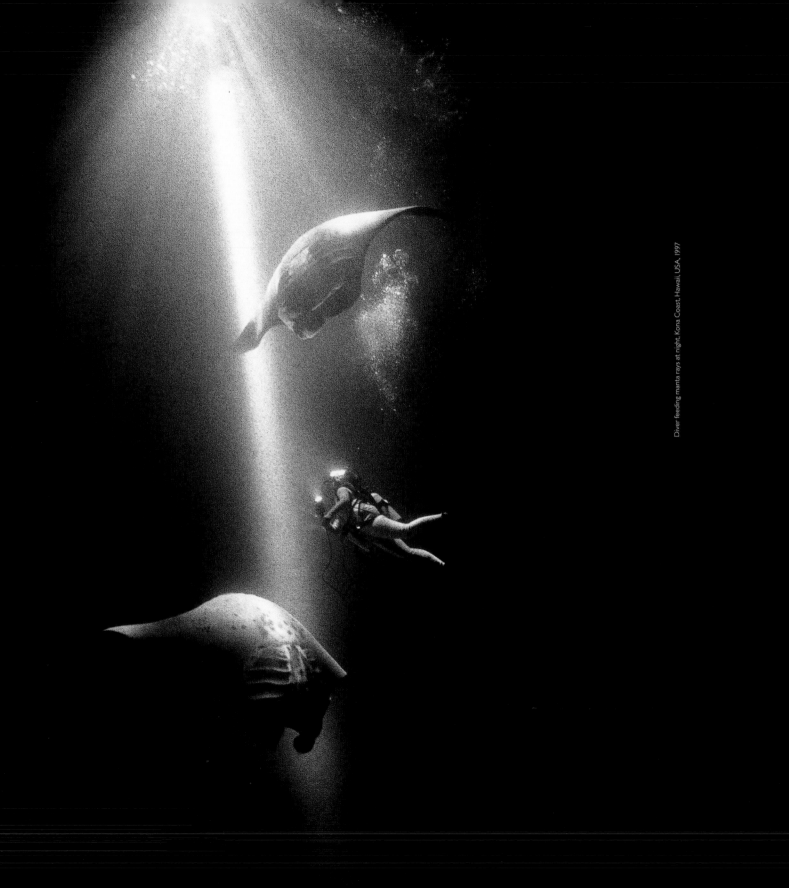

Diver feeding manta rays at night, Kona Coast, Hawaii, USA, 1997

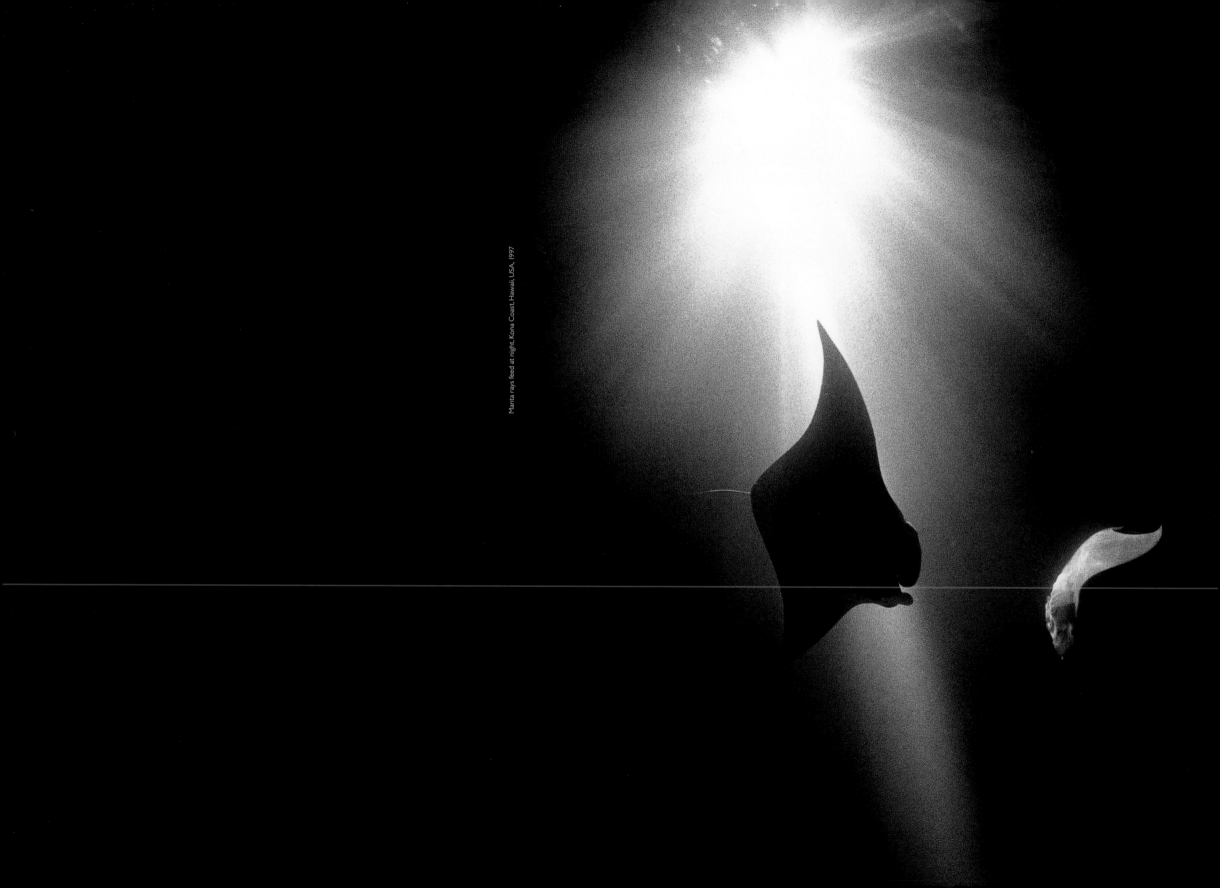

Manta rays feed at night, Kona Coast, Hawaii, USA, 1997

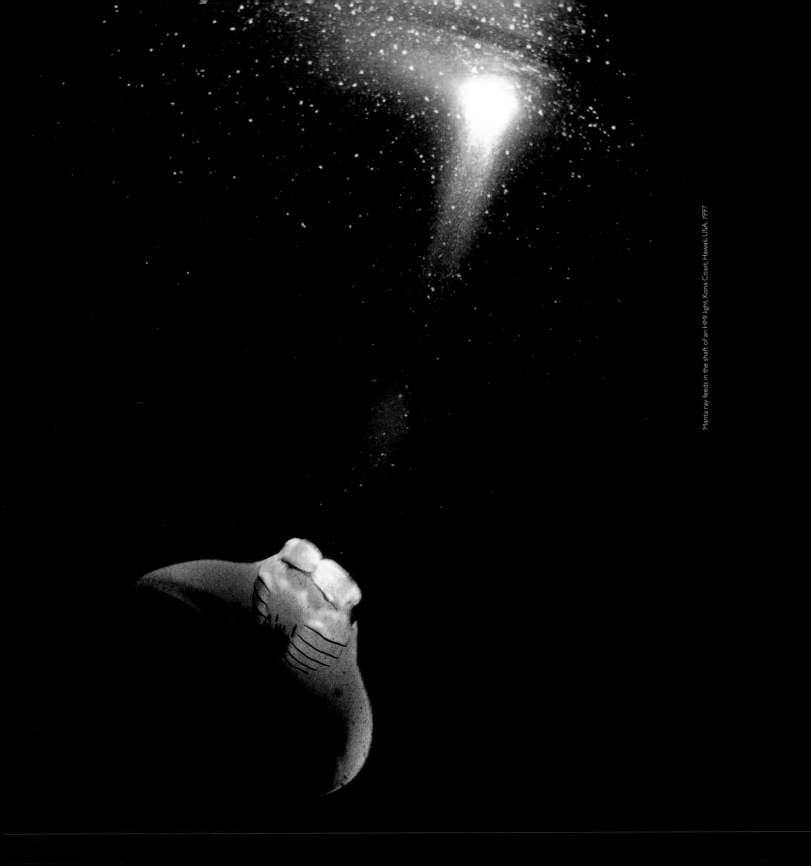

Manta ray feeds in the shaft of an HMI light, Kona Coast, Hawaii, USA, 1997

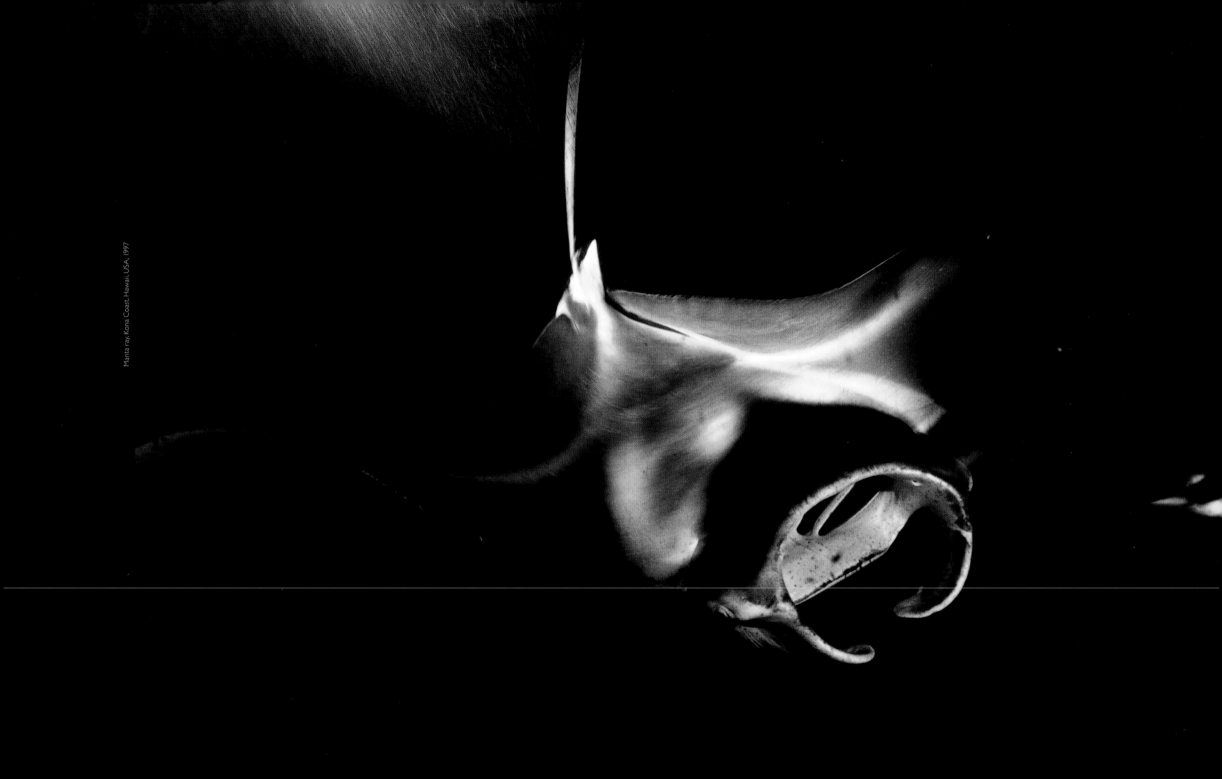

Manta ray, Kona Coast, Hawaii, USA, 1997

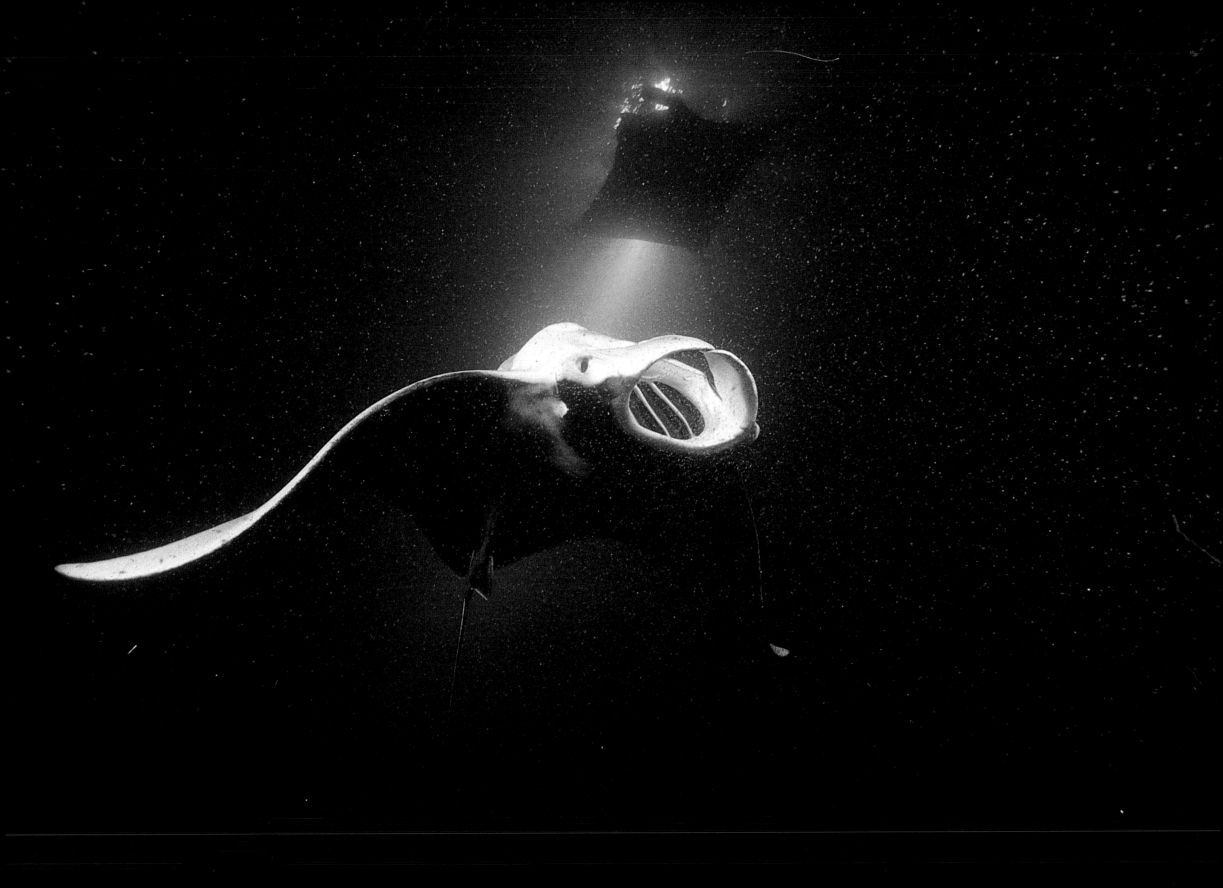

Manta rays feed at night, Kona Coast, Hawaii, USA, 1994

Manta ray in light, Kona Coast, Hawaii, USA, 1994

Diver watches manta ray in feeding dance, Kona Coast, Hawaii, USA, 1994

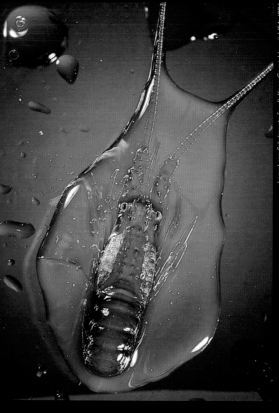

Larval crayfish (manta food), Kona Coast, Hawaii, USA, 1994

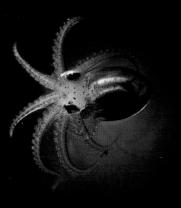

Larval octopus (manta food), Kona Coast, Hawaii, USA, 1994

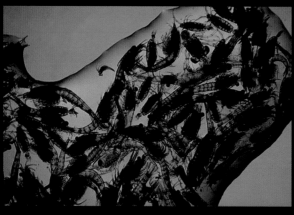

Mysid shrimp (manta food), Kona Coast, Hawaii, USA, 1994

Manta ray feeds on swarms of plankton, Kona Coast, Hawaii, USA, 1994

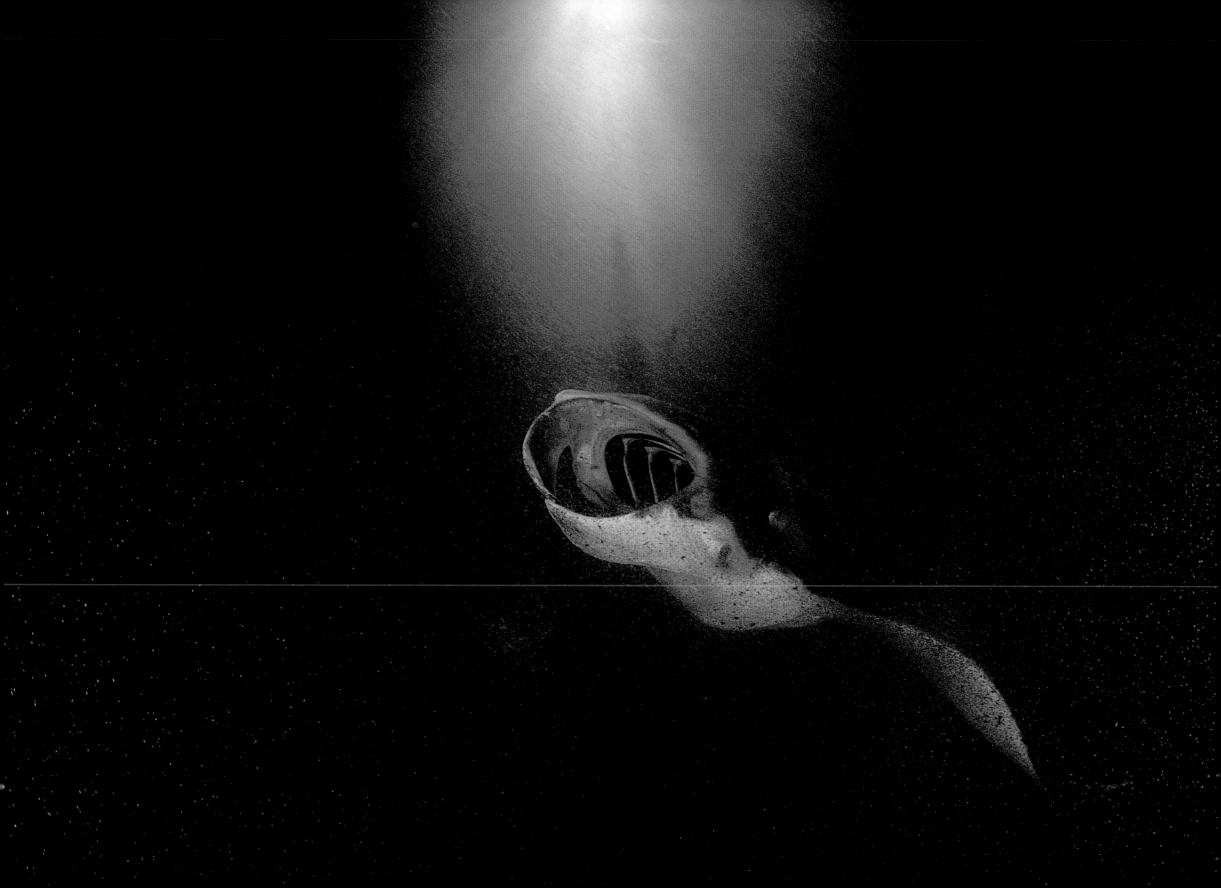

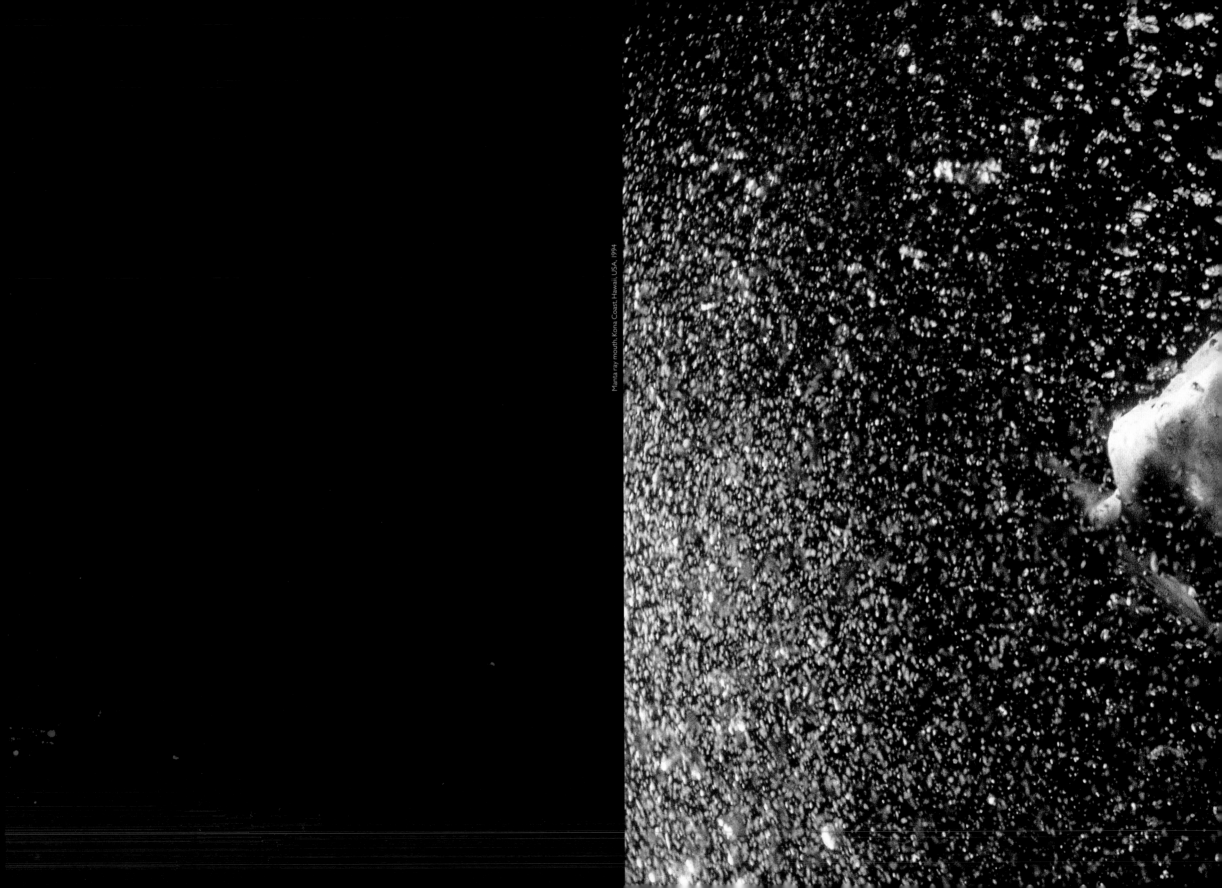

Manta ray mouth, Kona Coast, Hawaii, USA, 1994

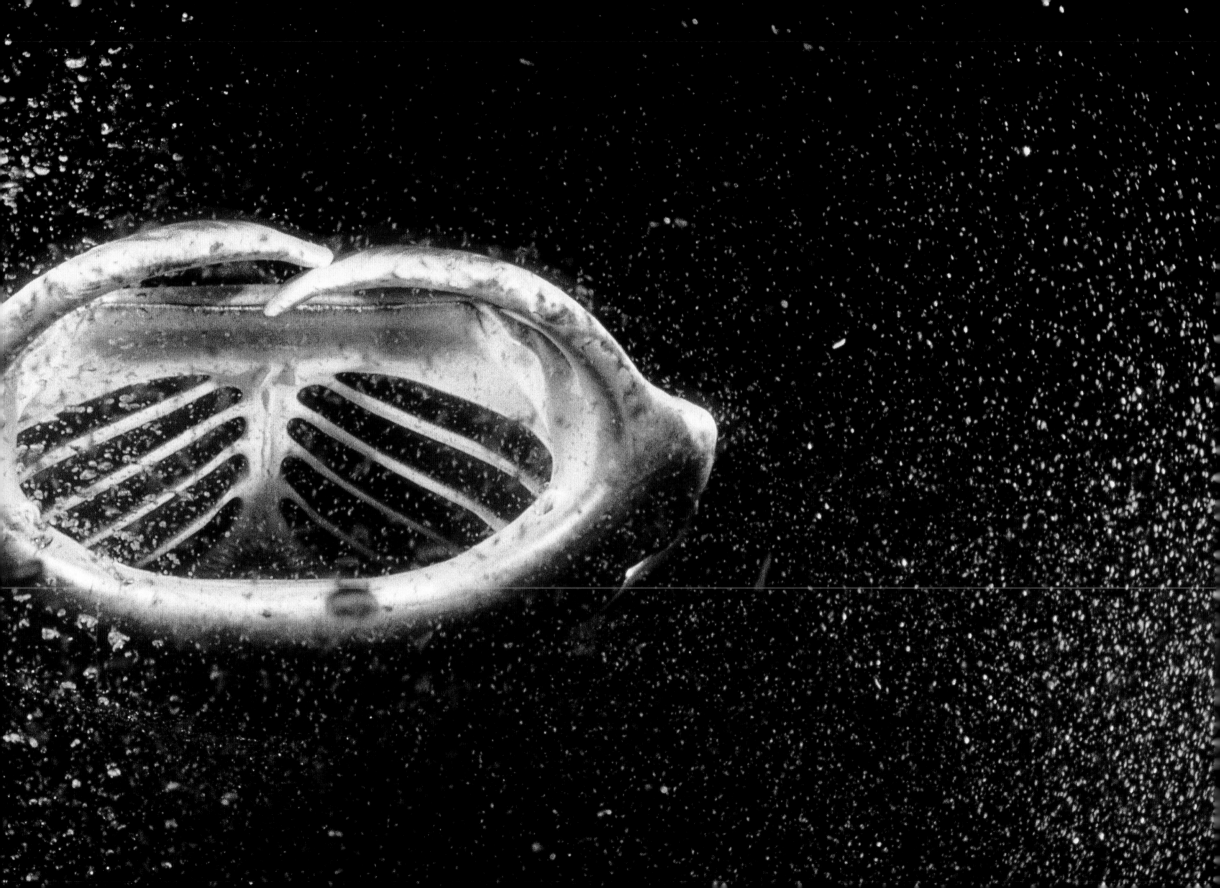

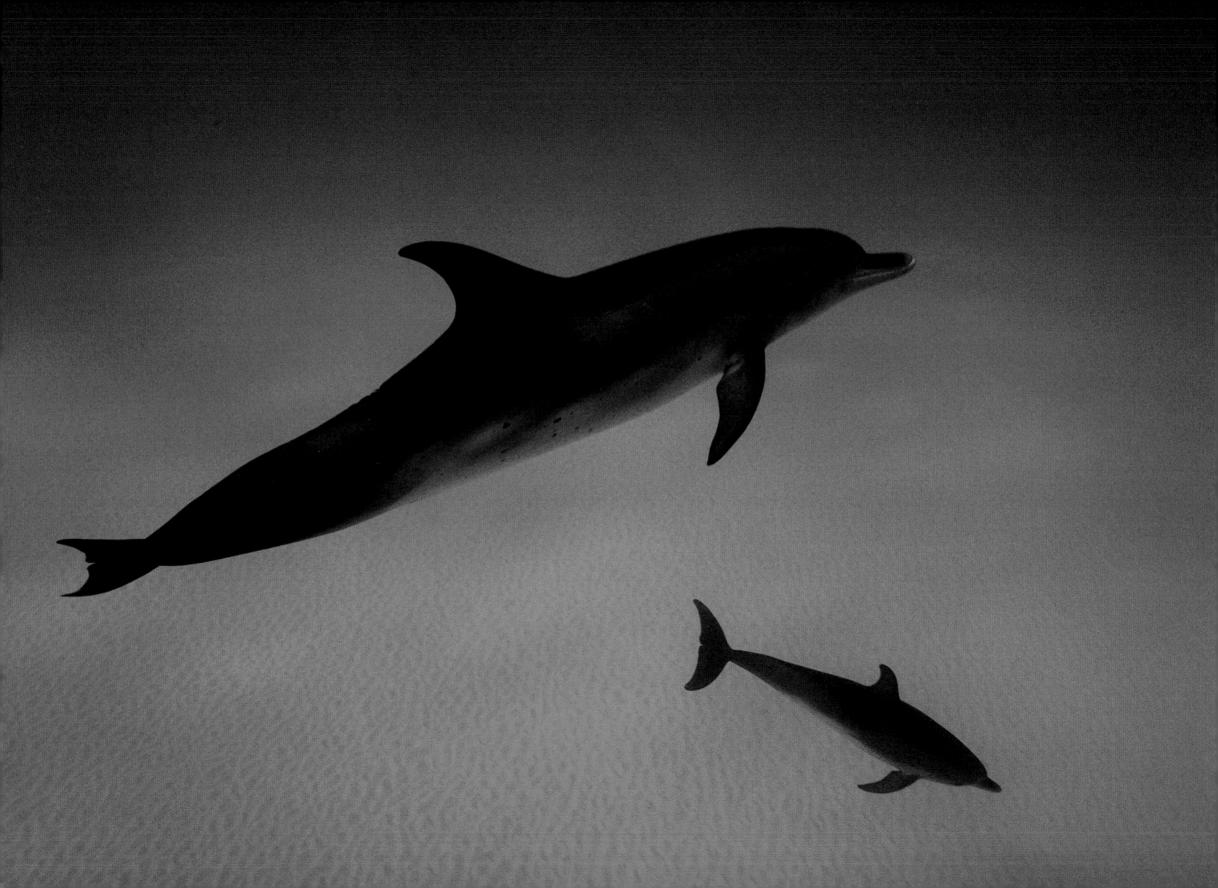

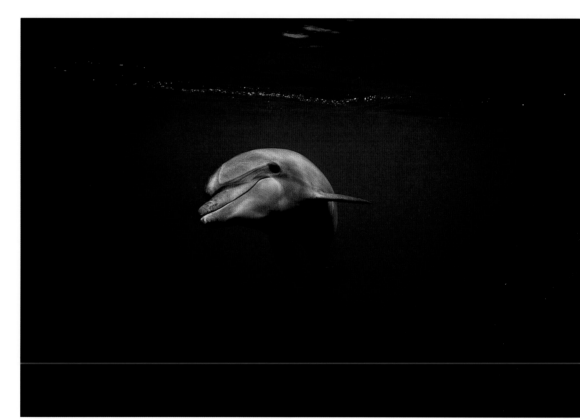

Spotted dolphins, Bahama Banks, Bahamas, West Indies, 1994

Bottle-nosed dolphin, Hawaii, USA, 1978

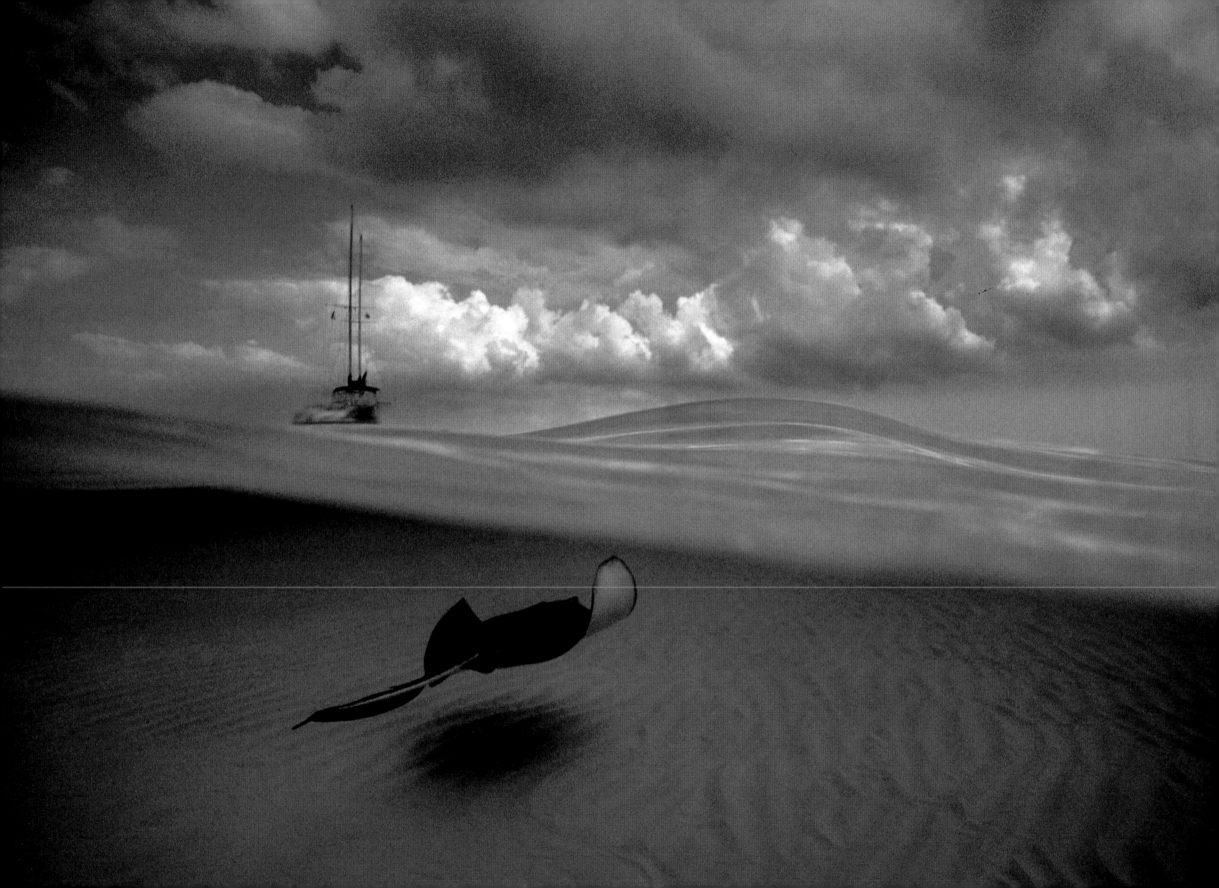

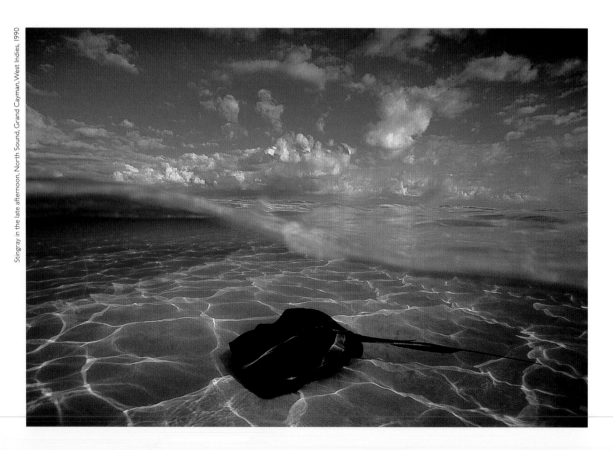

Stingray in the late afternoon, North Sound, Grand Cayman, West Indies, 1990

Stingray in the early evening, North Sound, Grand Cayman, West Indies, 1990

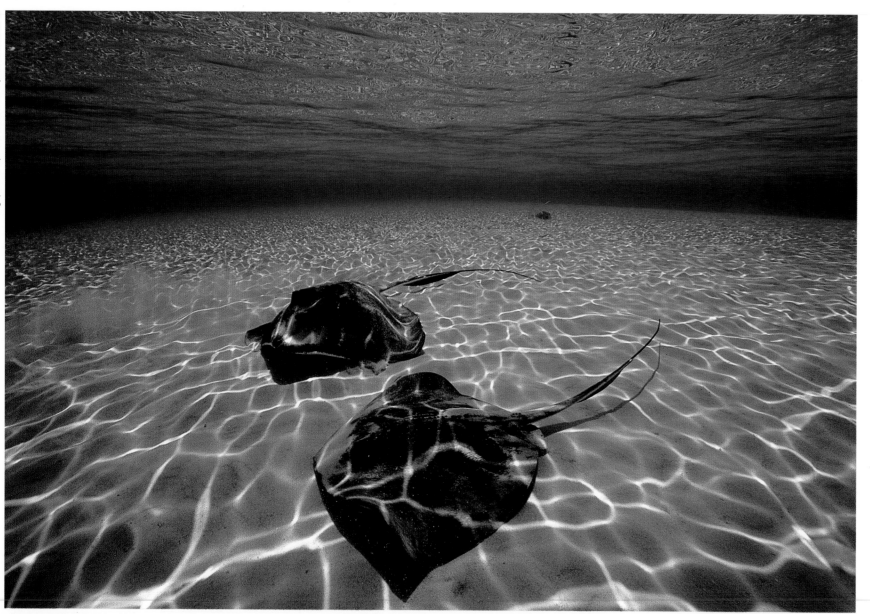

Stingrays at mid-day, North Sound, Grand Cayman, West Indies, 1990

Stingrays feeding in the evening light, North Sound, Grand Cayman, West Indies, 1990

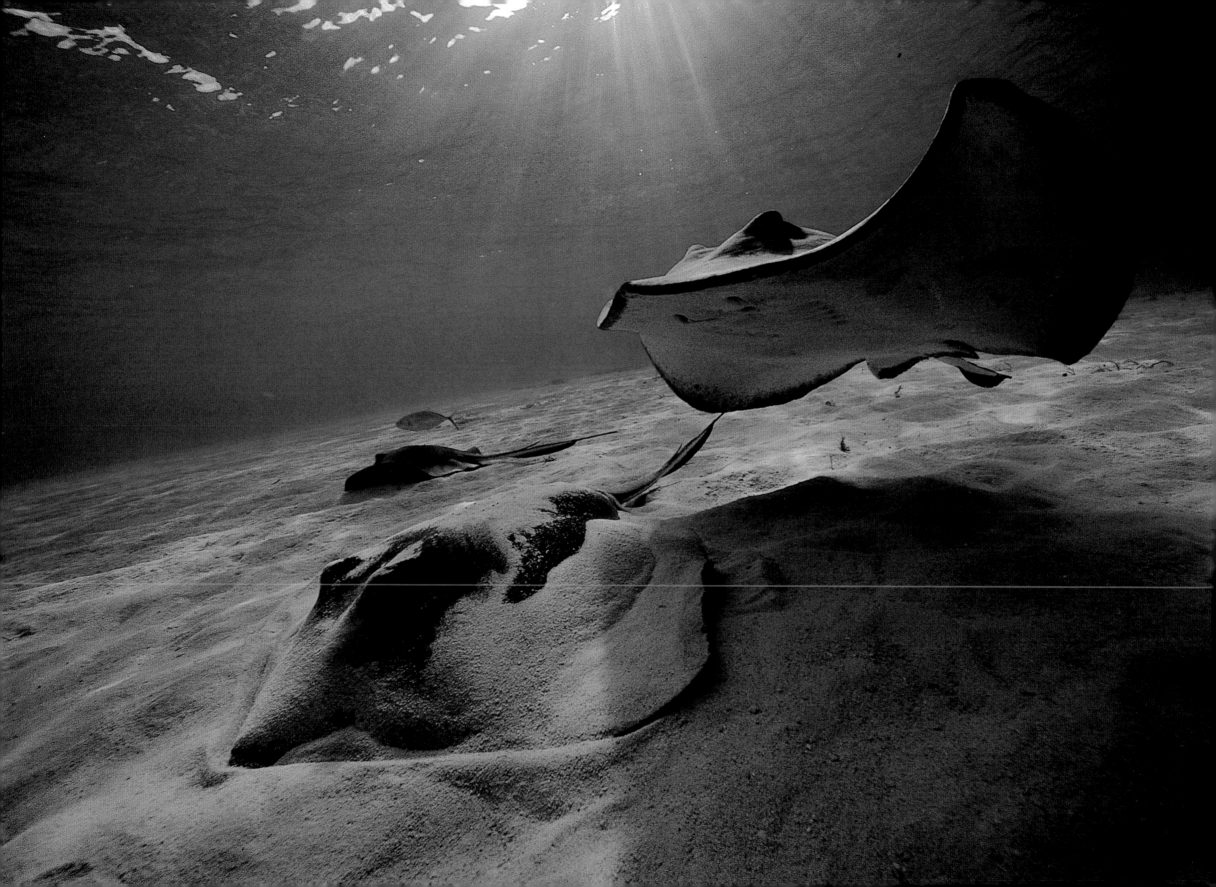

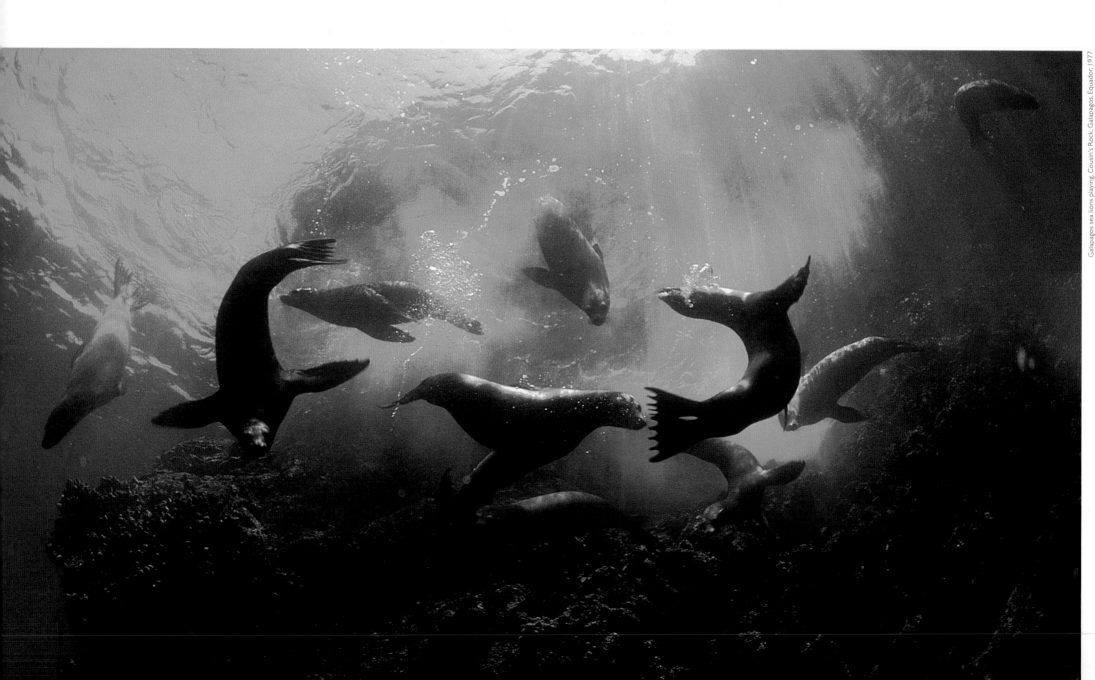

Galapagos sea lions playing, Cousin's Rock, Galapagos, Equador, 1977

Galapagos sea lion feeds on a school of striped salemas, Galapagos, Equador, 1997

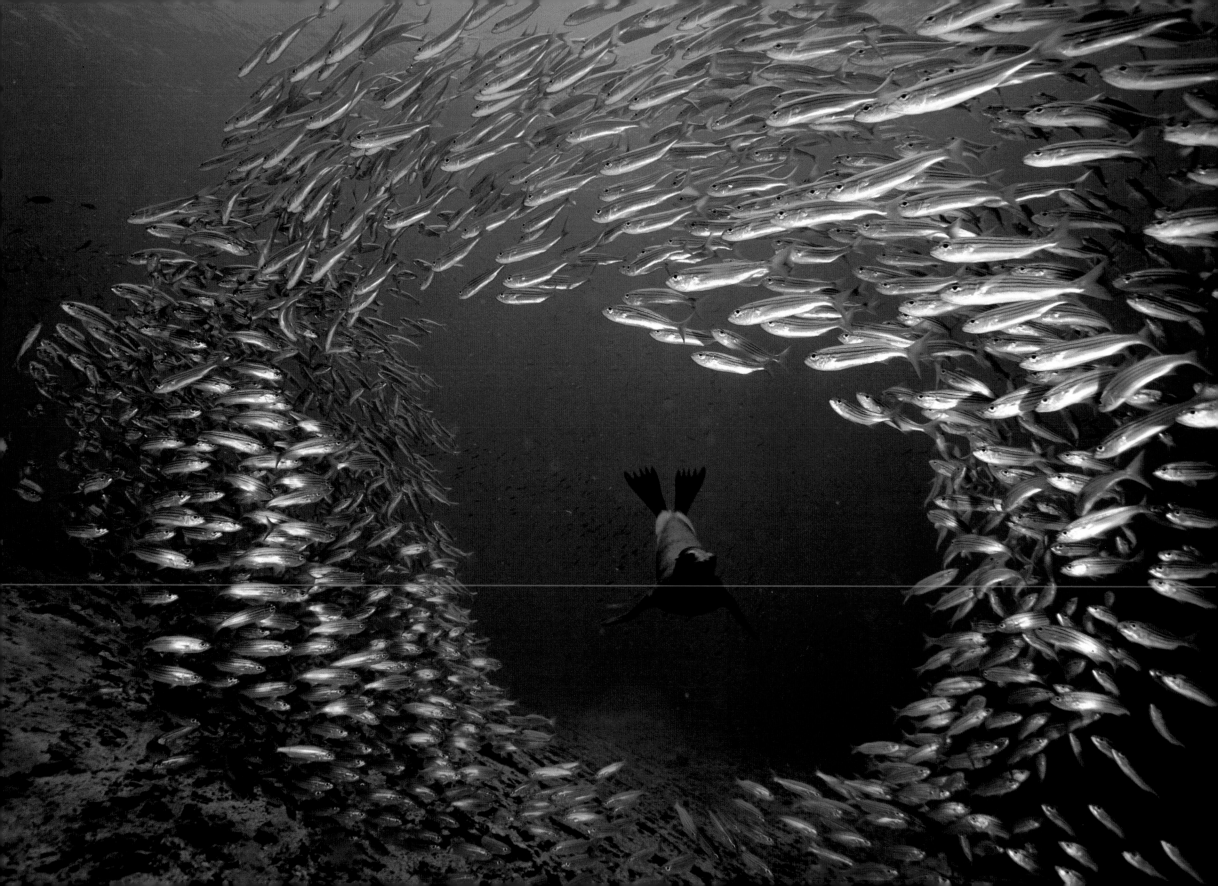

Dark blue

In the winter of 1997–8 the Galapagos Islands were caught in a massive El Niño. The cold Pacific counter-currents died and the surface water, heated by the equatorial sun, warmed up 15 degrees Fahrenheit above normal. The cold, rich dark waters of the Galapagos were suddenly a warm bright blue – the colour of starvation and death to many of the marine creatures. The sea lions were particularly affected; with their prey forced deeper into colder water, they had to search for alternative food sources.

At Cousin's Rock in the central Galapagos I watched a sea lion separate a school of black striped salemas and begin to feed. The fish surrounded the sea lion in a carousel of confusion. The school moved like a single organism and for every fish caught, hundreds escaped in the blue sea. A group of sea lions played in the shadow of our boat, except they were not playing but hunting nearly invisible two-inch long mantis shrimps. They combed the sand with their lower jaws and pulsed sonar-like signals to force the mantis shrimps out where they ate them like popcorn. The scene looked like sea lions playing in snow, but it was a dance, a desperate dance of starvation.

In a moment off the northern Galapagos Island of Darwin I played with a baby Galapagos fur seal – the most endangered seal in the world. The seal frolicked in the breaking swell and from time to time stopped and regarded me with its huge eyes. It would not survive this warm clear season of El Niño.

I found a huge school of hammerhead sharks in the late afternoon at the edge of light. Driven deeper, they were searching for colder water, disappearing like ghosts in the vast, dark, open Pacific.

Mother weans adolescent Galápagos sea lion, Cousin's Rock, Galápagos, Equador, 1997

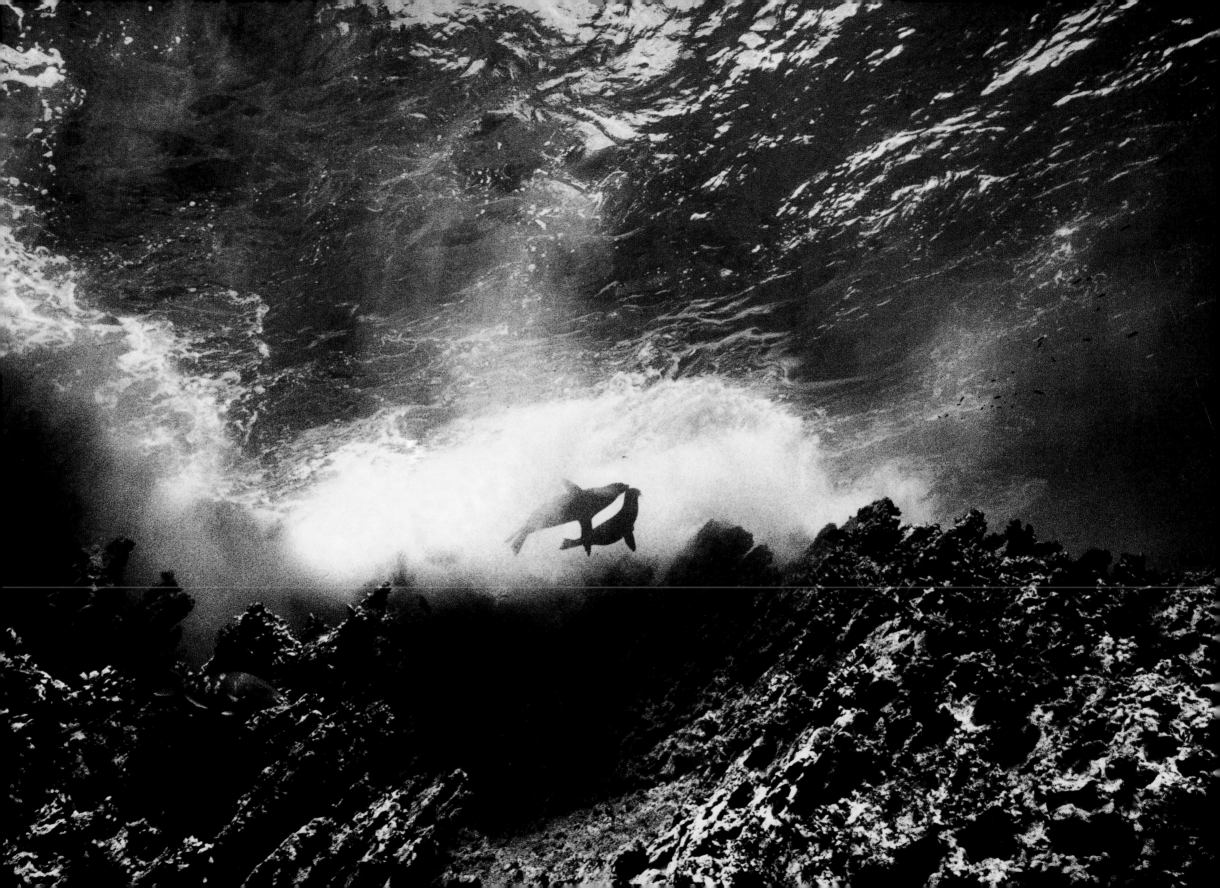

Galapagos sea lion feeds on striped salemas, Cousin's Rock, Galapagos, Equador, 1997

Galapagos sea lion feeds on striped salemas, Cousin's Rock, Galapagos, Equador, 1977

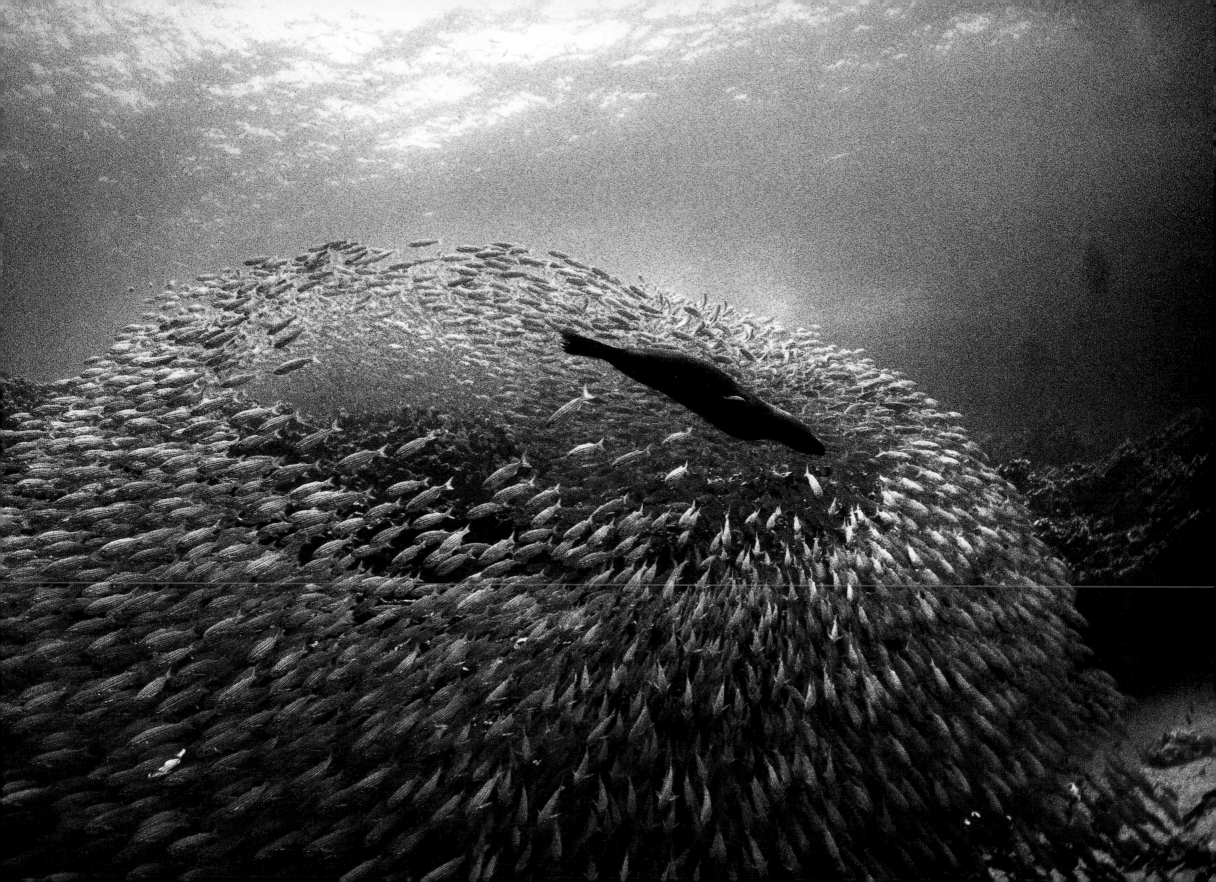

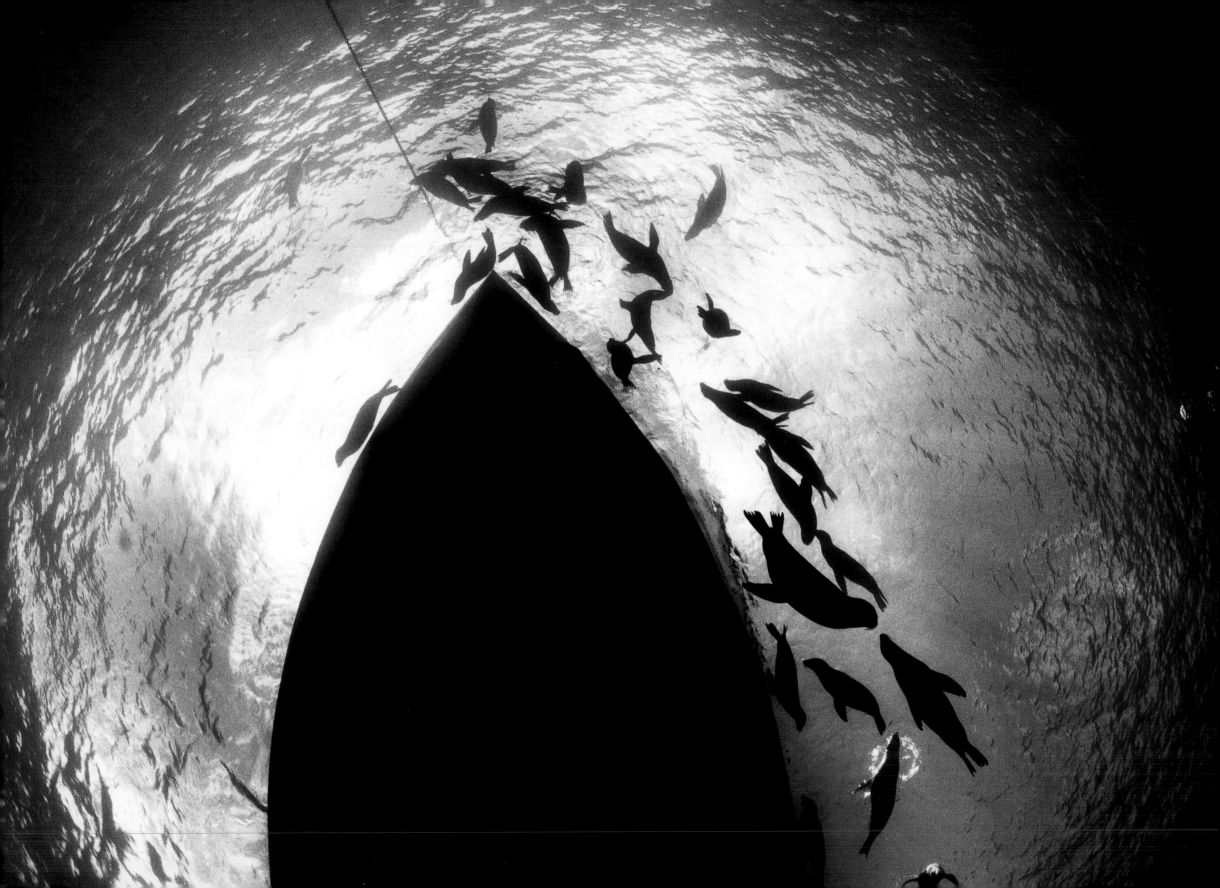

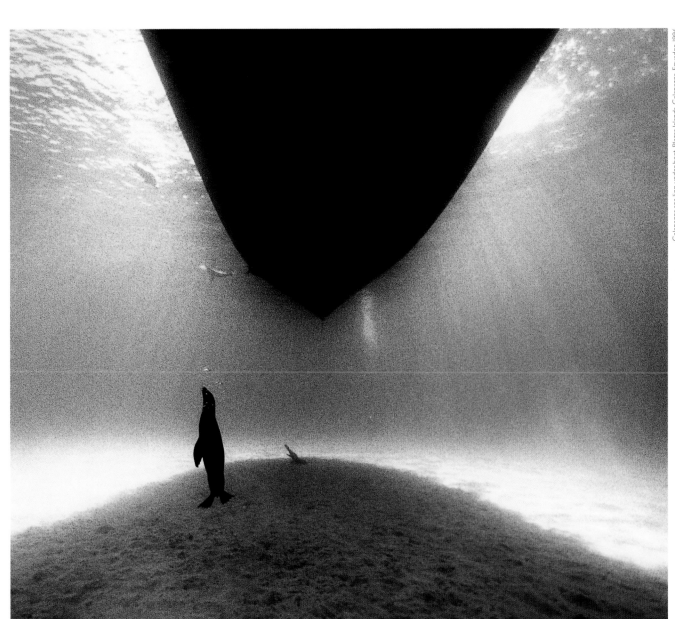

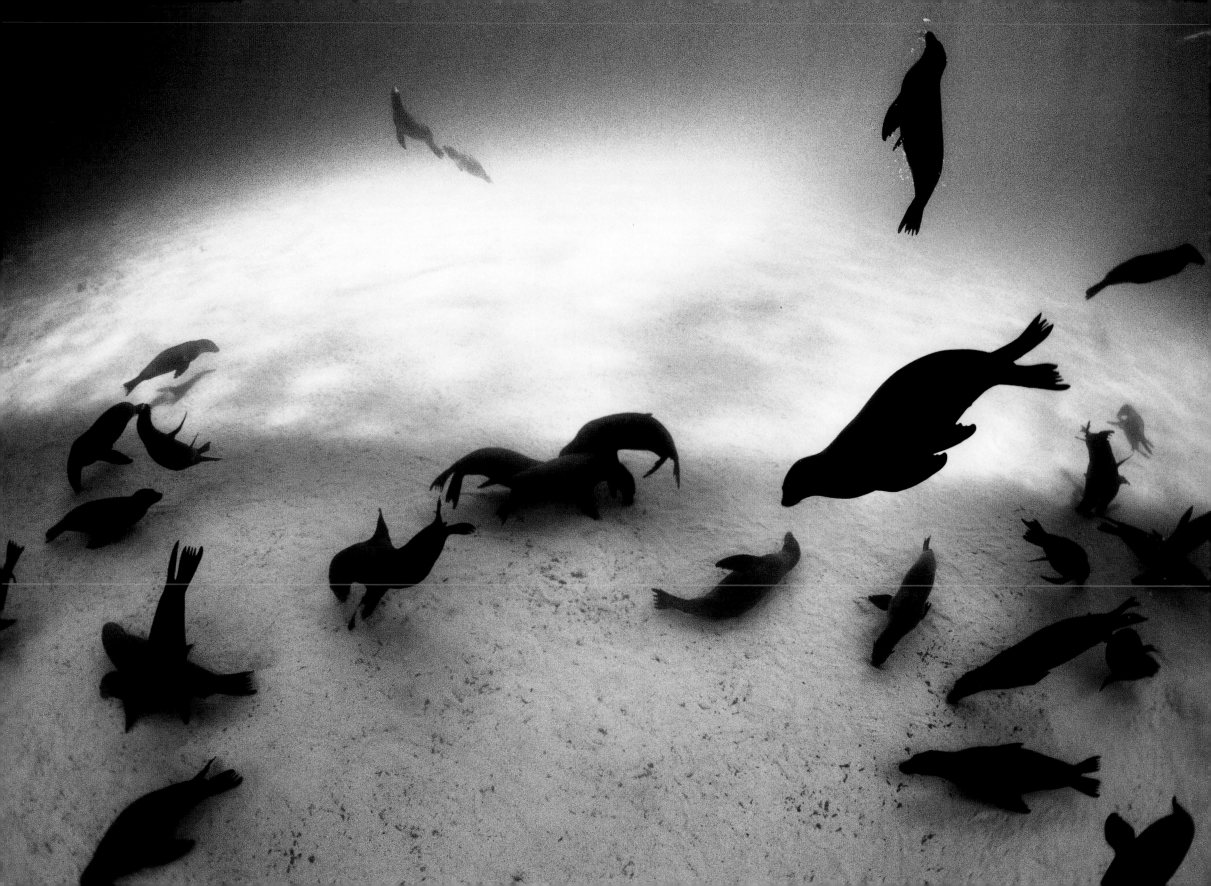

Galapagos baby fur seal, Darwin Island, Galapagos, Equador, 1997

Galapagos grey grunts and parrotfish, Devil's Crown, Galapagos, Equador, 1996

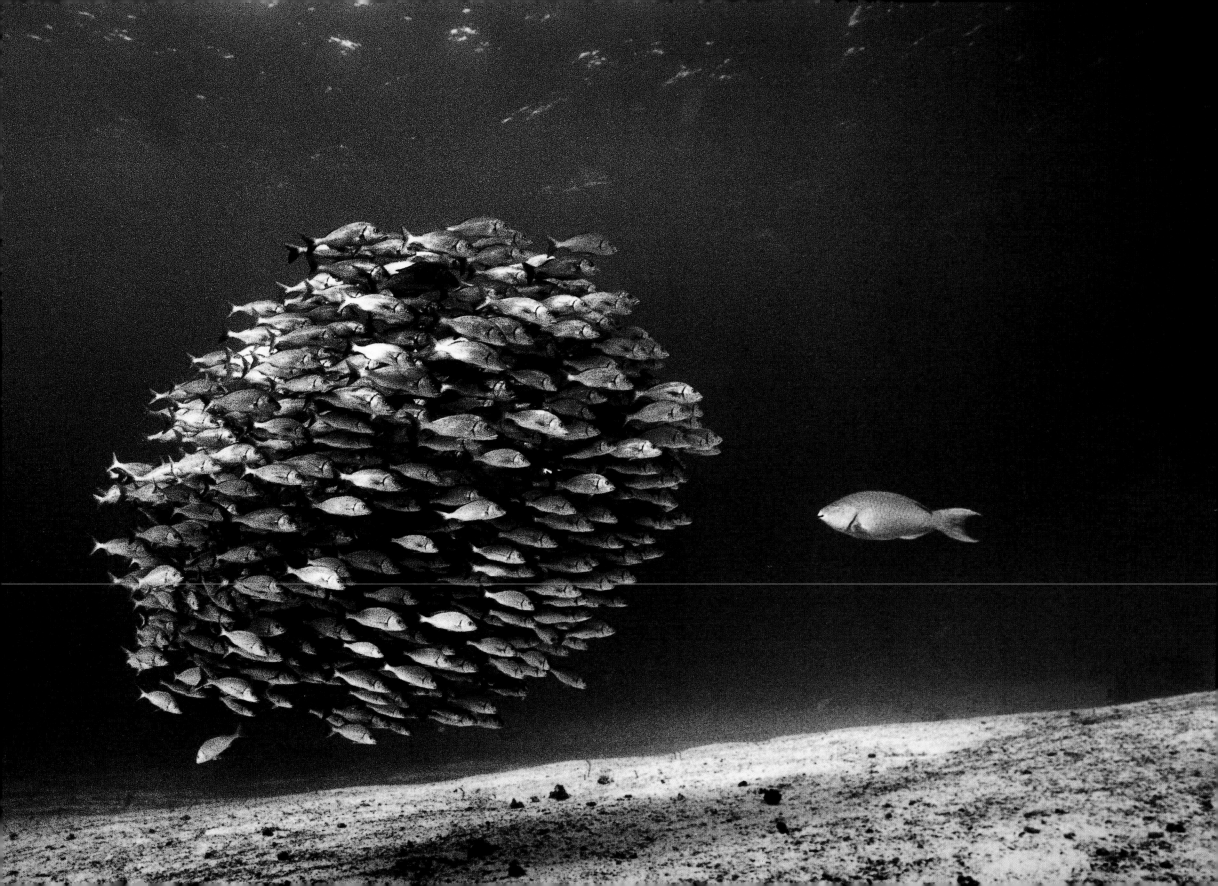

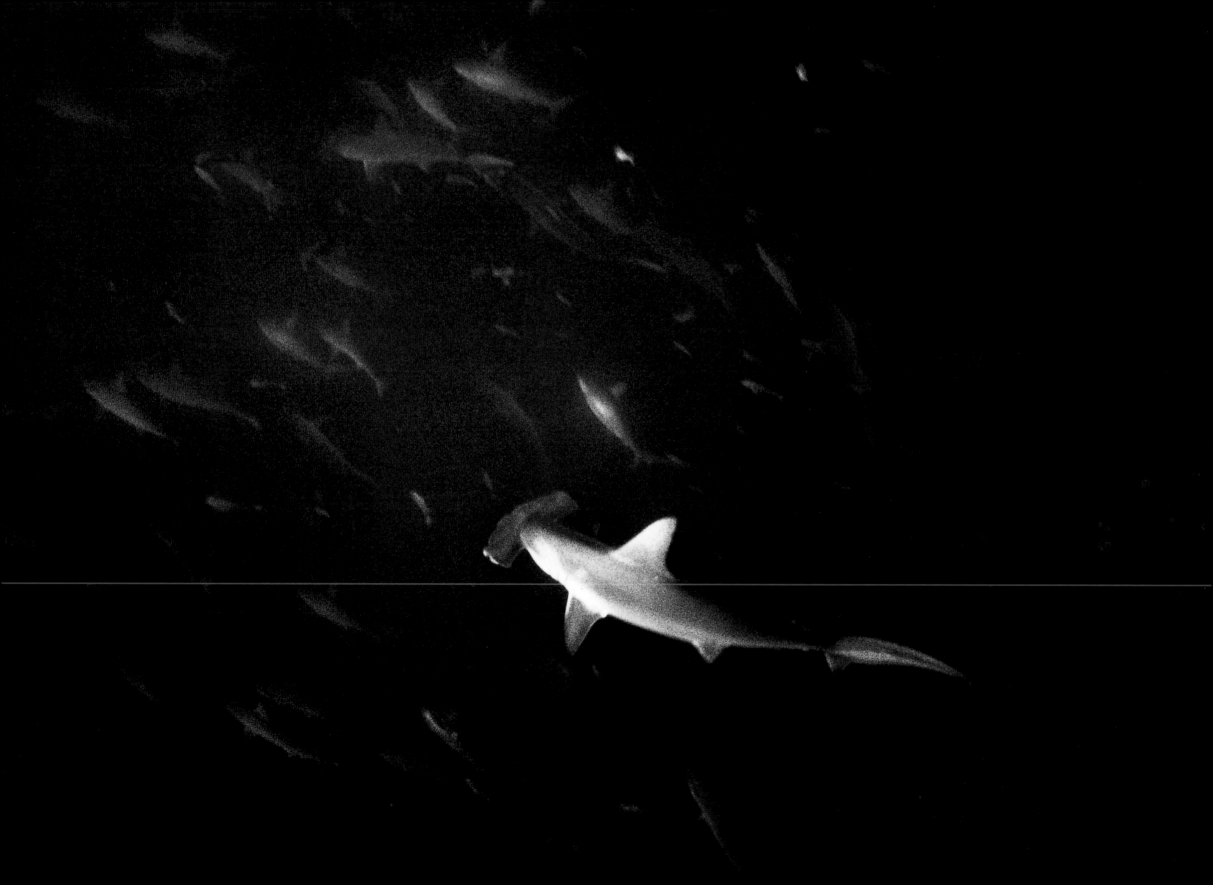

Water gardens

What was once ancient sea bottom is now farming land in the eastern corner of South Australia. Beneath the layer of soil the limestone substratum is cut and intercut, channelled like an enormous Swiss cheese. As the land rolls to the sea, freshwater springs bubble out and sinkholes appear. They are fed by ancient water, rain that fell centuries ago coursing through this underground aquifer. And where this ancient water reaches the surface, gardens bloom with fields of bright-green algae and water plants that form the hedgerows of silent meadows. The water filtered through the limestone is incredibly clear and cool. There are no particles in suspension so the surface light is not softened. It is hard blue and distant objects look as if they are etched in glass. Long-necked turtles break the surface to breathe; fish hide in algae beds that look like green noodles.

Freshwater is usually murky. But in the St. Lawrence river on the US–Canada border, introduced zebra mussels that have devastated the Great Lakes have filtered the water to a relatively clear emerald green – clear enough to see sturgeons swimming along the bottom.

In Central Florida, Ginnie Springs emerges from a vast limestone aquifer. Again, the pure freshwater is ancient. We dive in rain water that fell on Georgia when Thomas Jefferson was President. This water pours out of the earth and during a few days a year it mixes with brown tannin-stained water from the meandering Santa Fe River. Light comes through these two mixing waters and looking towards the surface is like peering into billowing orange flames.

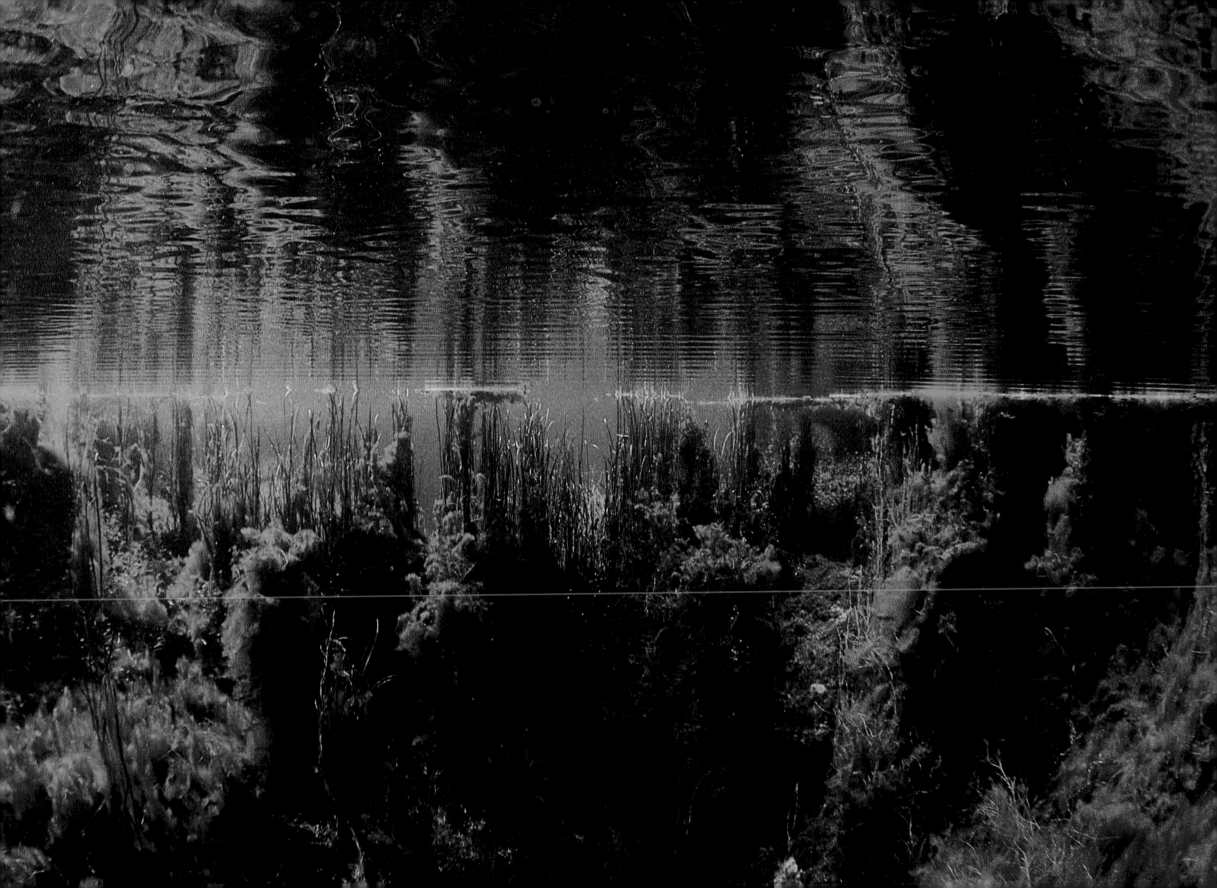

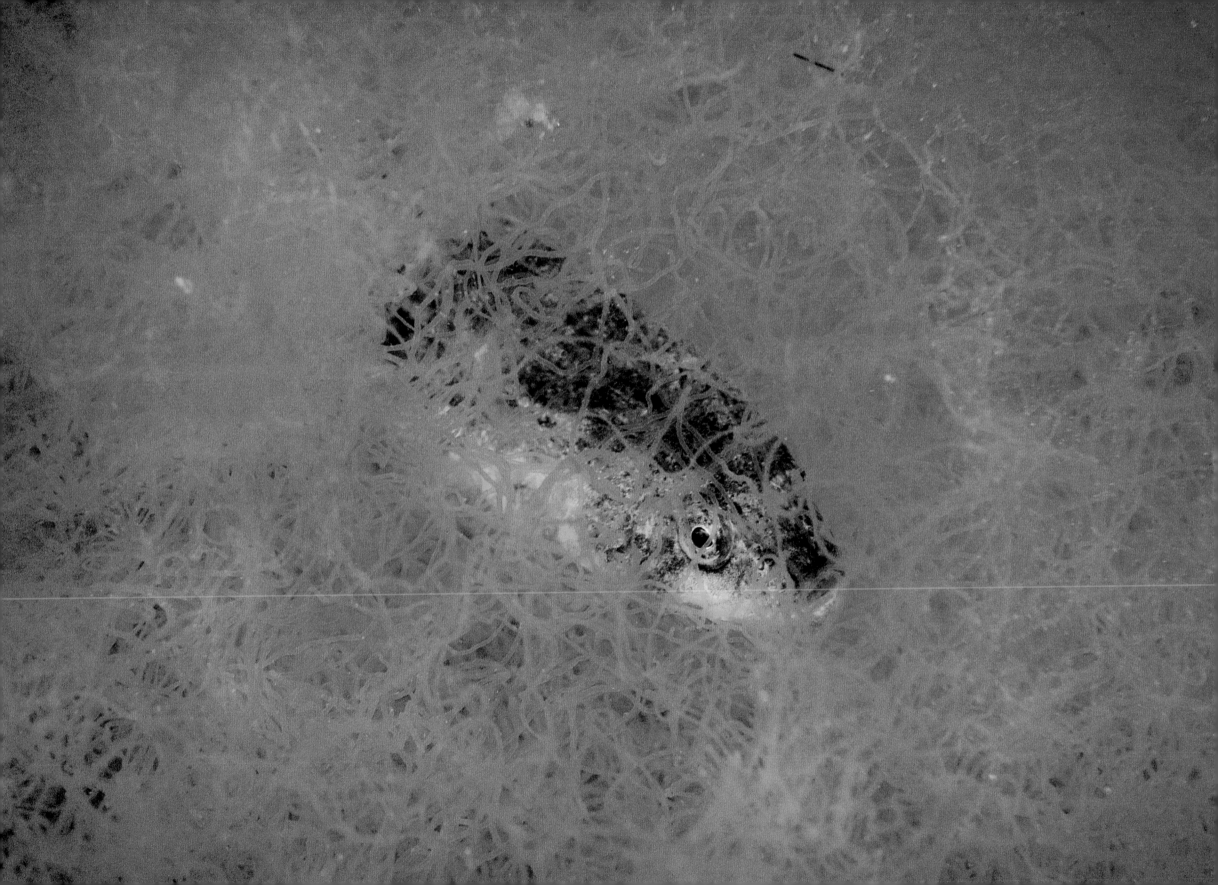

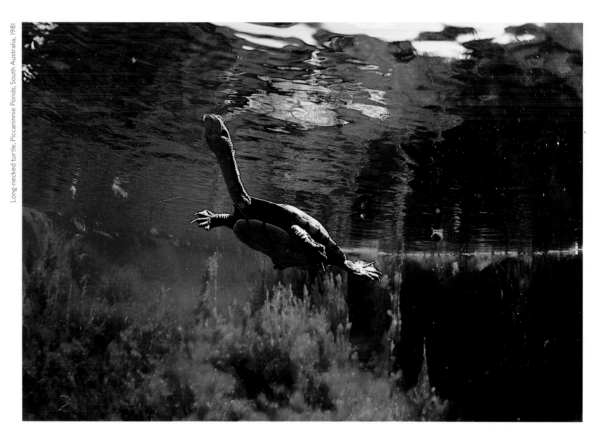

Long-necked turtle, Piccaninnie Ponds, South Australia, 1981

Ginnie Springs, Florida, USA, 1992

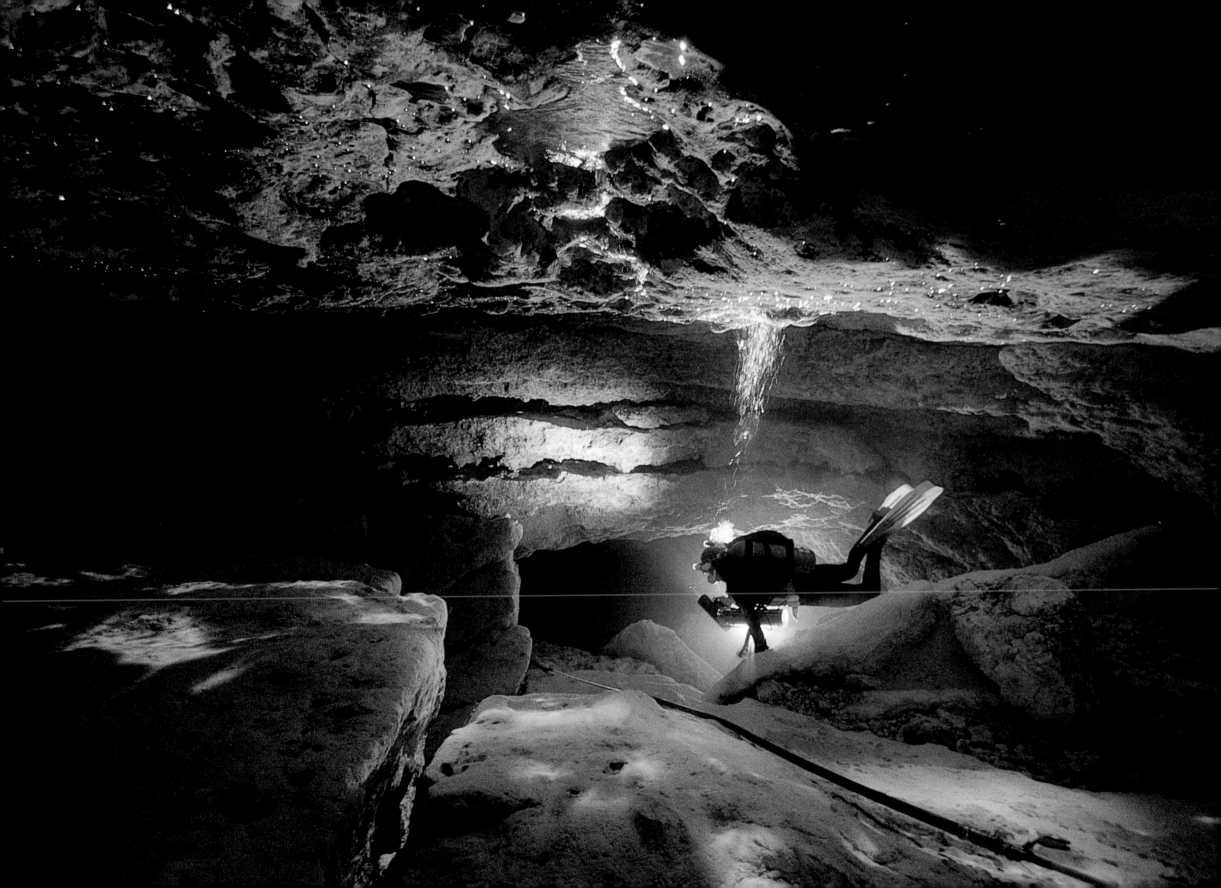

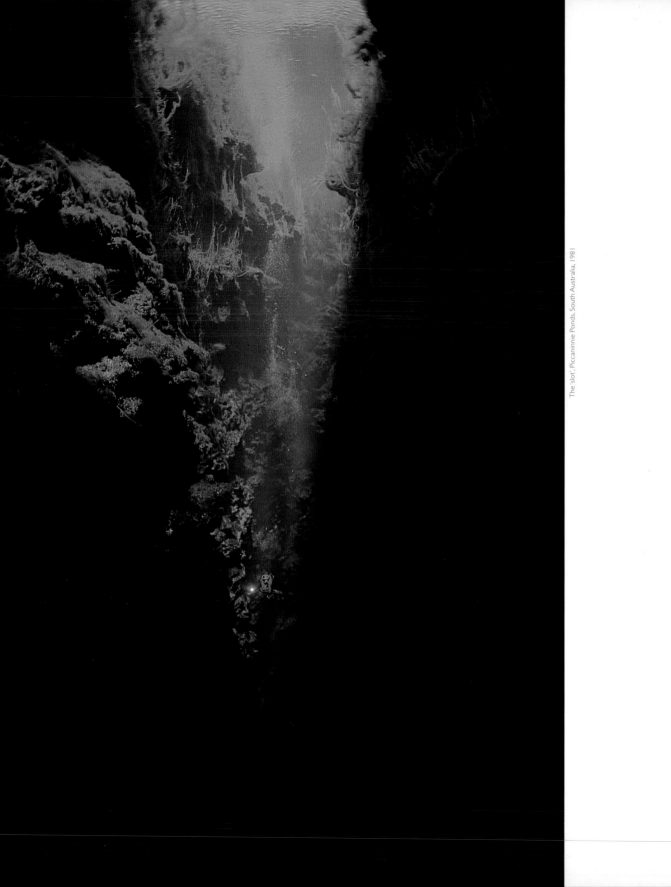

The 'slot', Piccaninnie Ponds, South Australia, 1981

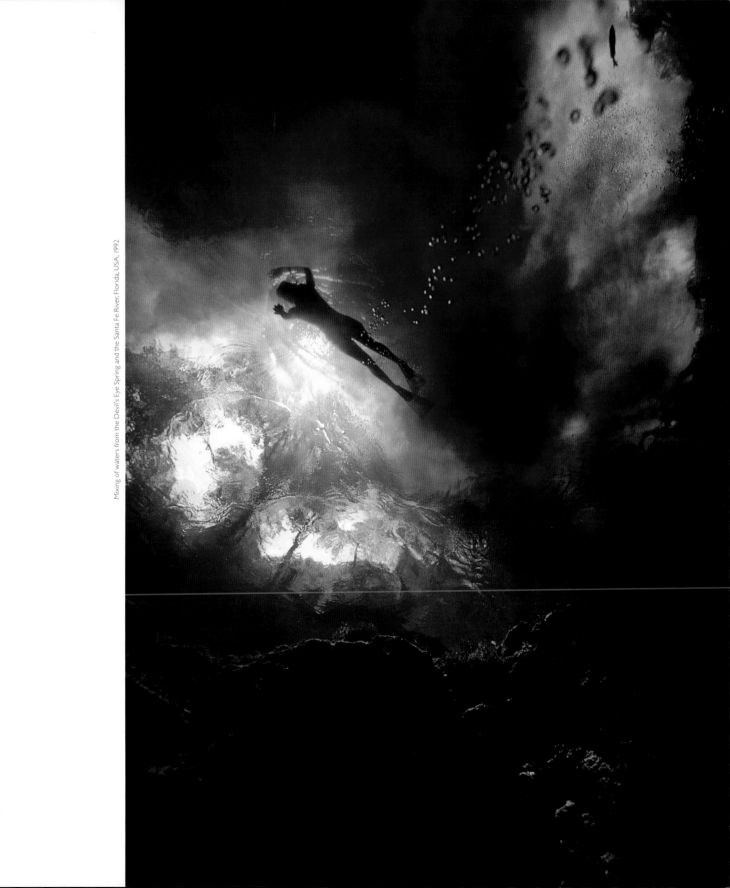

Mixing of waters from the Devil's Eye Spring and the Santa Fe River, Florida, USA, 1992.

Desert ocean

No rivers run into it. Little rain falls on its shores. The Red Sea is surrounded by desert and the colour of the water is a warm blue tinged with an edge of yellow from the sand. From space it is a long blue arm; a water-filled trench of the Great Rift Valley that divides Asia from Africa. It is the very end of the vast Indo-Pacific Ocean, isolated in time and distance. But the steep walls and small continental shelf mean that corals must viciously compete for space. The reefs are diverse wondrous coral carpets.

To dive in the Red Sea is like becoming entwined in an Impressionist painting. Veils of orange anthias fish cover the reef, feeding on plankton. When marauding jacks attack the anthias, the entire reef flinches. Plaid long-nosed hawkfish wait totally camouflaged in branches of black coral and sea fans. They are like tigers stalking the juvenile anthias.

The Red Sea was my studio and laboratory, a window into the secret cities of a coral reef. I remember watching, with my wife Anne, our friend Howard Rosenstein and the extraordinary naturalist, David Fridman, for the moon to set and the sea to become totally black. This is the time for the remarkable photoblepharon or flashlight fish to emerge from their hiding places on the night reef. They have bioluminescent pockets under their eyes, and form small schools where their combined blue-green light attracts plankton. The schools roll along the reef edge like distant galaxies.

On another night nearly 20 years later I used my powerful HMI movie light, now covered with ultra-violet filters, to illuminate a collected group of mundane looking corals. The corals absorbed the light and re-emitted visible light. This is called florescence and the secret colours seem to pulsate like neon cities. The group of corals burned into my eyes. When I surfaced the moon was rising over Aqaba in Jordan on the other side of the Red Sea.

One evening I swam into a school of glassy sweepers in a coral alcove off Little Brother Island. I wanted to take a picture of fish becoming water. The school turned as one: tails moving, gills closing. They made a sound like a bed sheet flapping in the wind.

And why is the Red Sea red? On windless summer evenings the superheated air traps the dust of the desert. The setting sun makes the air glow. Sea and sky combine, the horizon disappears and the sea throbs like a red heart.

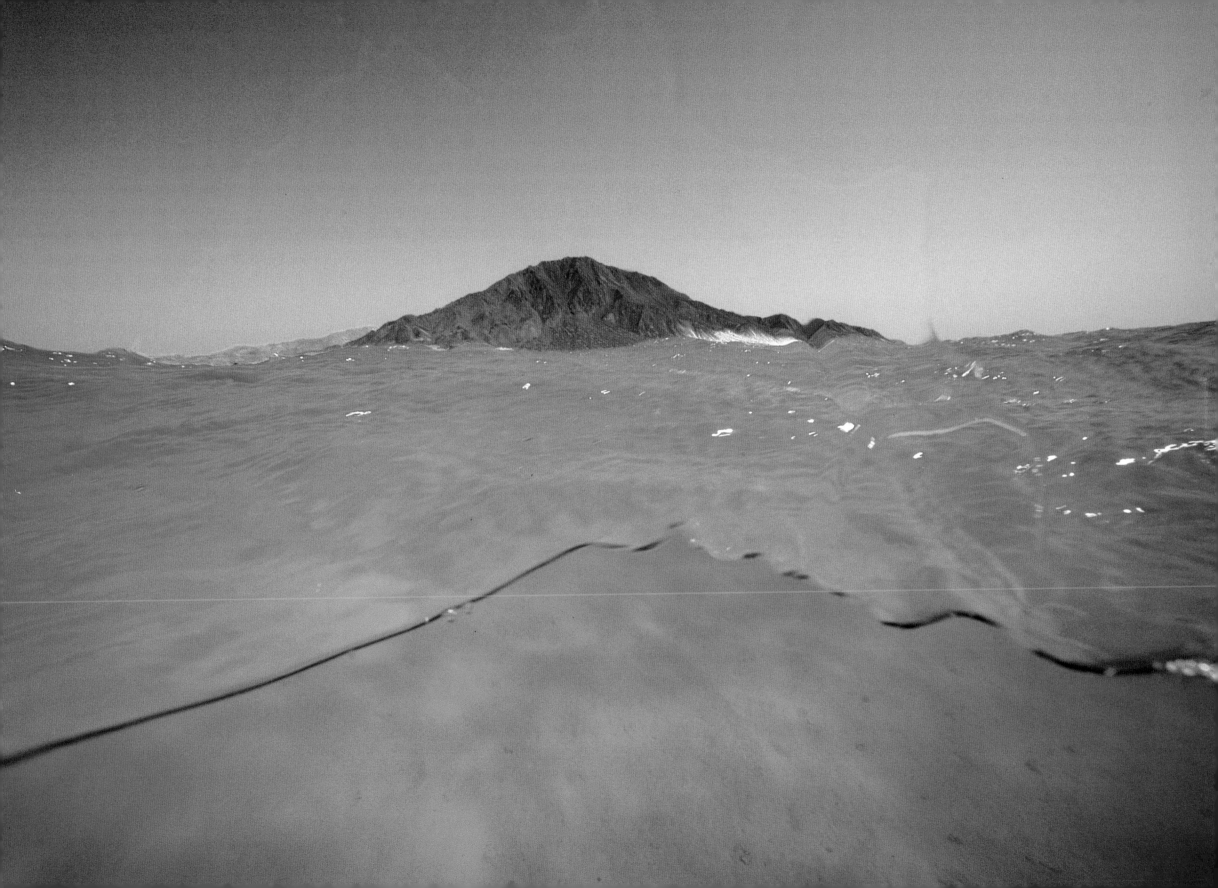

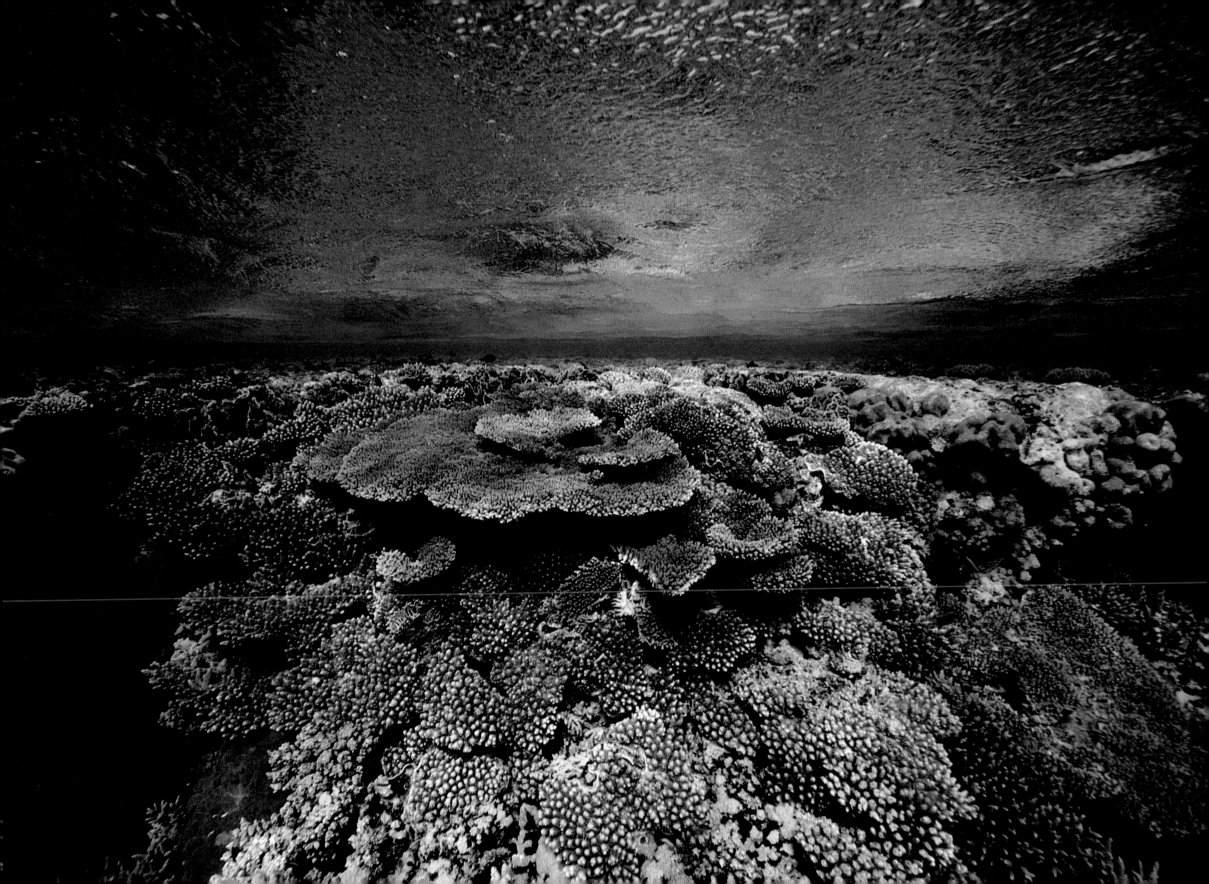

Glassy sweepers, Sinai Coast, North Red Sea, Egypt, 1991

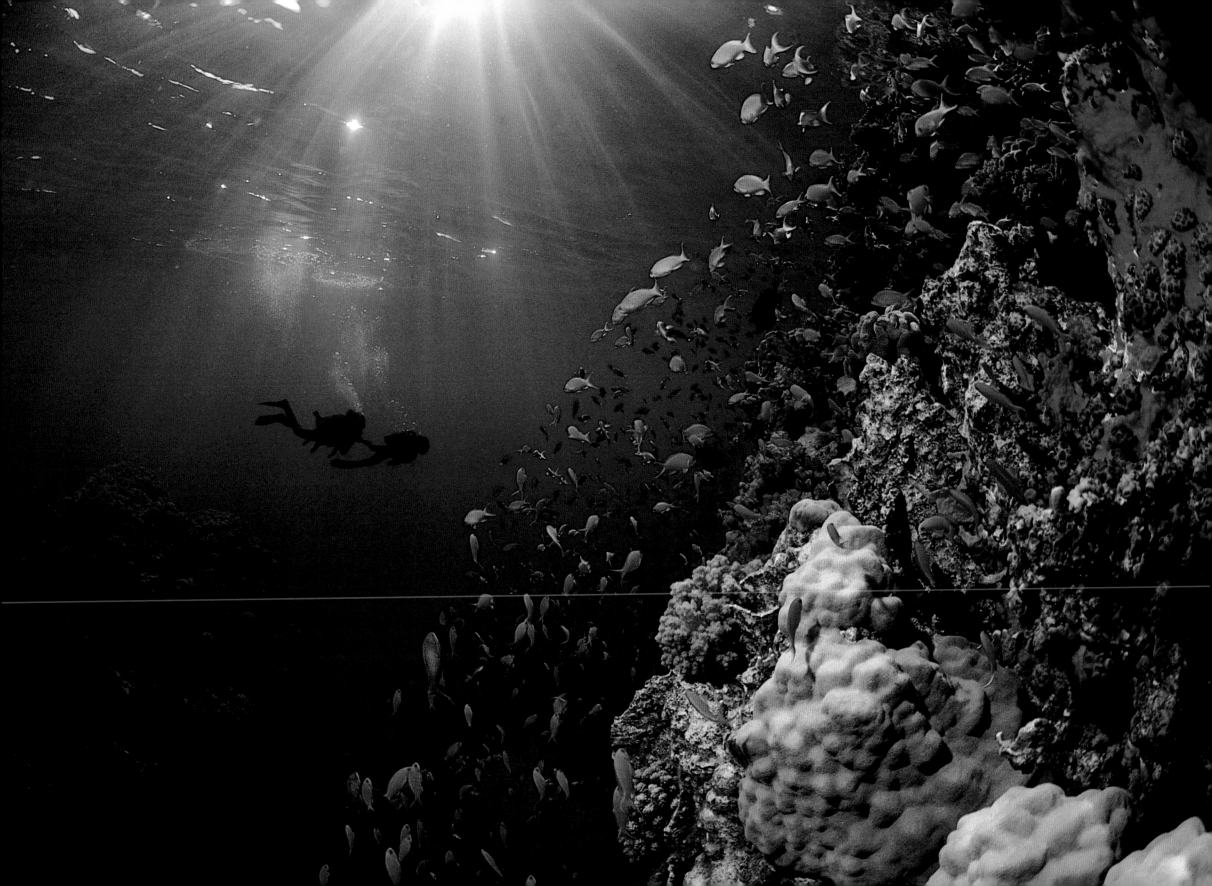

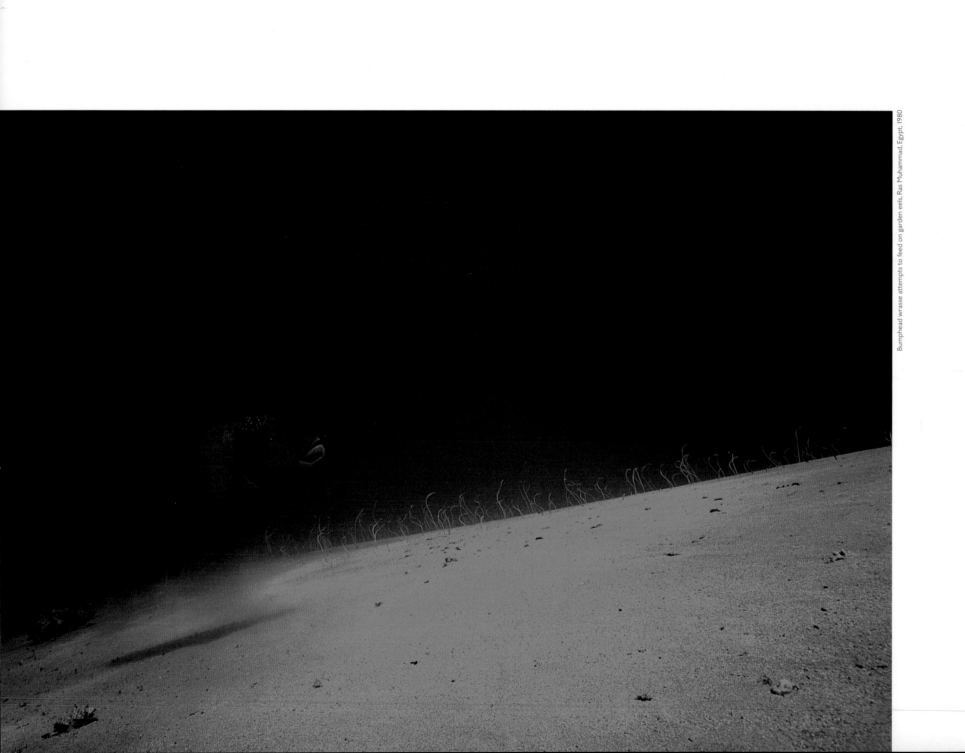

Bumphead wrasse attempts to feed on garden eels, Ras Muhammad, Egypt, 1980

Garden eels feed, Ras Muhammad, Egypt, 1980

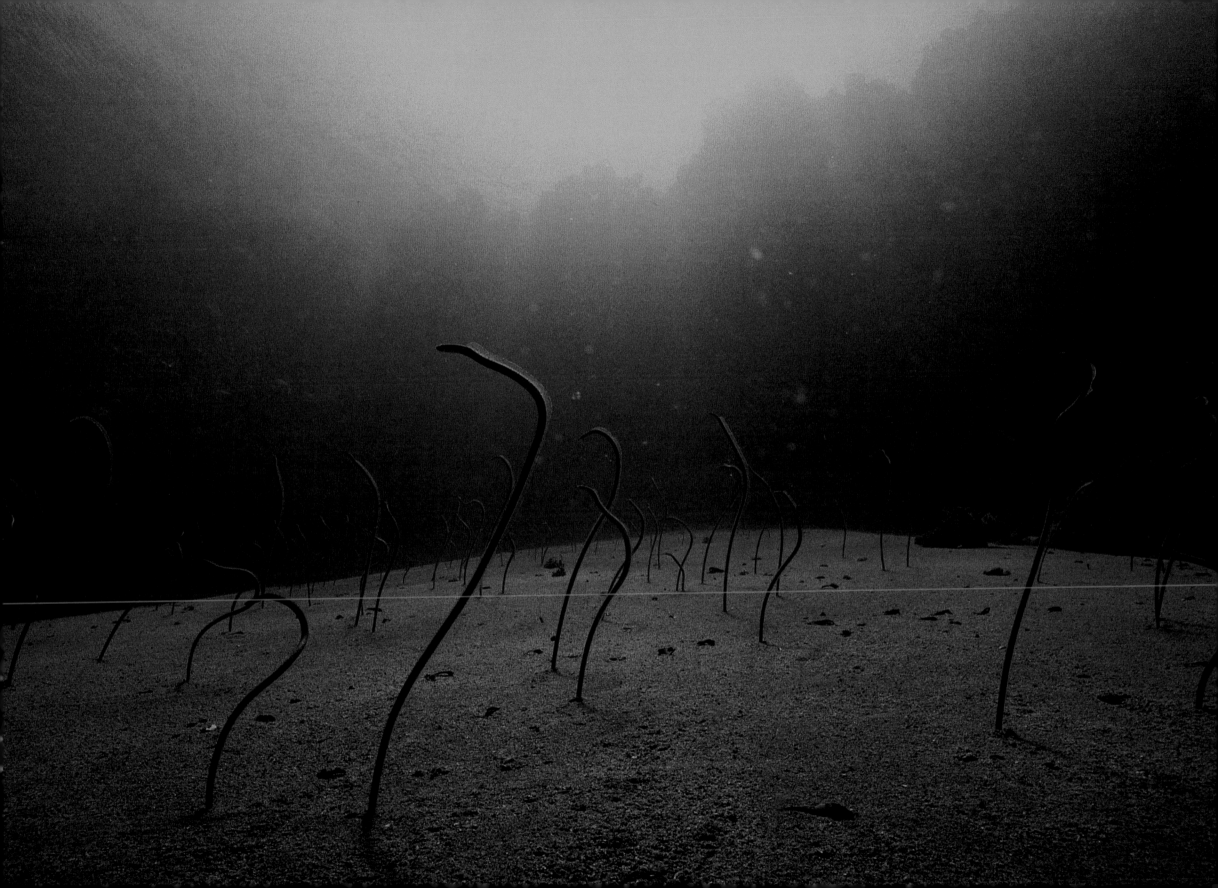

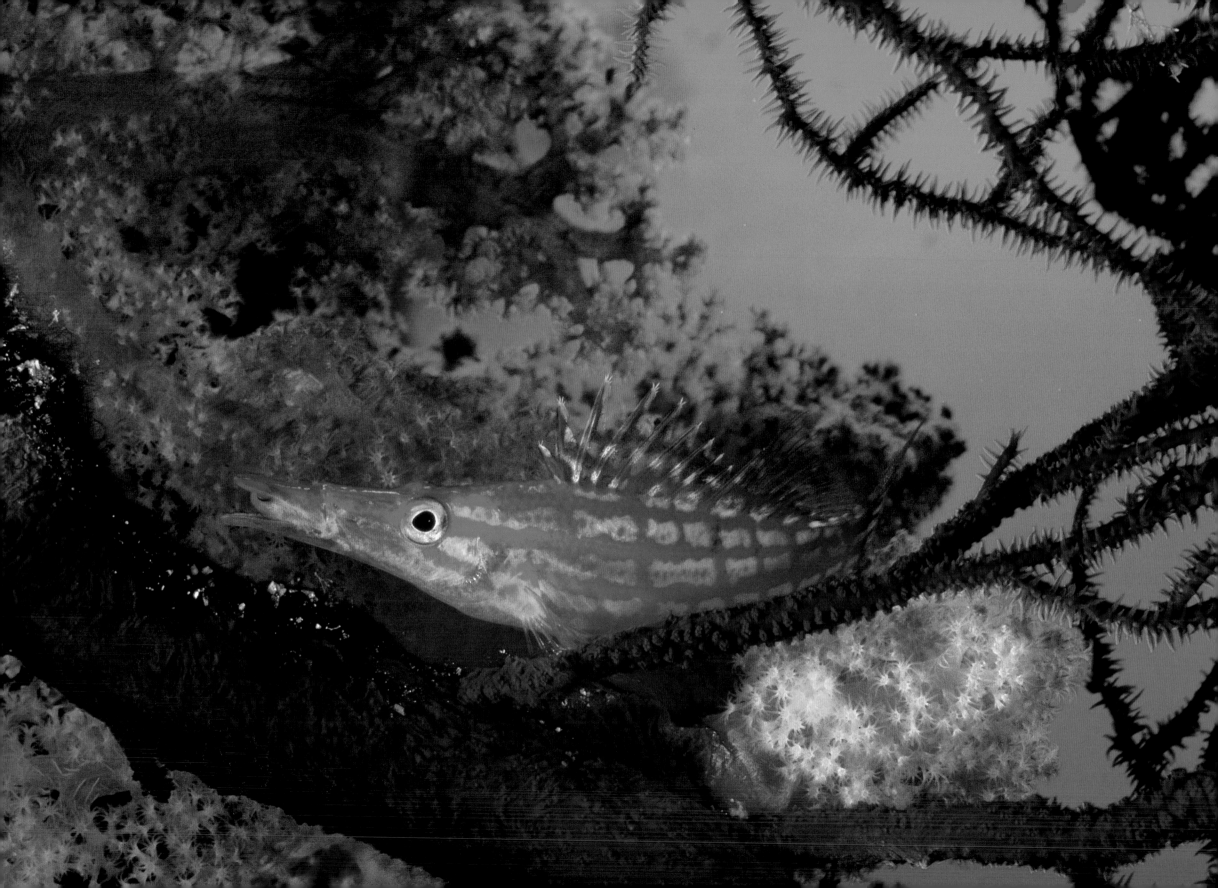

Long-nosed hawkfish eats an orange anthias, Brother's Island, North Red Sea, Egypt, 1991

Sea fans, Brother's Island, North Red Sea, Egypt, 1991

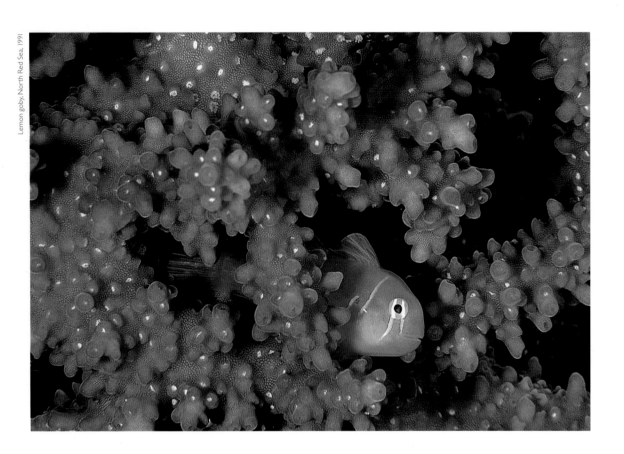

Lemon goby, North Red Sea, 1991

White moray eel, Marsa Mikrubella, Egypt, 1977

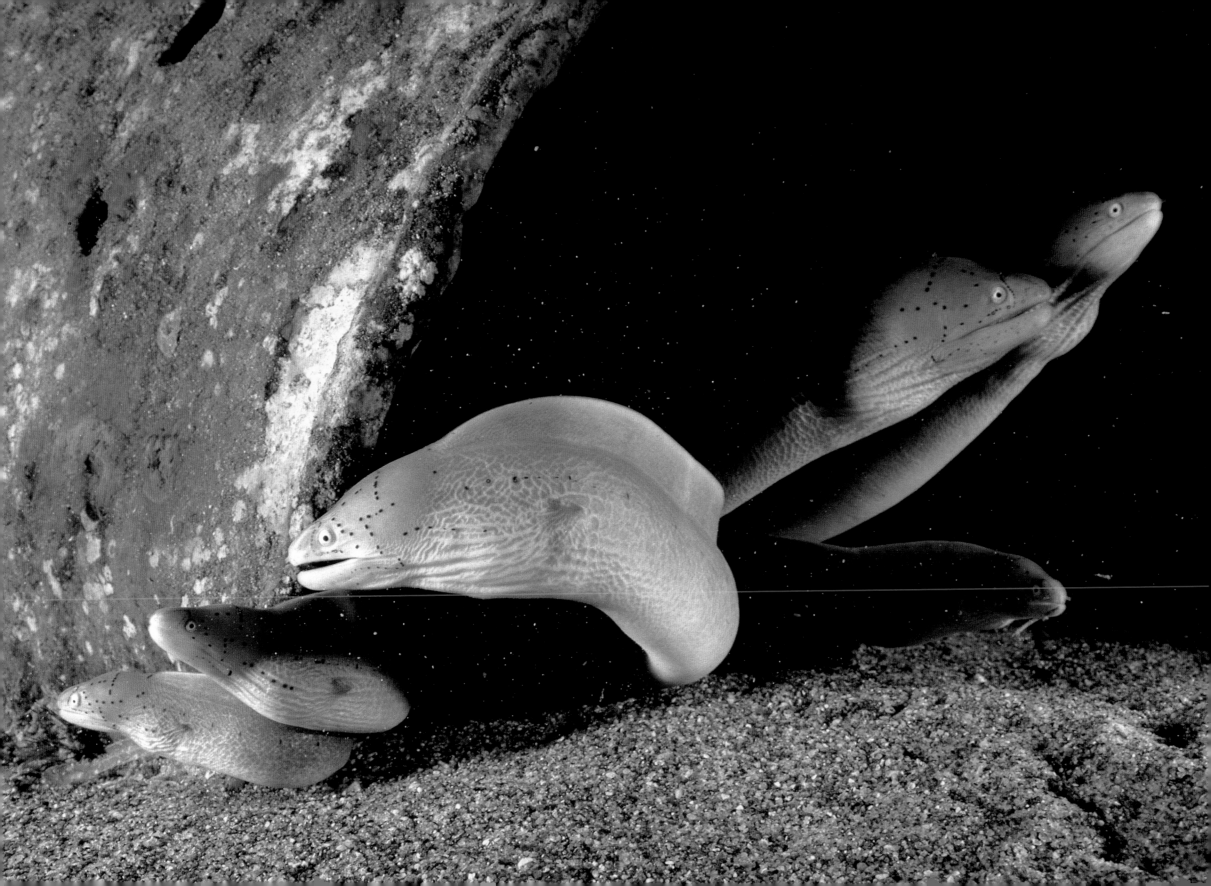

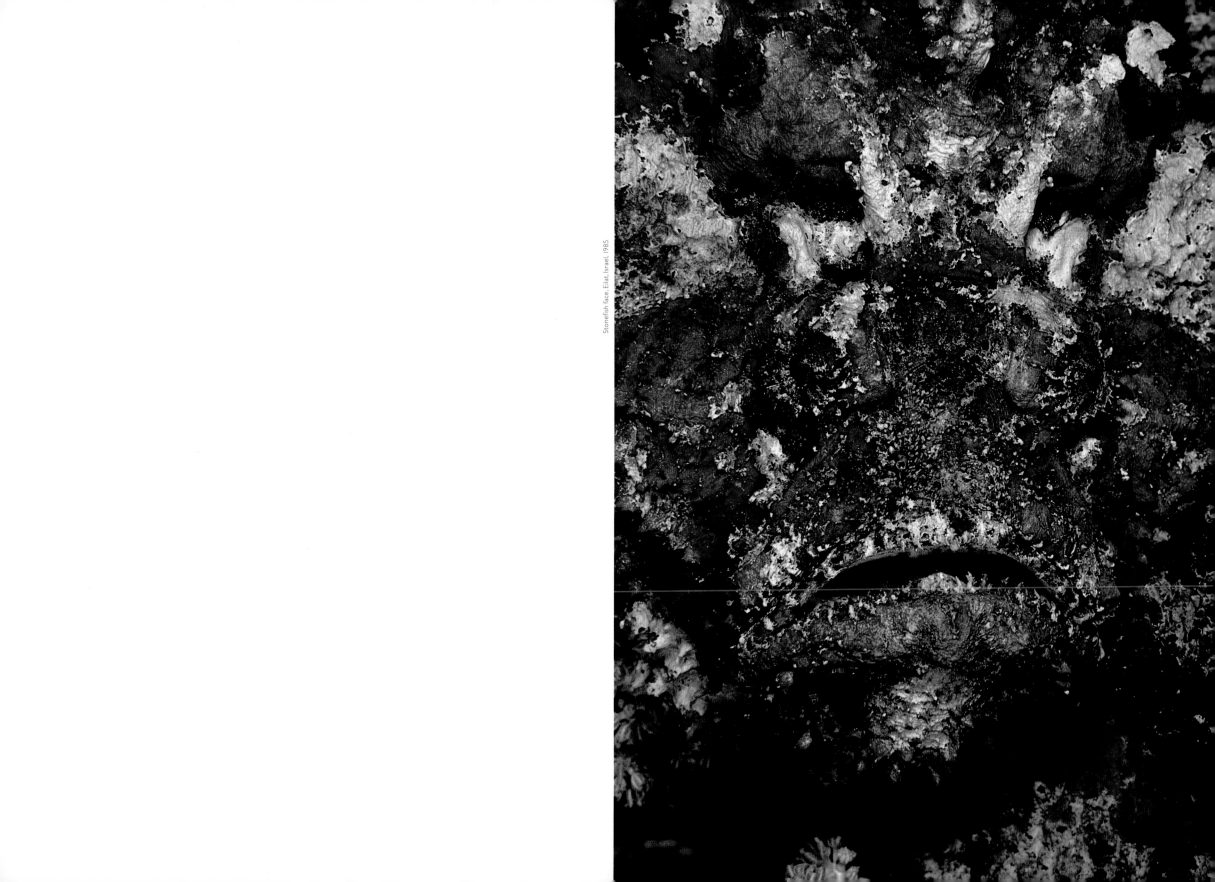

Stonefish face, Eilat, Israel, 1985

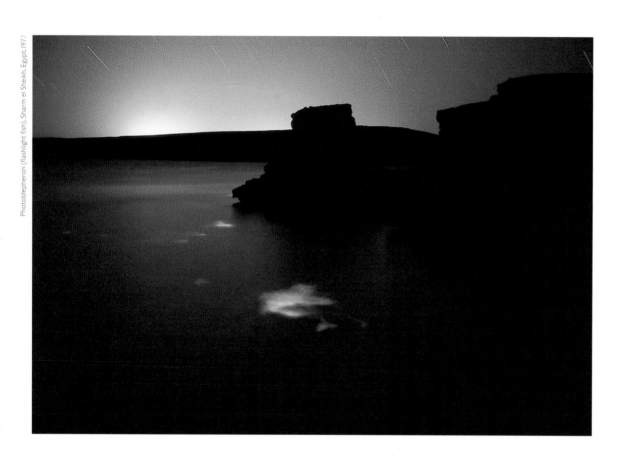

Photoblepheron (flashlight fish), Sharm el Sheikh, Egypt, 1977

Evening, Red Sea, 1991

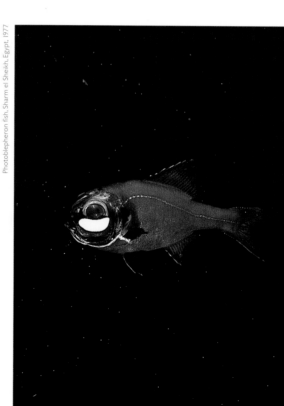

Photoblepheron fish, Sharm el Sheikh, Egypt, 1977

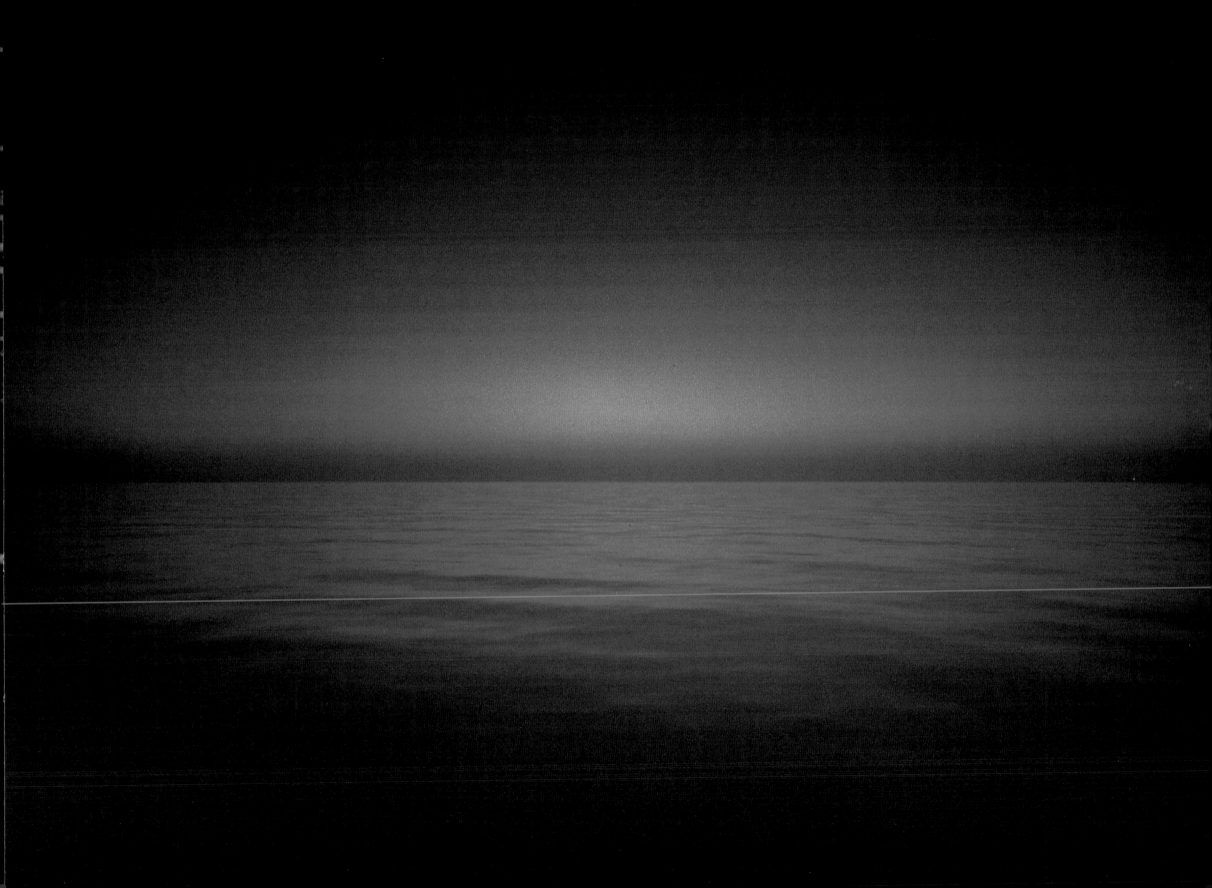

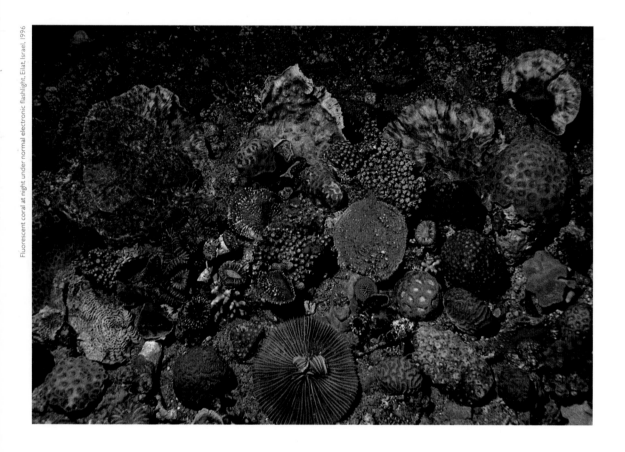

Fluorescent coral at night under normal electronic flashlight, Eilat, Israel, 1996

The same corals fluoresce under ultra-violet light, Eilat, Israel, 1996

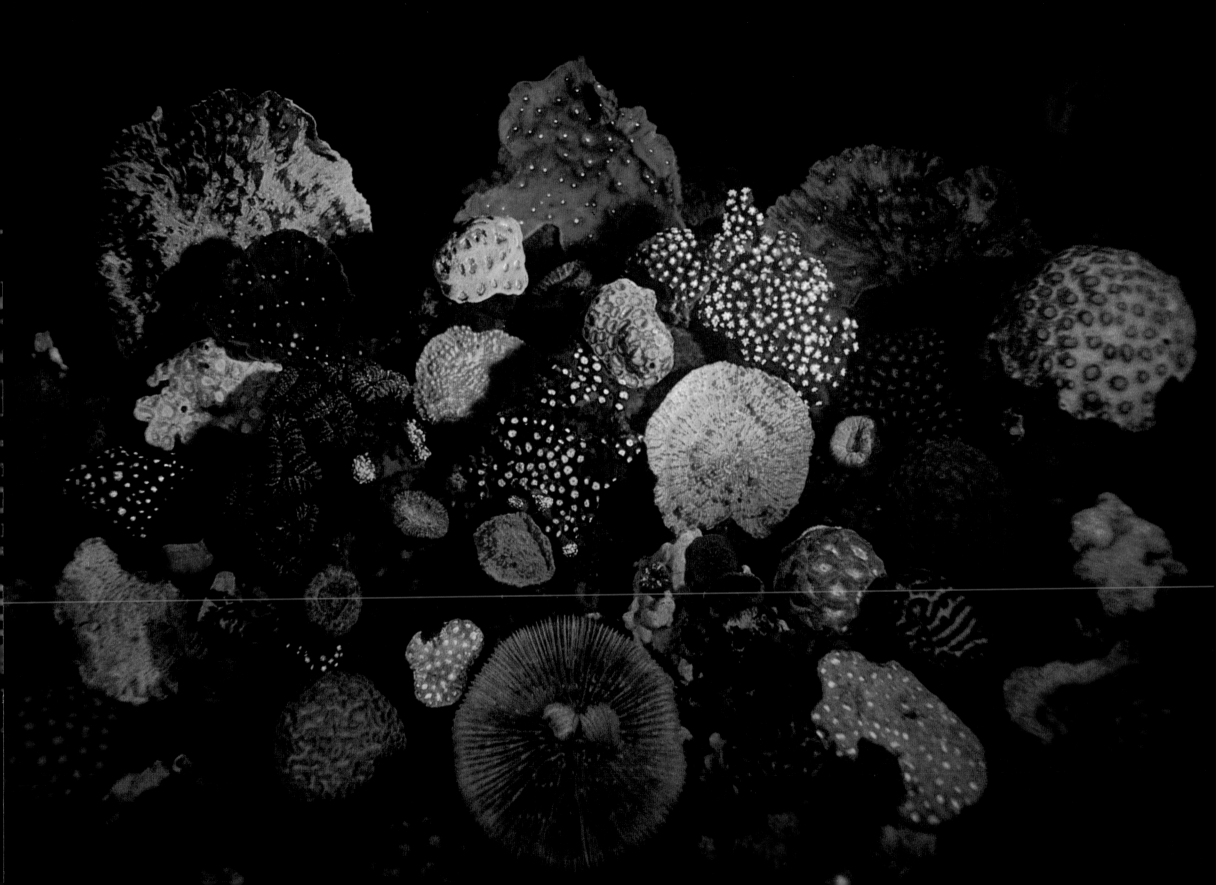

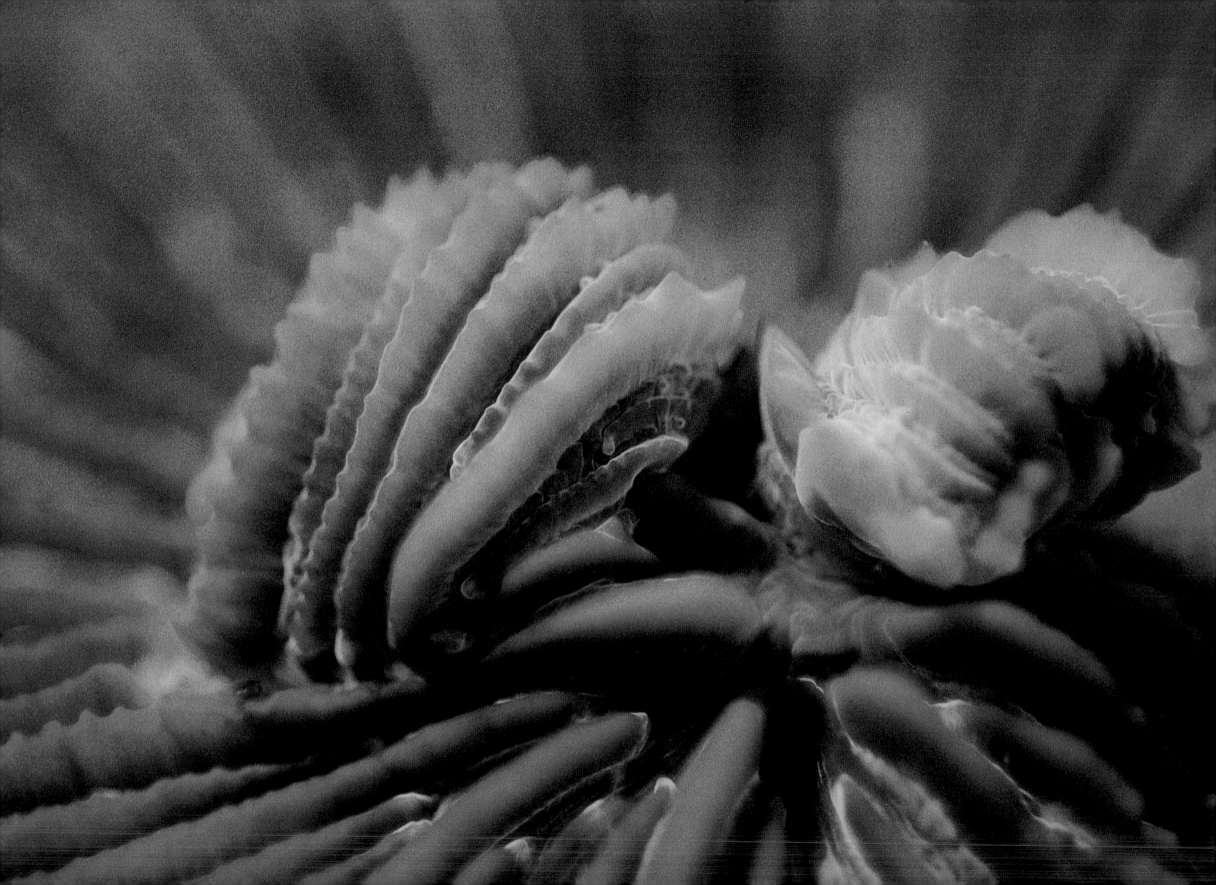

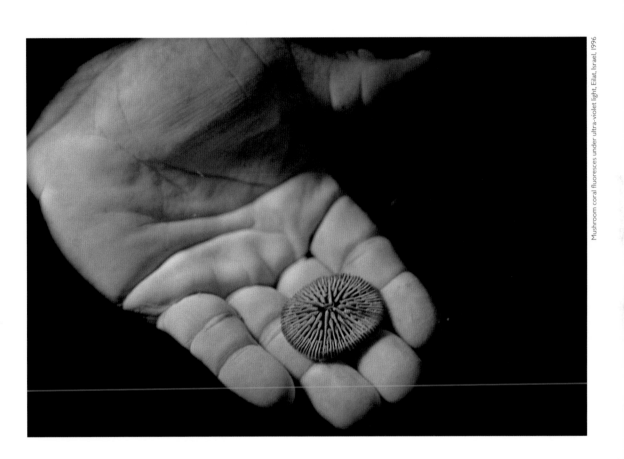

Detail of mushroom coral under ultra-violet light, Eilat, Israel, 1996

Mushroom coral fluoresces under ultra-violet light, Eilat, Israel, 1996

Favites coral fluoresces under ultra-violet light, Eilat, Israel, 1996

Knob coral fluoresces under ultra-violet light, Eilat, Israel, 1996

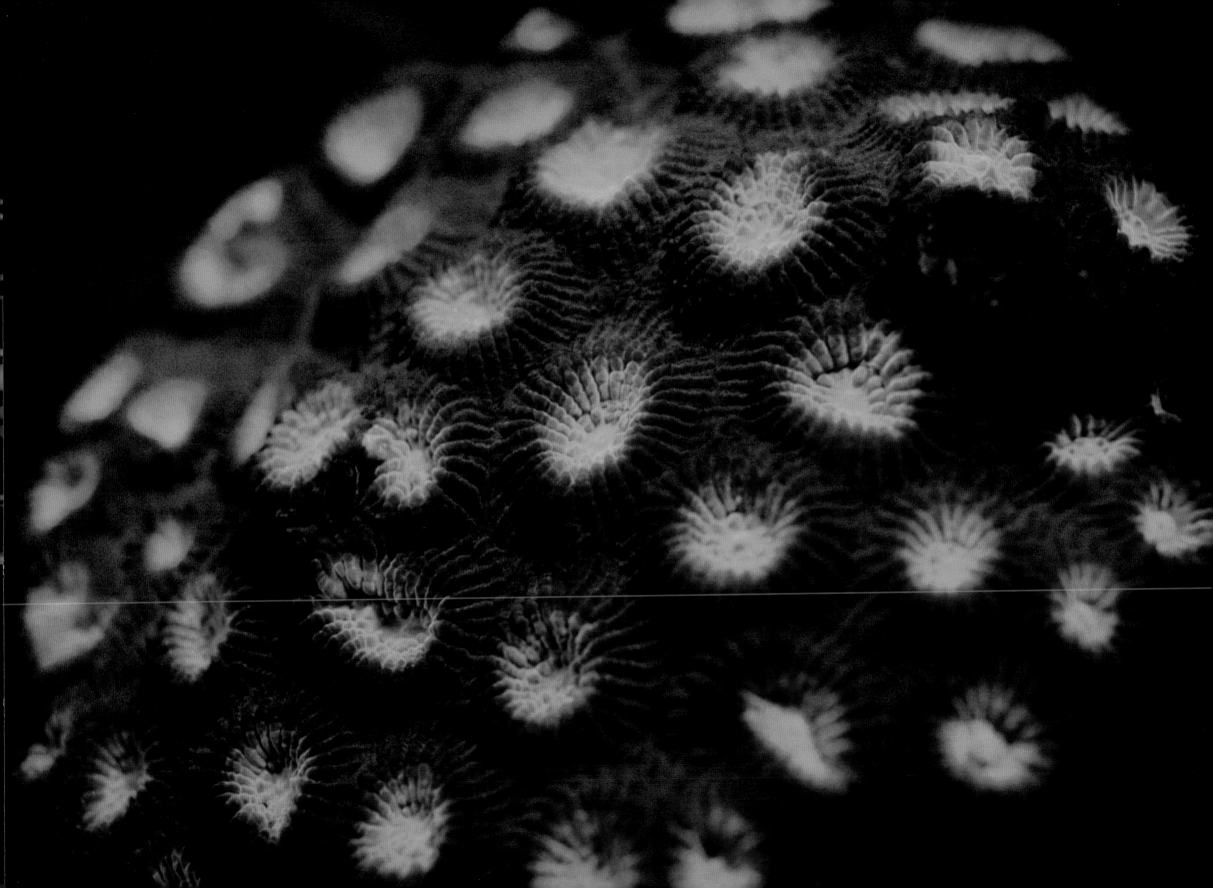

Cup coral fluoresces under ultra-violet light, Eilat, Israel, 1996

Elephant-ear coral fluoresces under ultra-violet light, Eilat, Israel, 1996

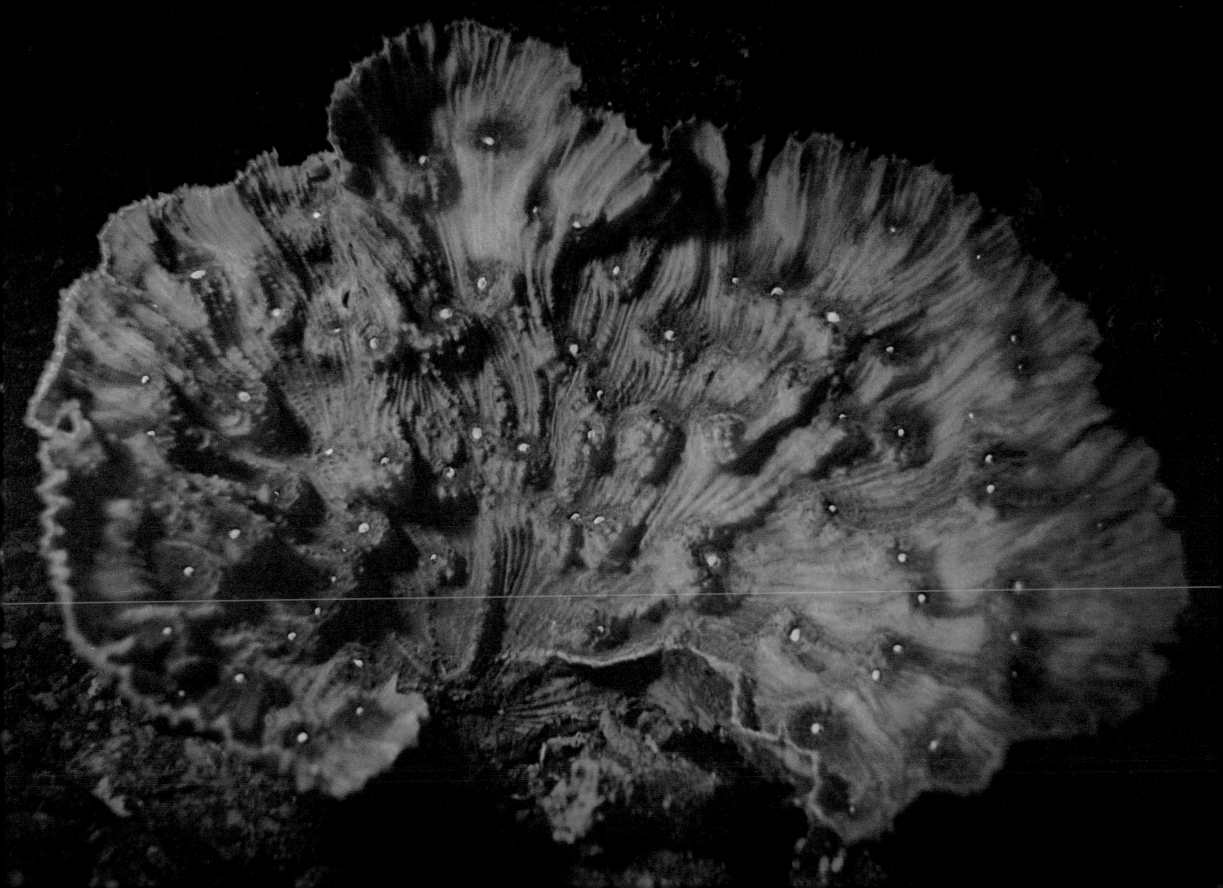

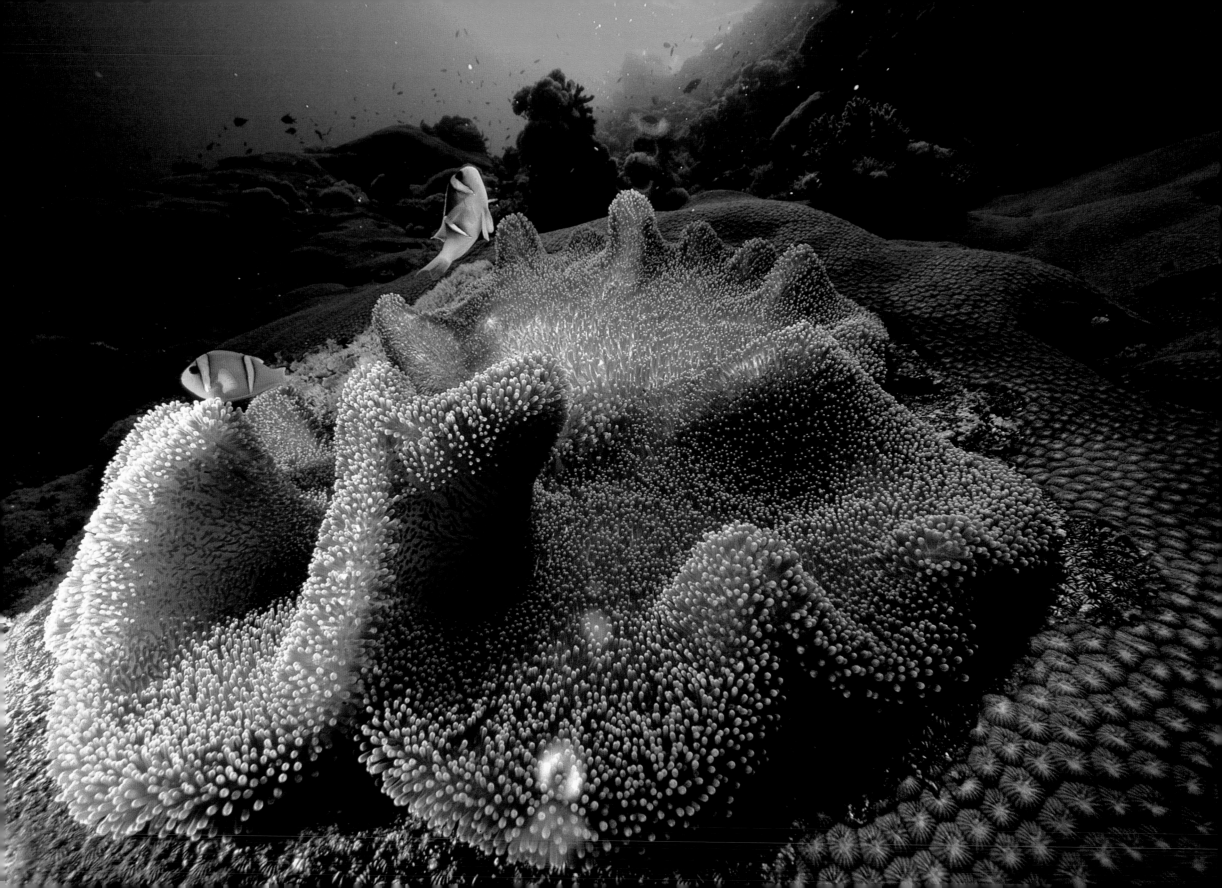

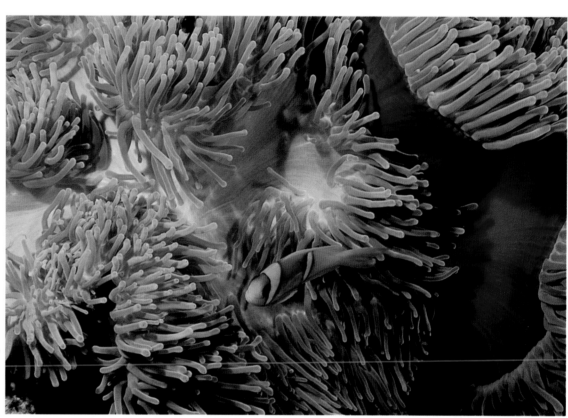

Anemone and clown fish, Ras Muhammad, Egypt, 1977

Spinner dolphin, Straits of Tiran, Gulf of Aqaba, North Red Sea, Egypt, 1980

Hawksbill turtle in evening light, Eilat, Israel, 1991

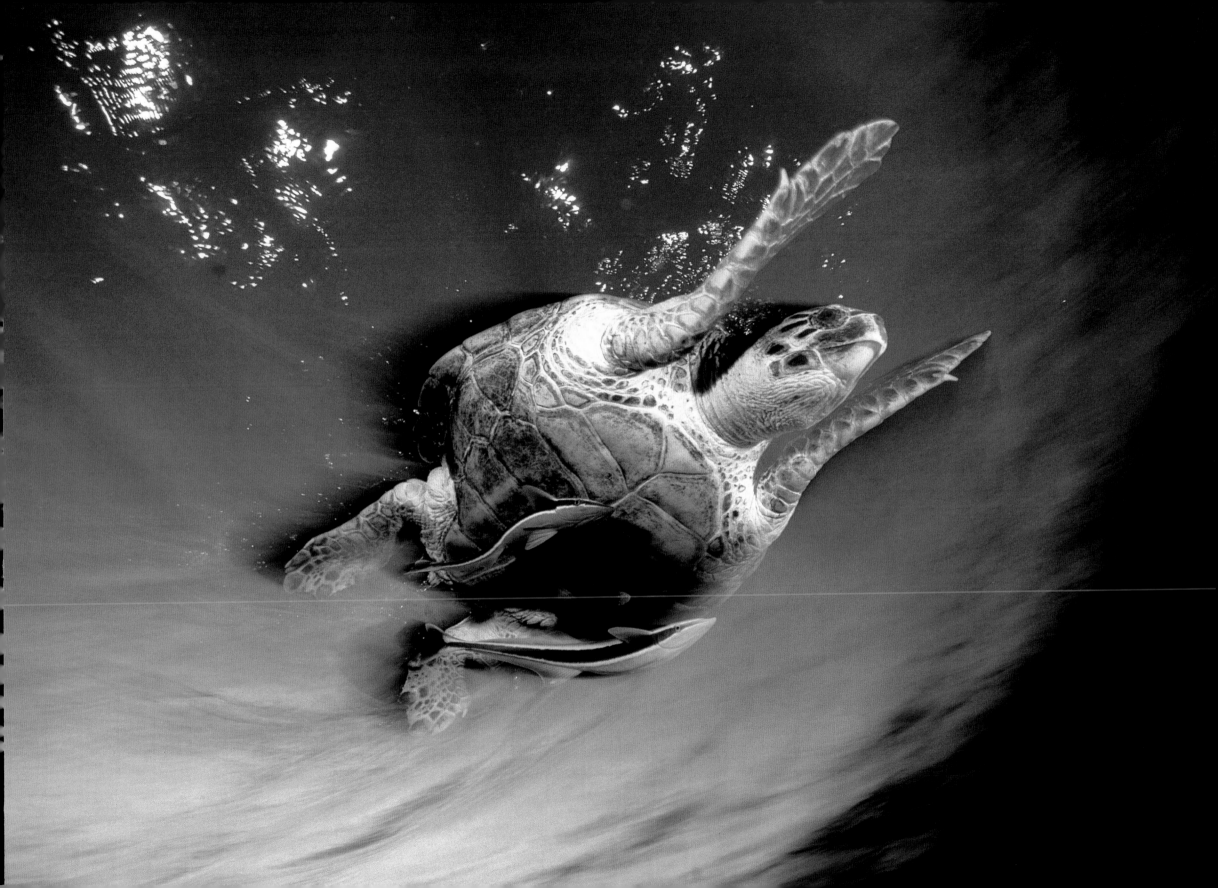

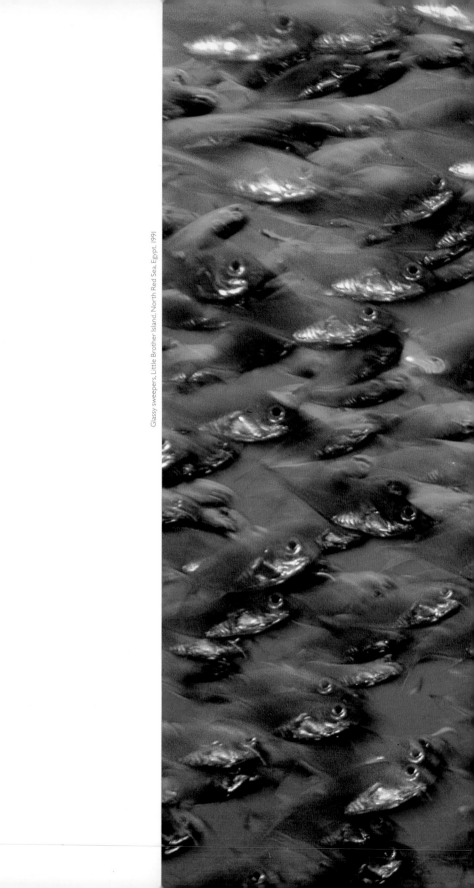

Glassy sweepers, Little Brother Island, North Red Sea, Egypt, 1991

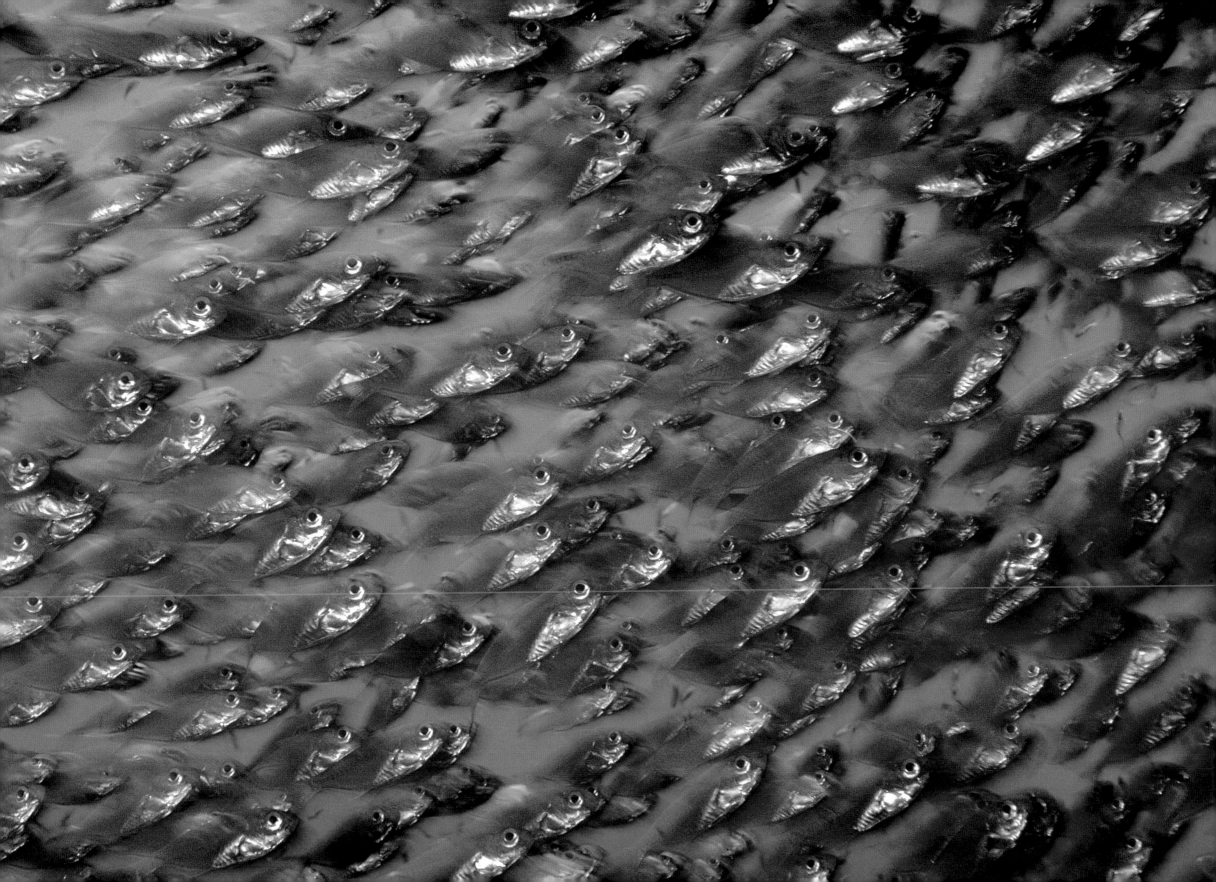

South light

At 39,000 feet high I look down at the south-eastern corner of Australia. There is a beach that nearly stretches to the horizon. This is a land that in its isolation became an alternative laboratory for life. No cows, no deer, but kangaroos, koalas, wombats and, in the wildest evolutionary experiment, the platypus: an animal that lays eggs and has hair. The sea is just as wonderfully bizarre. The leafy sea dragon, one foot long, a distant cousin of the sea horse, lives here and so do pink clingfish and blue-ringed octopus.

Australia is not just the Great Barrier Reef. The national park reef in the state of Queensland forms only a small percentage of the endless ribbon of coastline. There is the cold-water beauty of the eastern and southern coastlines, meadows of kelp in South Australia and the strange power of north-western Australia's waters at the edge of the Indian Ocean. It is also for me a place of high drama, sometimes fear. I have been caught outside of a shark cage with a marauding 15-foot white shark and had a venomous sea snake actually come between me and my dive vest.

In the north I snorkelled down the Jardine River, a seemingly peaceful meandering English river, looking for saltwater crocodiles. The water was warm, the air delightful with chugging, puffy clouds, and I was terrified.

There is a moment I remember off Little Hopkins Island in South Australia where I dived with a group of South Australian hair sea lions. They played on a bed of green seaweed in a sea full of summer light. They put their muzzels into the camera lens, chewed on the strobe cords and when I put out the flat of my hand one of them tickled my palm with its whiskers.

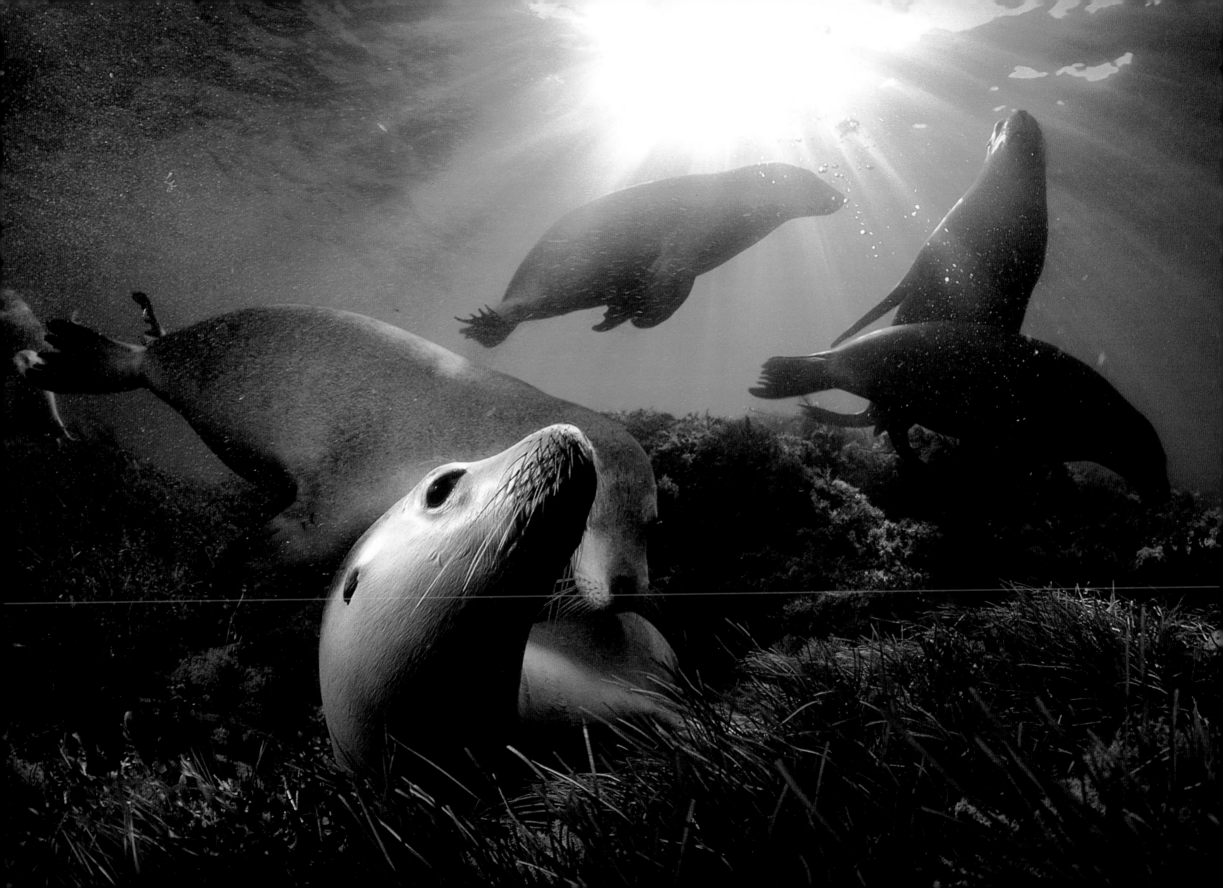

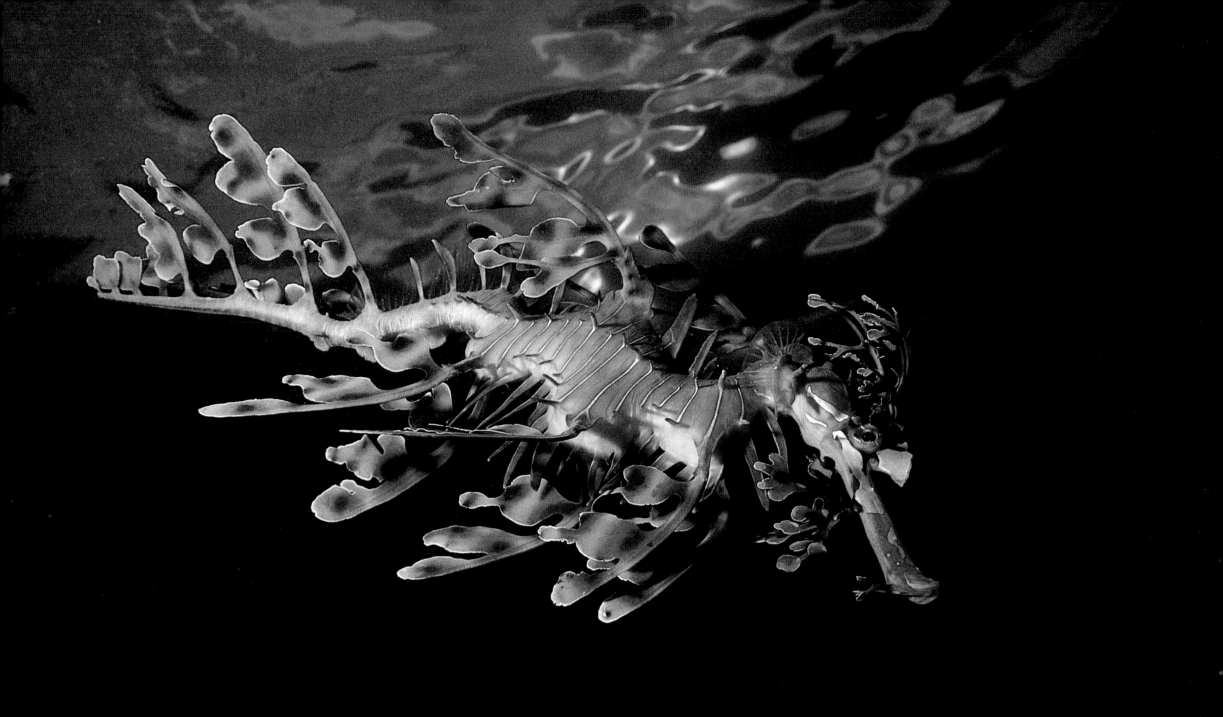

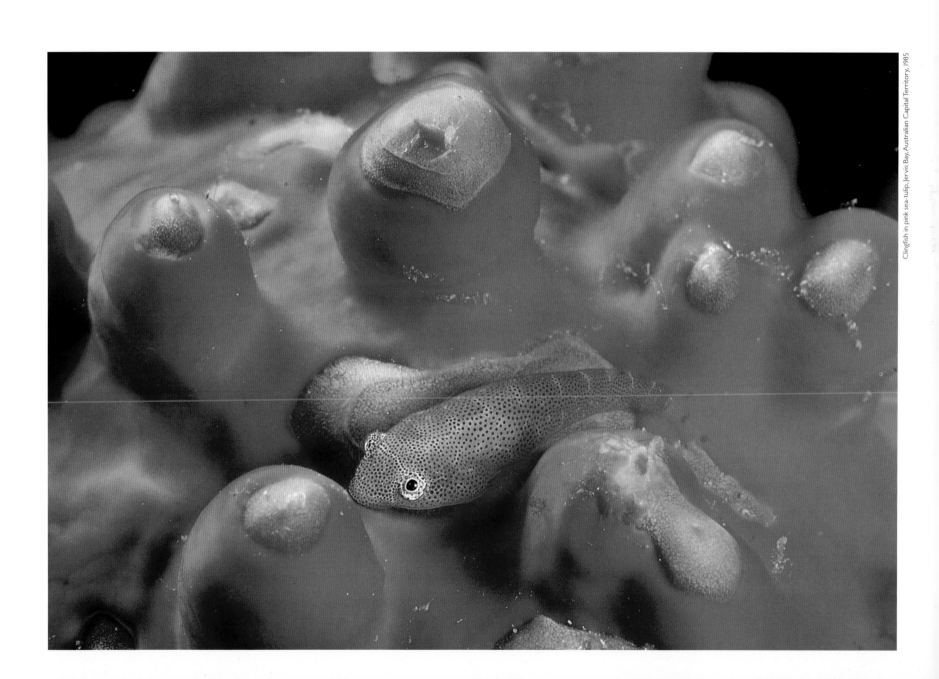

Clingfish in pink sea-tulip, Jervis Bay, Australian Capital Territory, 1985

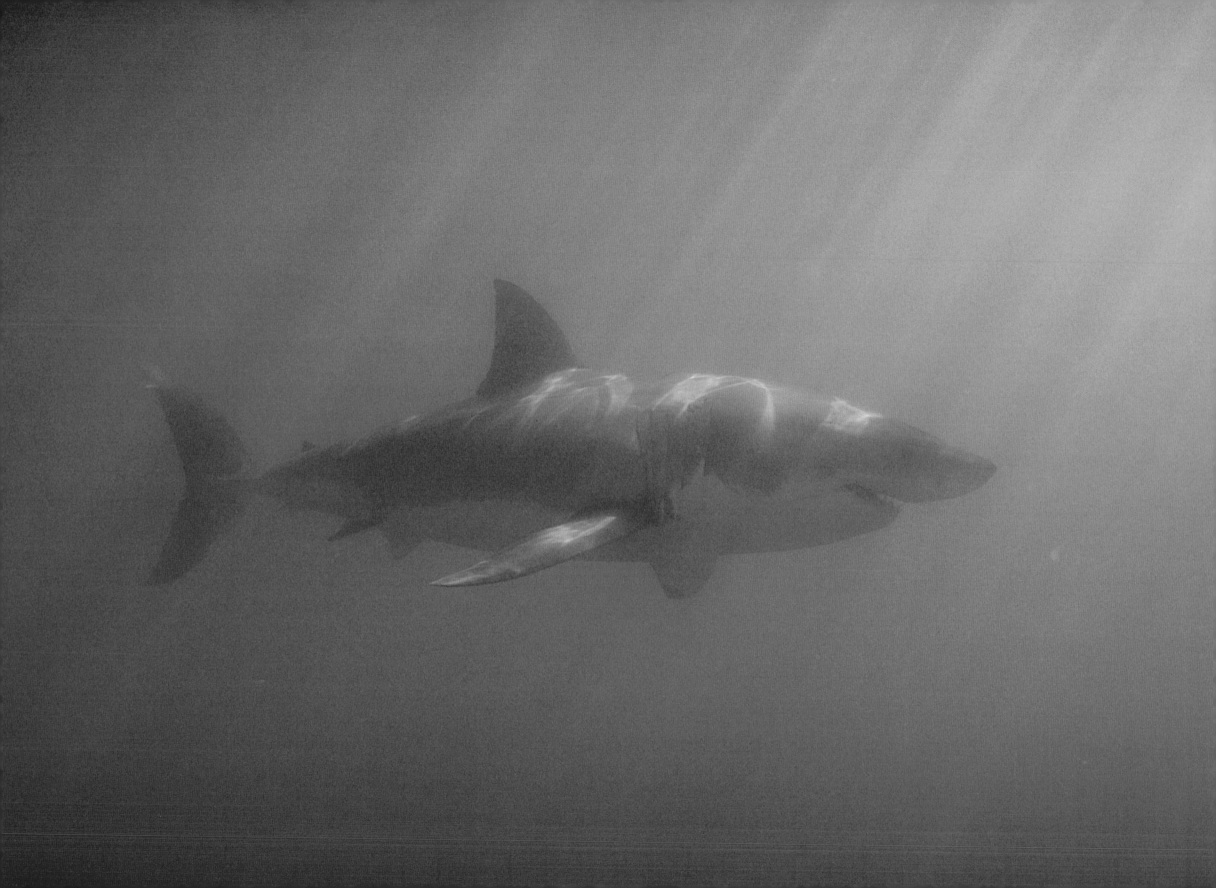

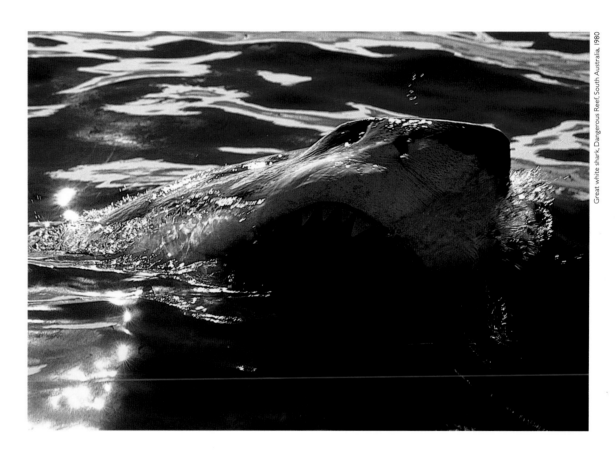

Great white shark, Dangerous Reef, South Australia, 1980

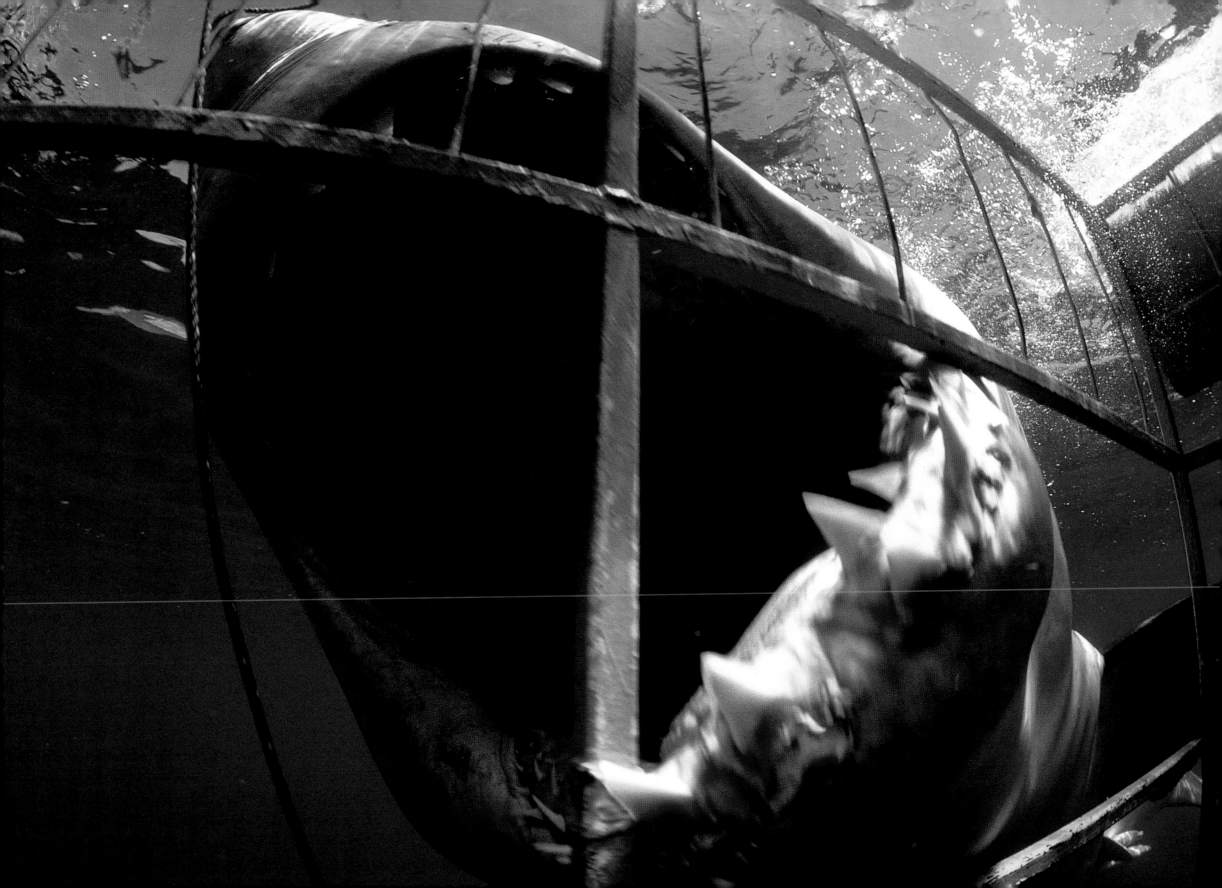

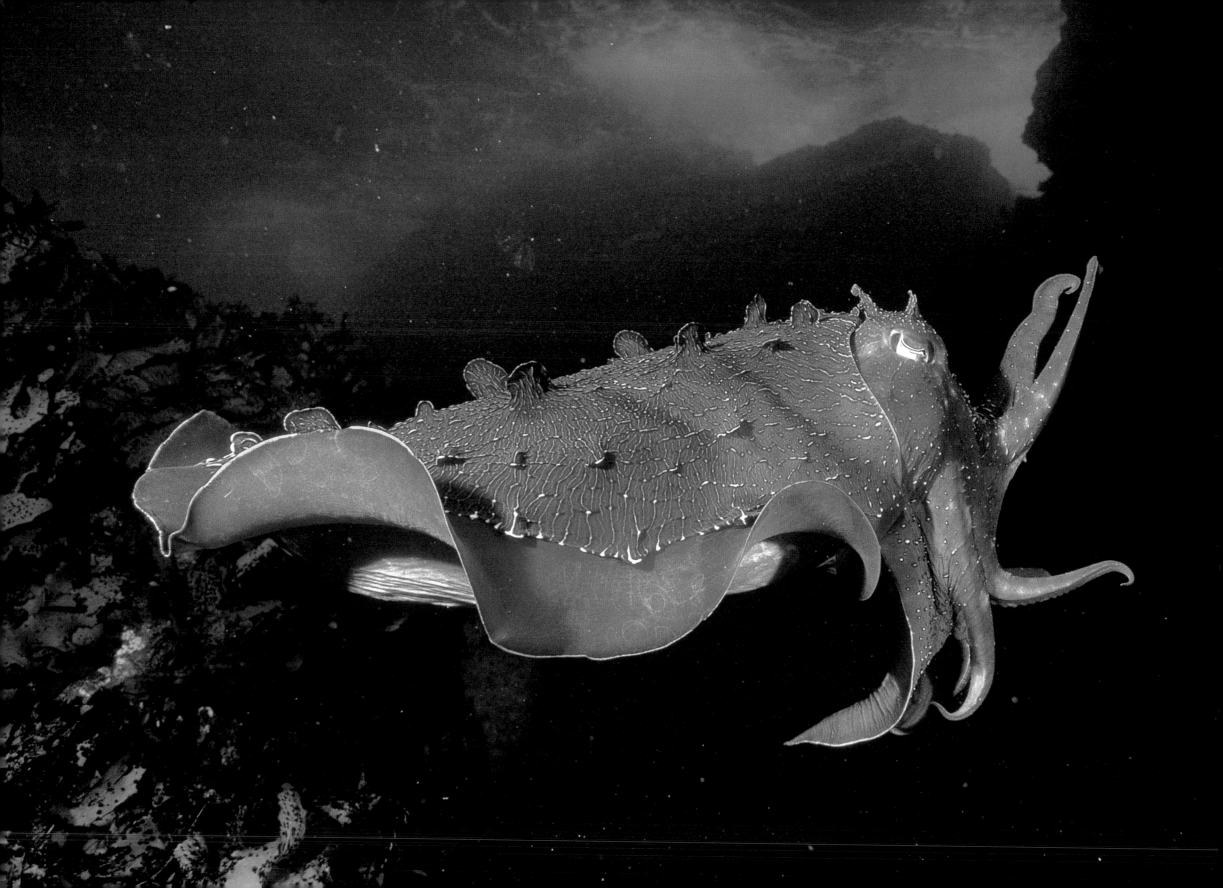

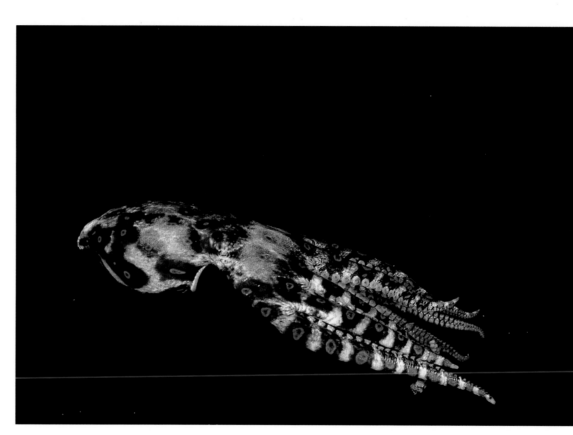

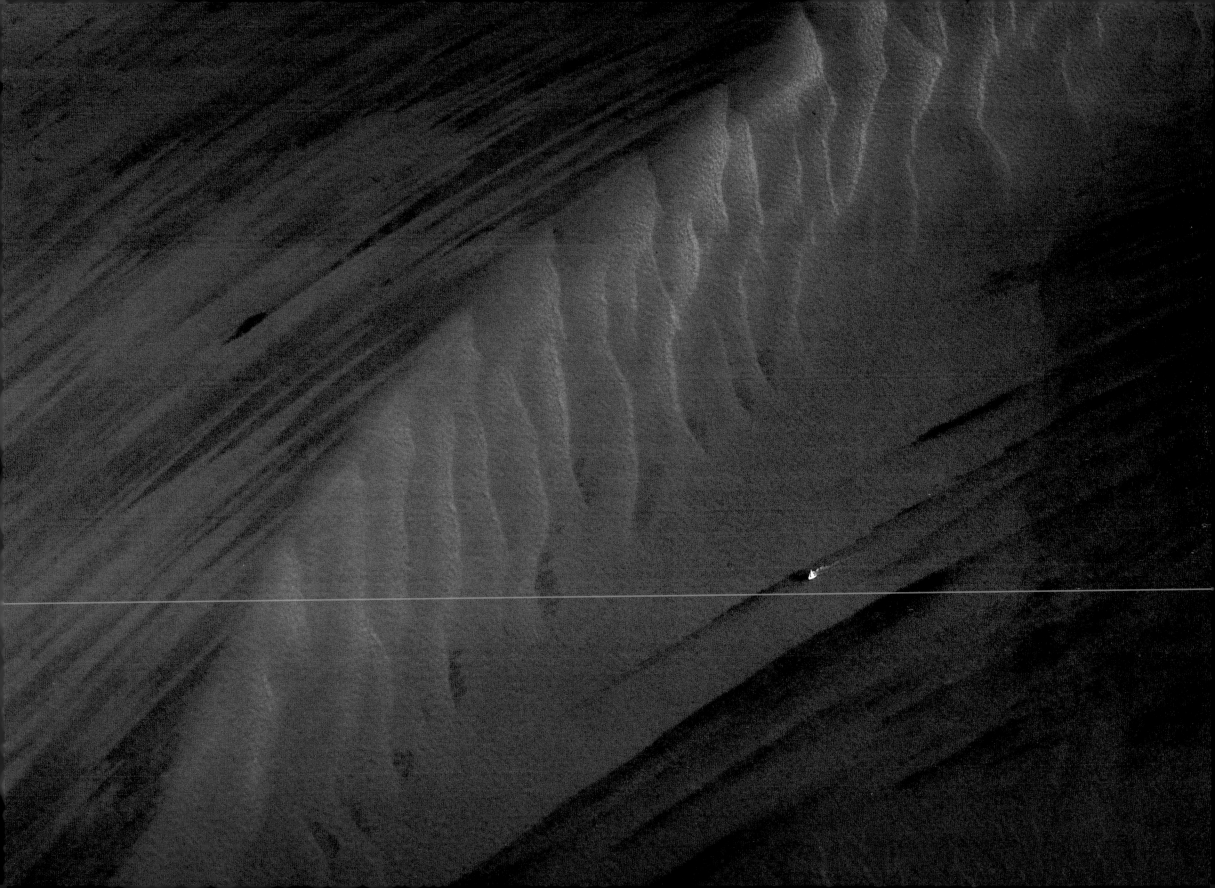

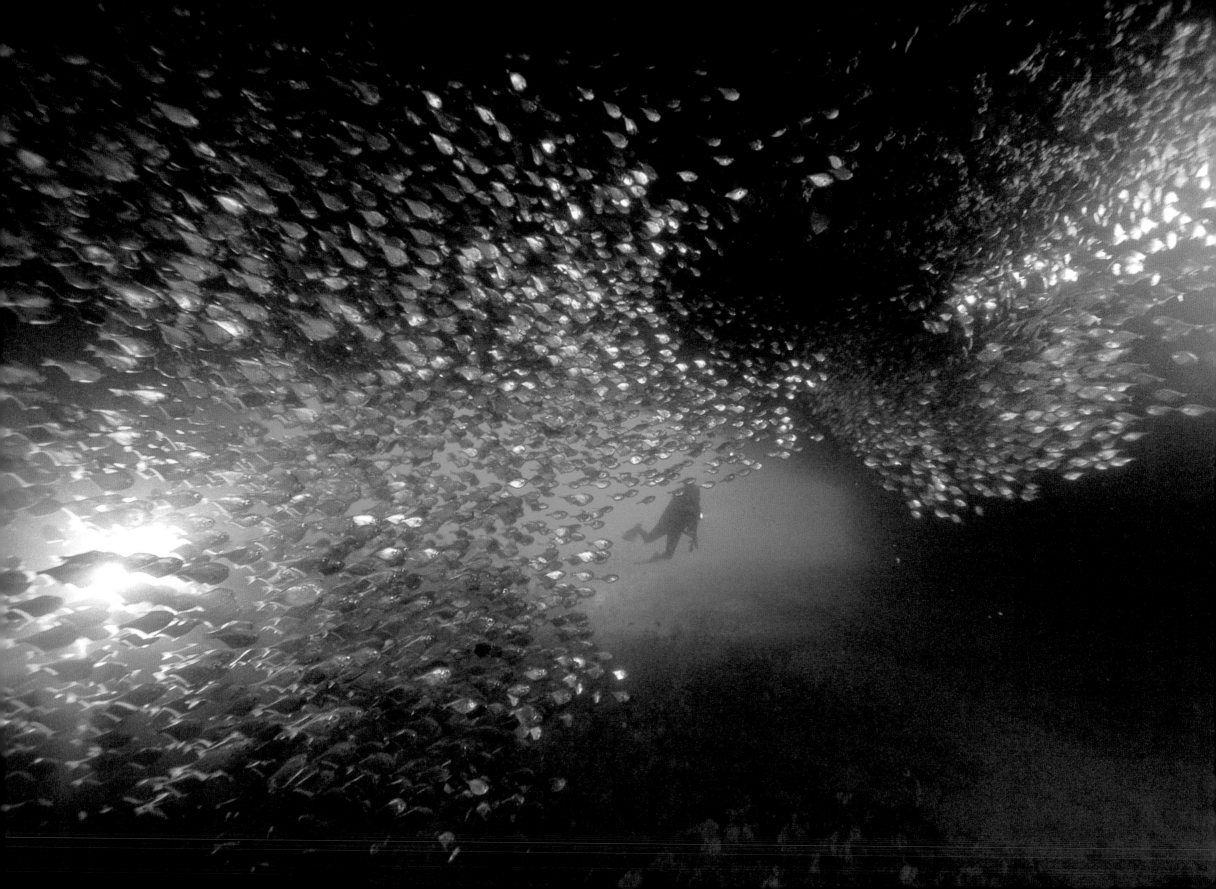

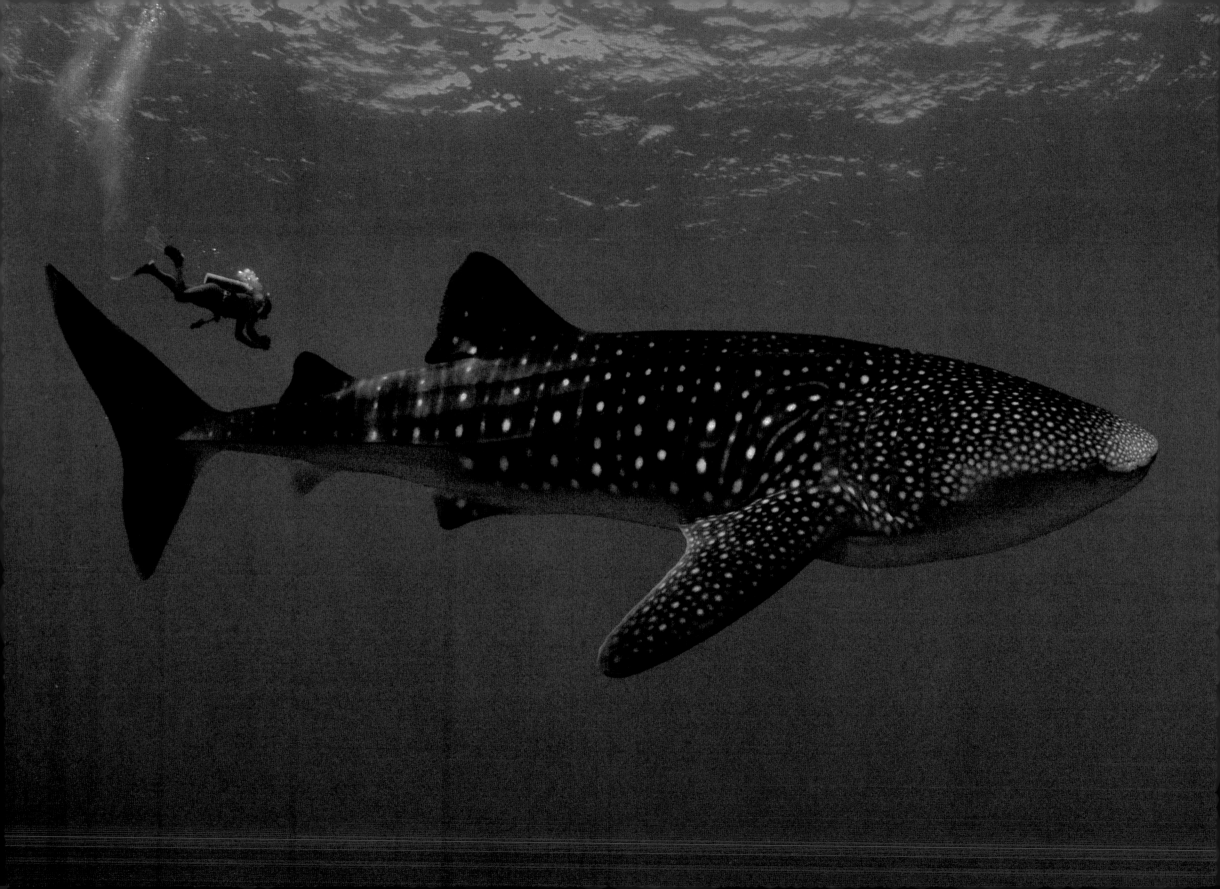

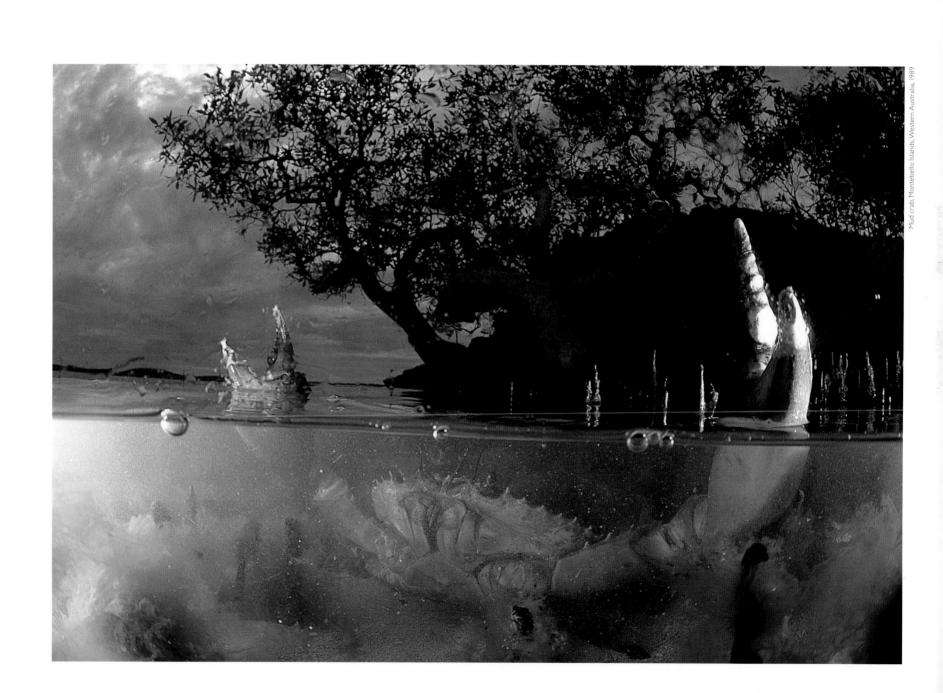

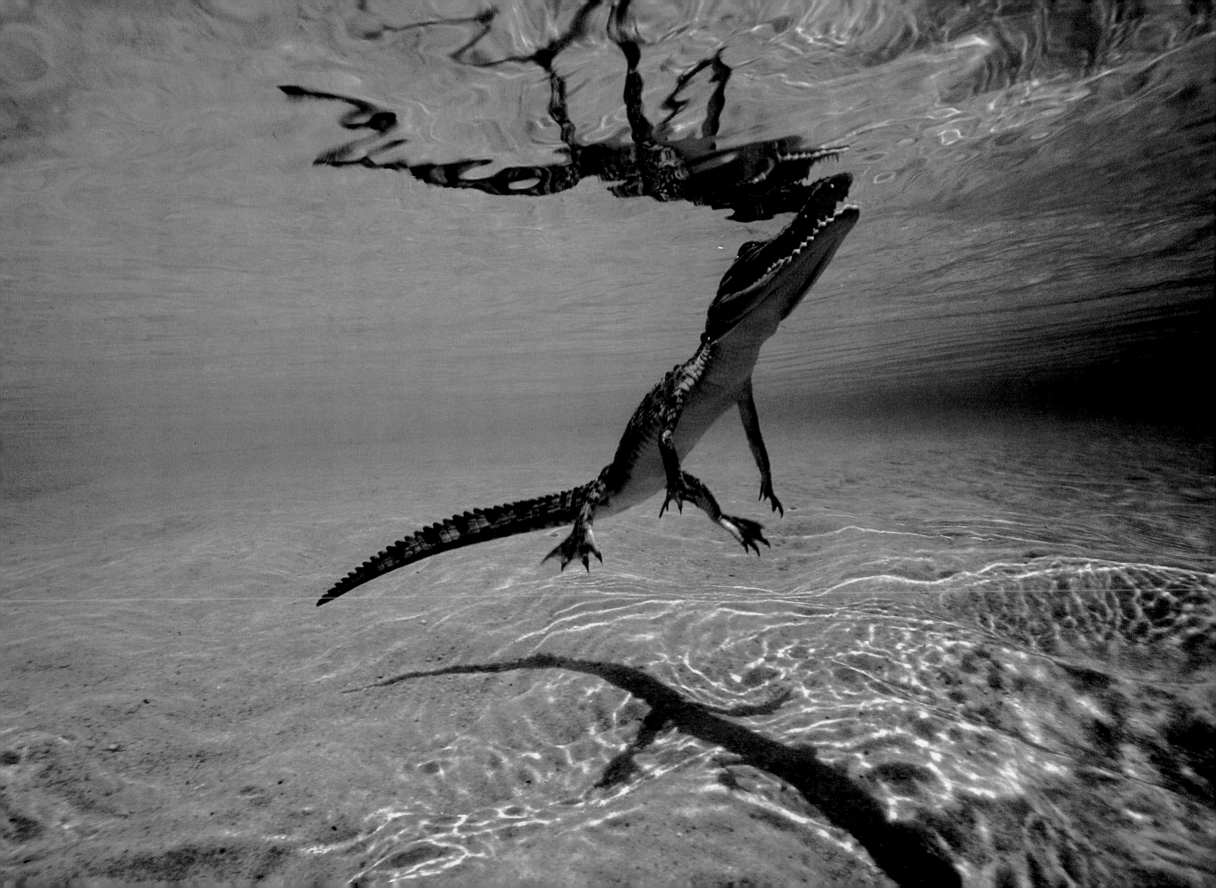

Island kingdoms

In the water two-and-a-half miles off the giant atoll of Rangiroa, in French Polynesia, we are exactly in front of the mouth of its main pass. The water is a very clear Polynesian blue. Noon sunlight shafts into a bottomless sea and far below I see a group of white shapes fluttering like doves. Actually, these are the tips of the dorsal and pectoral fins of silver-tip sharks. Suddenly three sharks, clean and elegant, are upon us, up from the depths in a heartbeat. With thick bodies and silver-tipped fins, they circle, attack, and bite at my friend Yves Lefevre's hands and the yellow electronic flashes. We are in their kingdom. Then, having investigated us, they are gone. Sharks and palm trees, the atoll breathes with the changing tides.

From space the Rock Islands of Palau look like green calligraphy written on the surface of a blue sea. These islands are the tops of ancient coral reefs and at times some of them actually surround pieces of ocean water creating marine or saltwater lakes. They harbour life that is found nowhere else; enormous schools, billowing clouds, of Mastigas jellyfish. These lakes are like miniature ancient oceans. The falling rotting vegetation from the forest causes the bottom of the lakes to stagnate, sealed off from the main ocean. Spooky Lake, far

in the interior of Eil Malk island, is layered with clear water floating over bacteria-laden 'plates' of water. It is like diving in fog. Palau is a coral-reef system surrounding a wonderful ocean jungle, with caves containing stalactites, hidden passageways and undercut islands that look like topiary.

Lord Howe, meanwhile, is an island that is a single dream. The remnants of an ancient volcano, it is surrounded by the world's most southern coral reefs, four hundred miles off the south-eastern coast of Australia. A temperate island in a tropical sea, its lagoon is full of fish — damoselles, chromis — and double-headed wrasse that move with the rhythm of the open ocean swell.

One hundred and fifty miles north of Lord Howe, Middleton Reef blooms in the empty sea like an orchid. Large black cod live here guarding Middleton's many shipwrecks. One adopted me, following me everywhere. It would become enraged when I photographed other fish. It would then try to eat them.

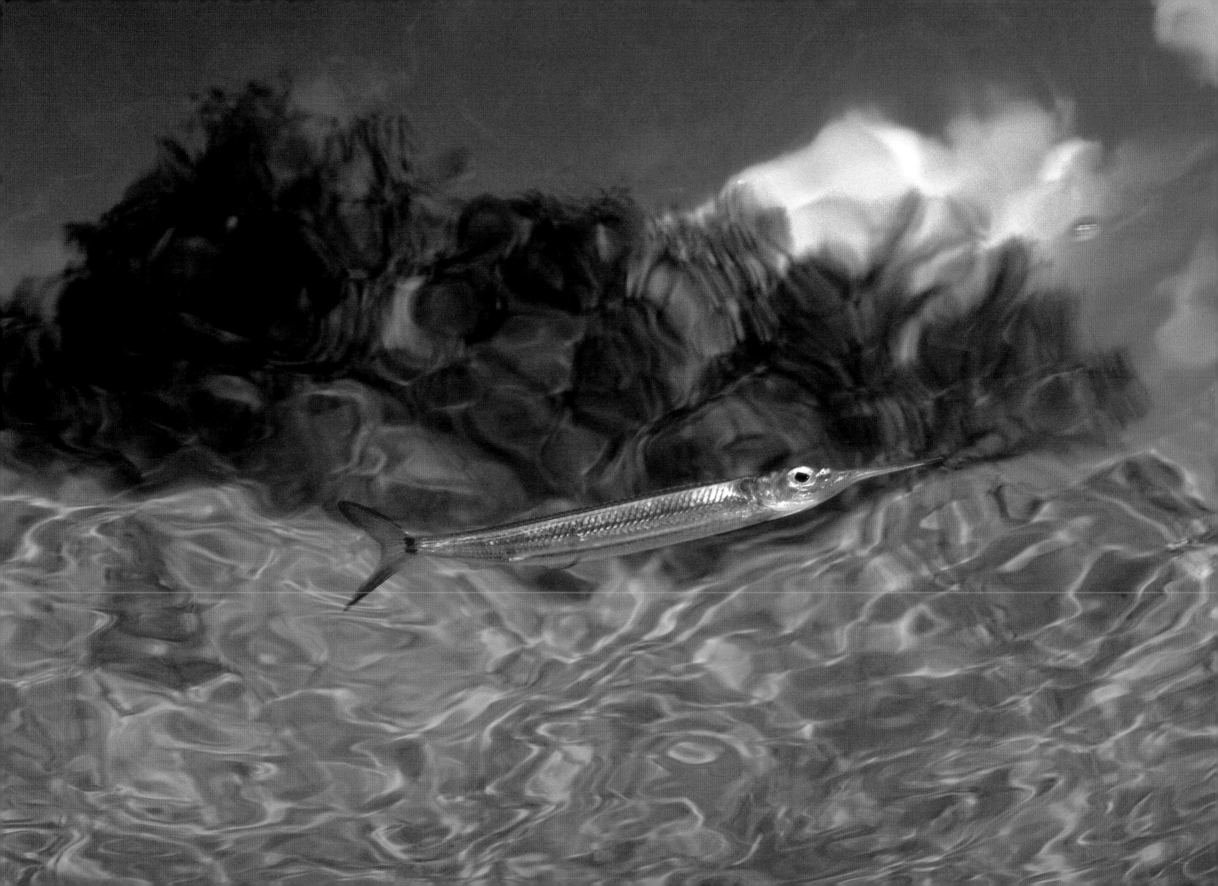

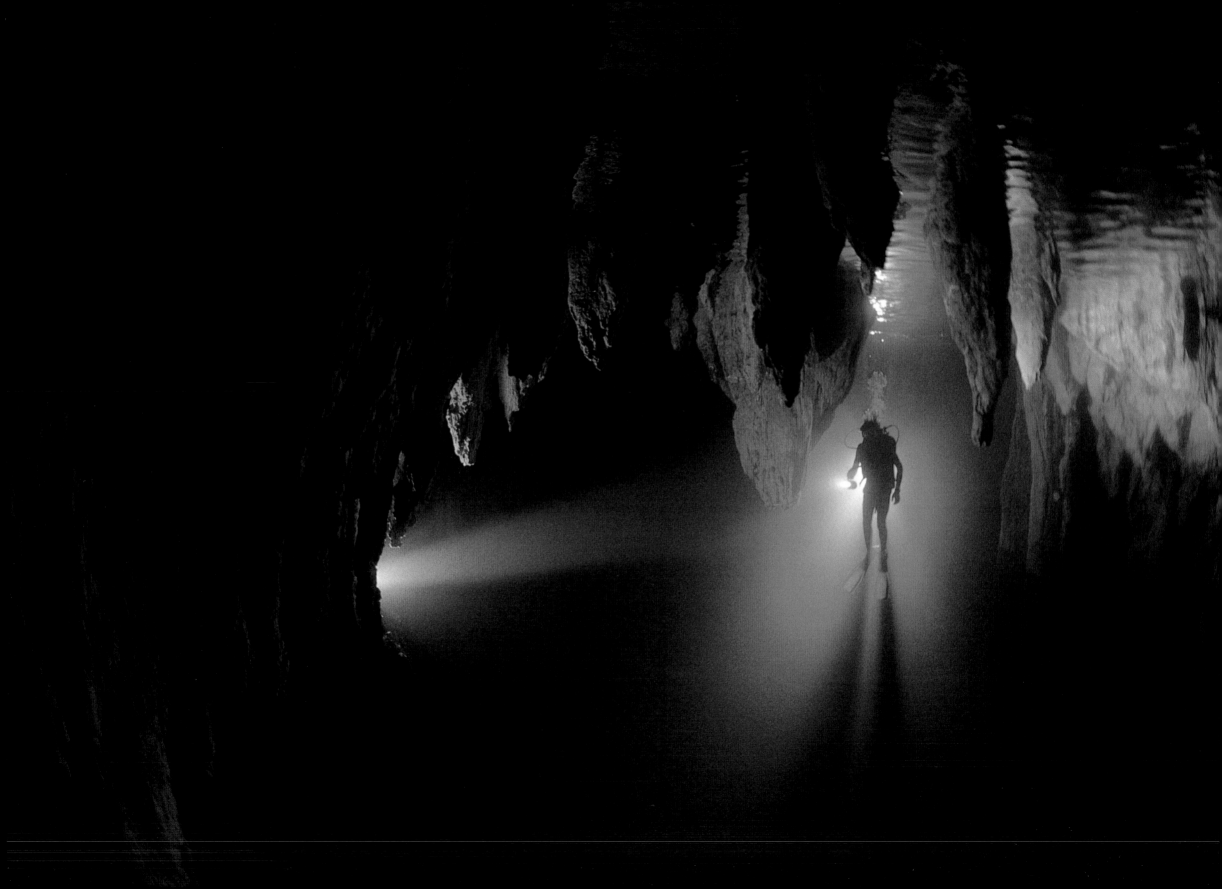

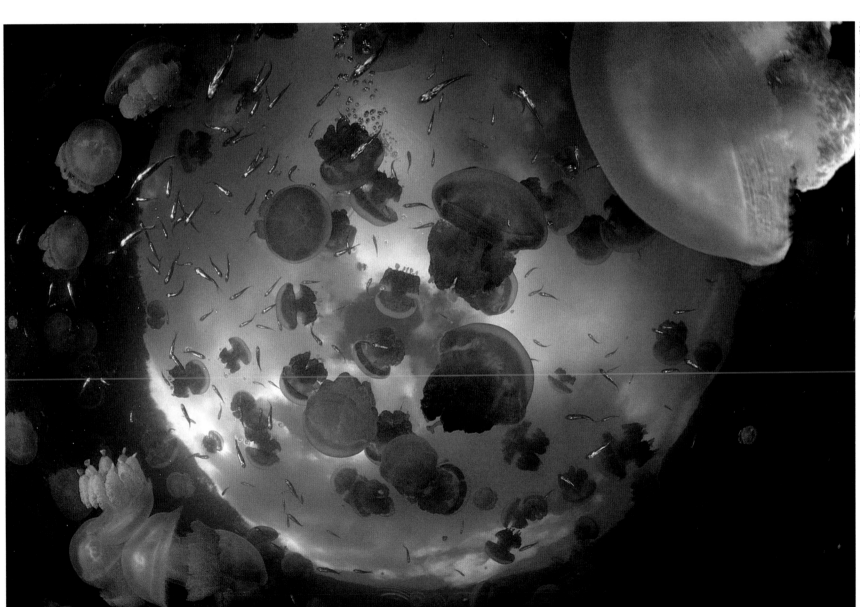

Spooky Lake, Eil Malk Island, Palau, 1981

Mastigas jellyfish school, Jellyfish Lake, Eil Malk Island, Palau, 1981

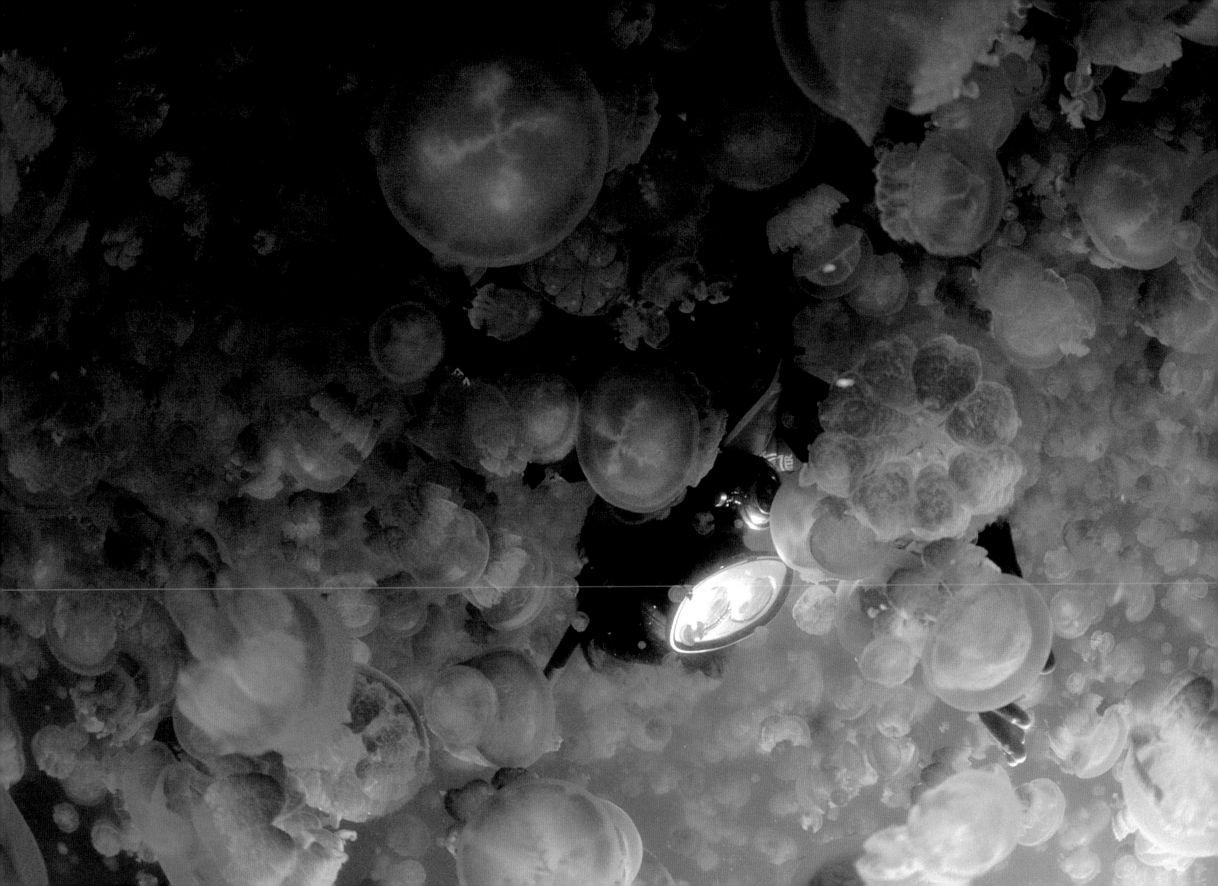

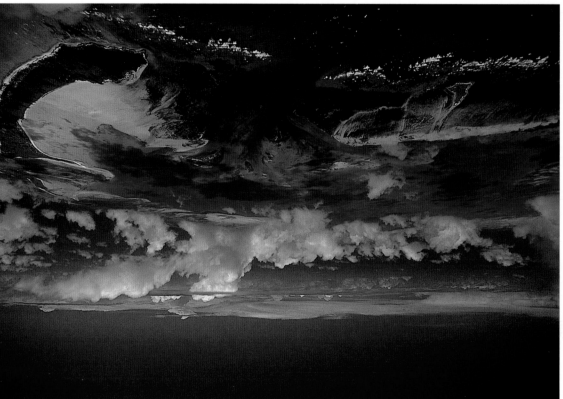

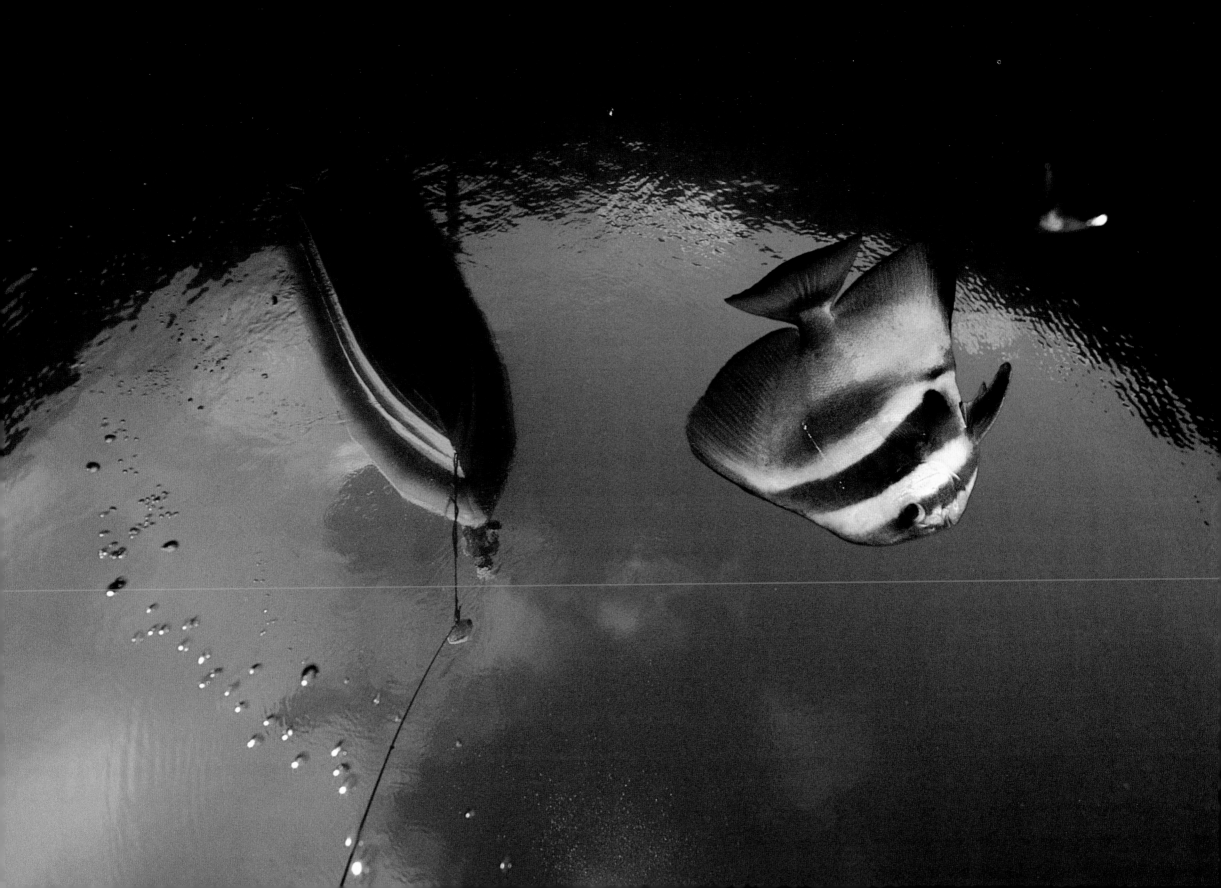

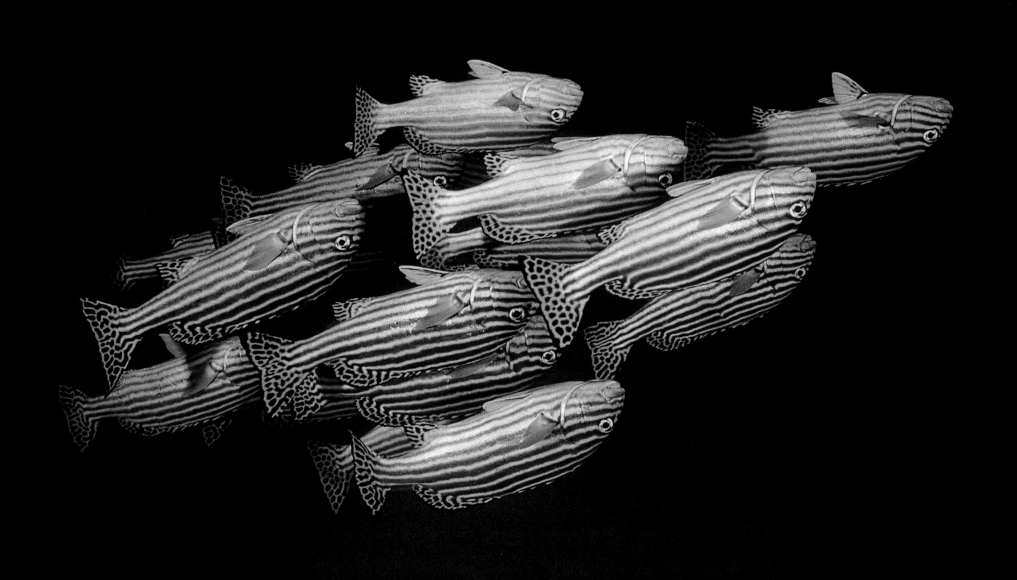

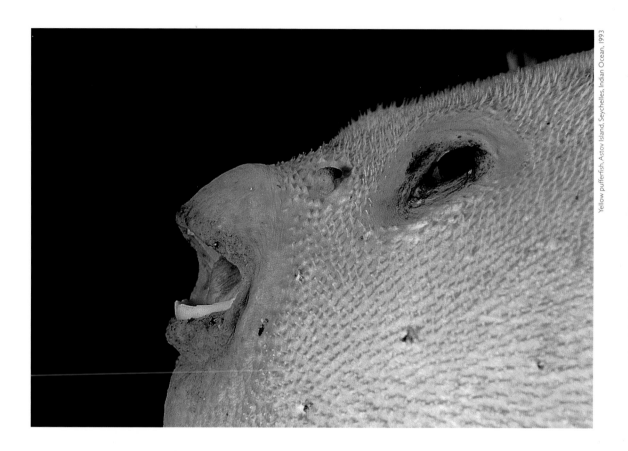

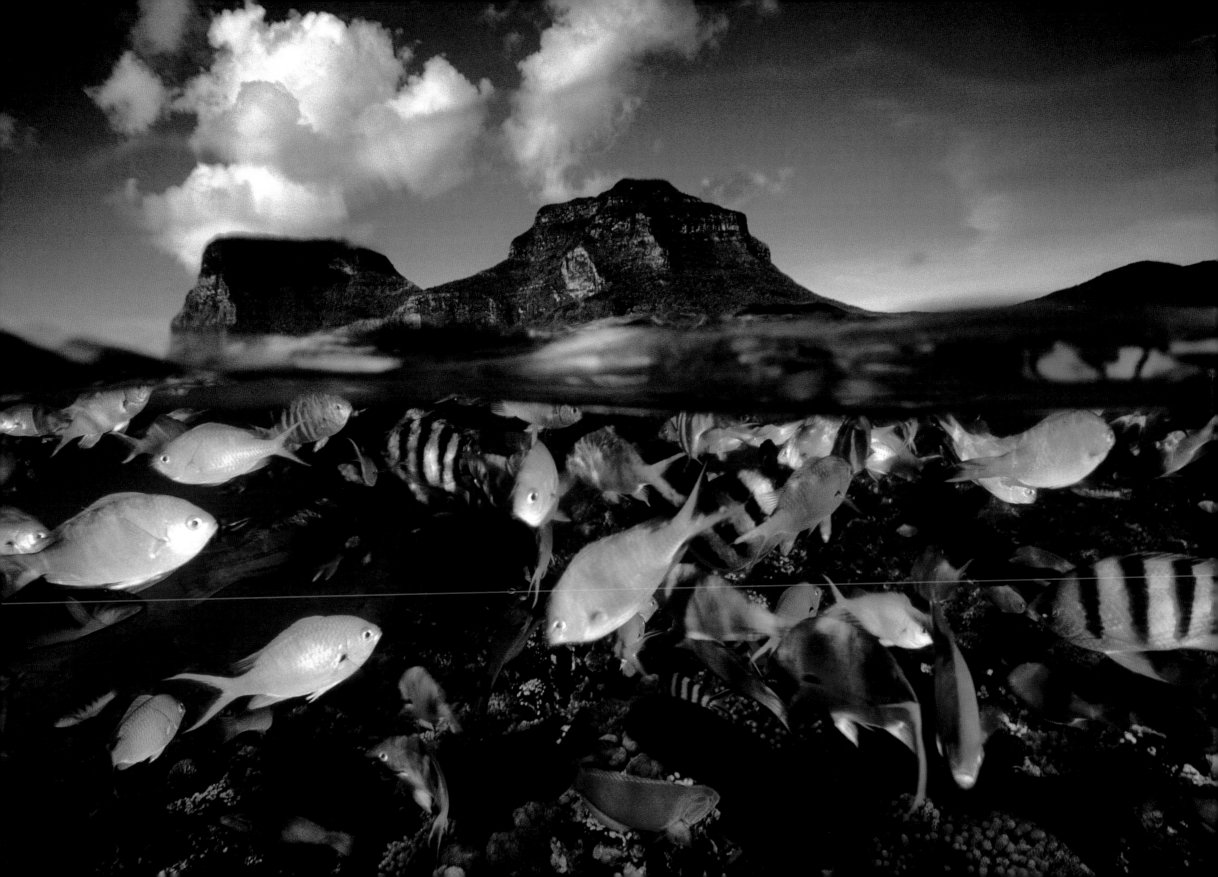

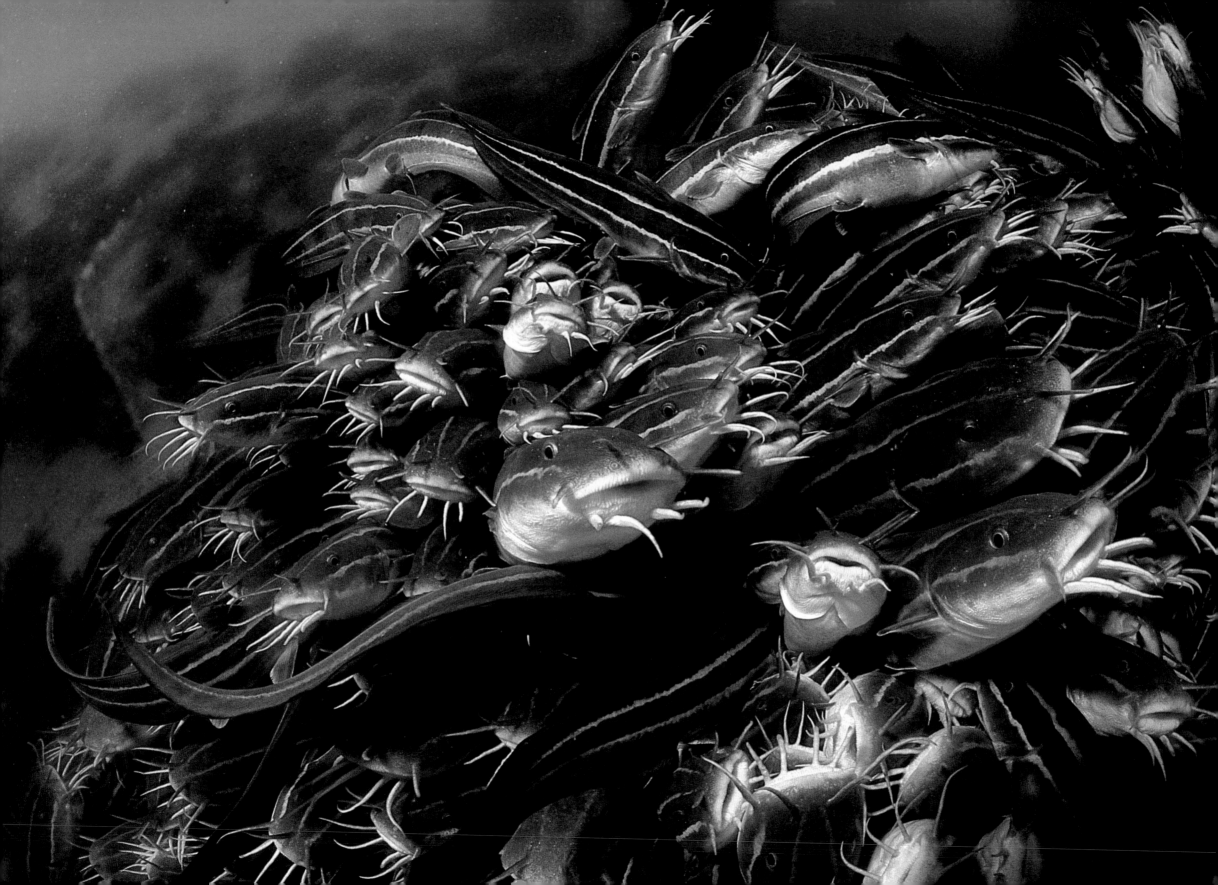

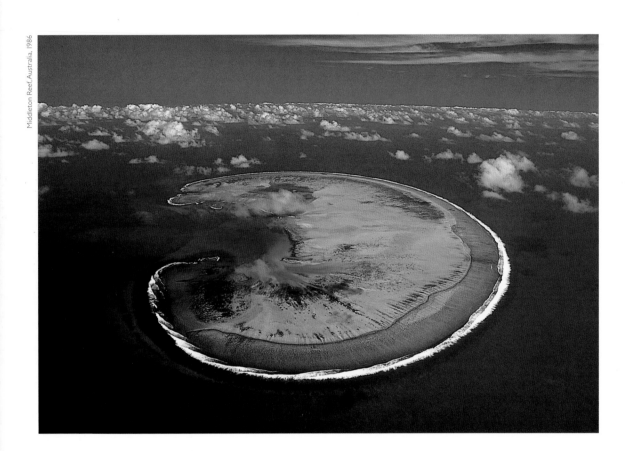

Black cod and wrecked Japanese fishing boat, Middleton Reef, Australia, 1987

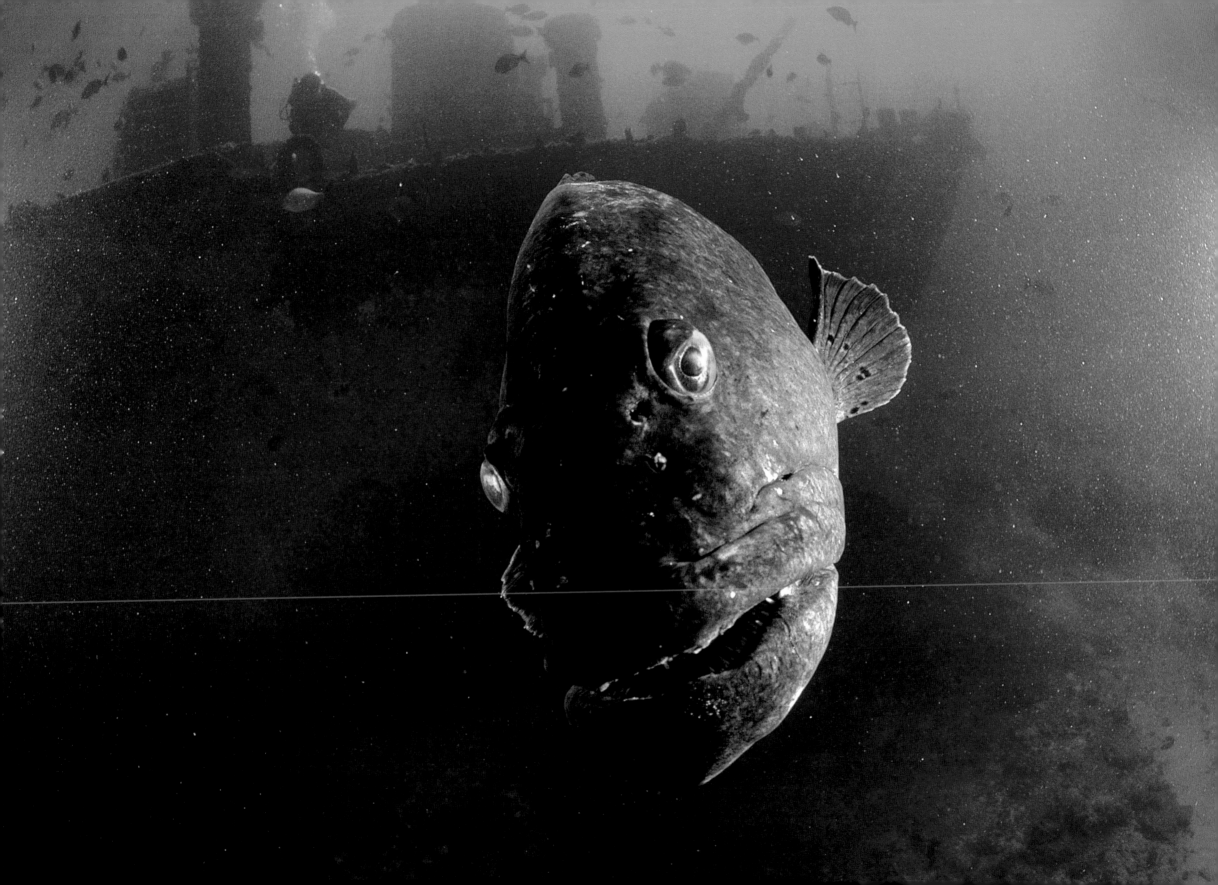

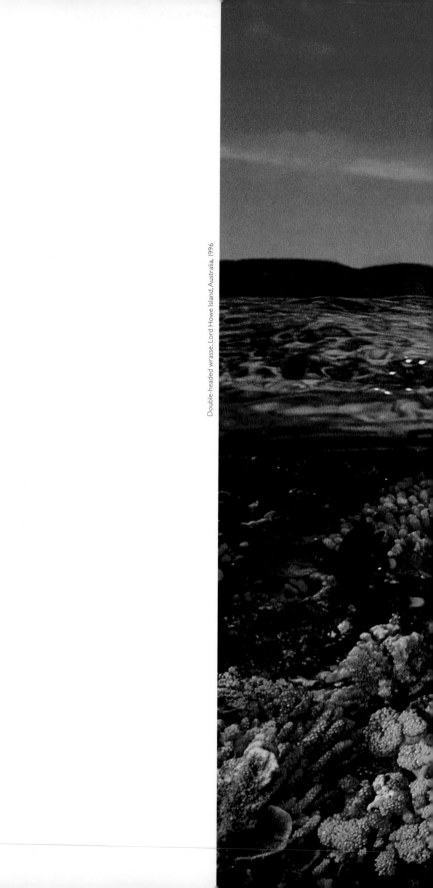

Double-headed wrasse, Lord Howe Island, Australia, 1996

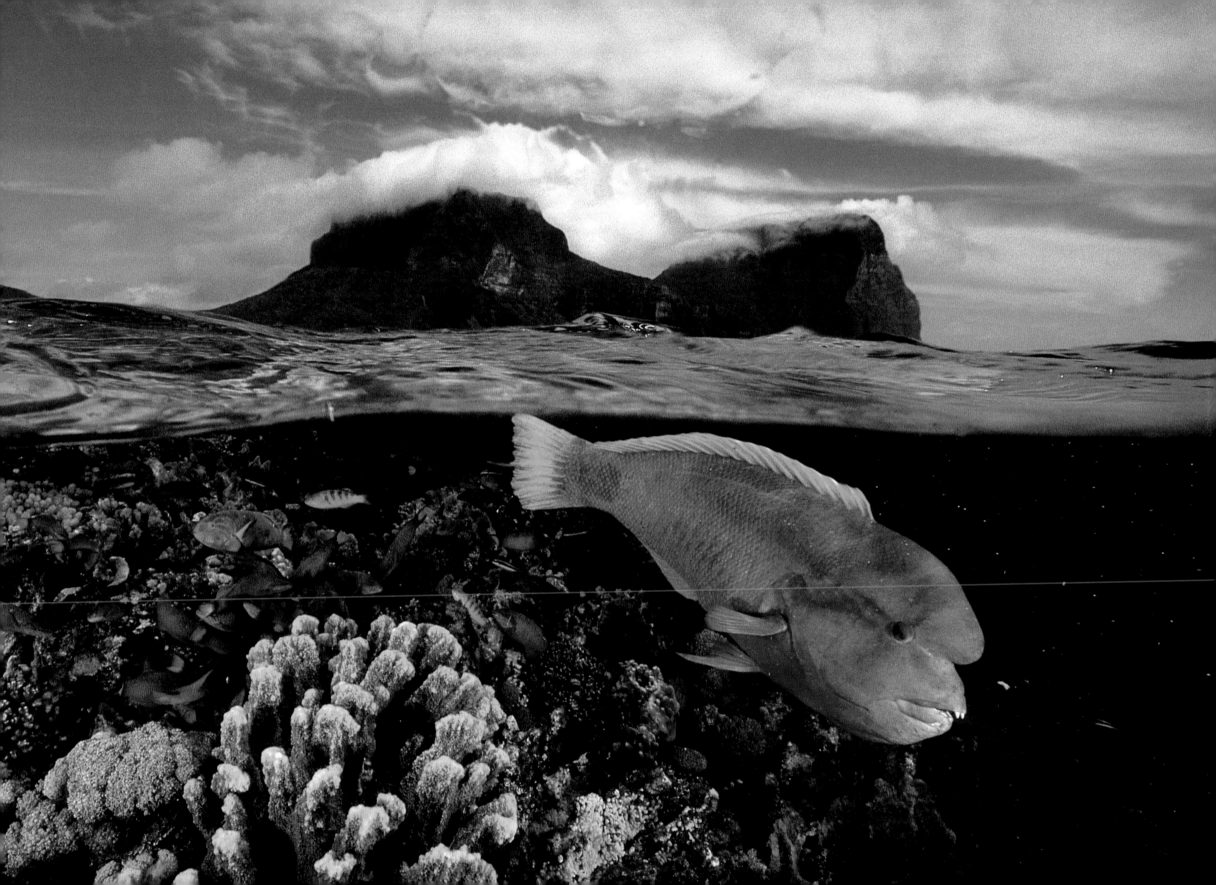

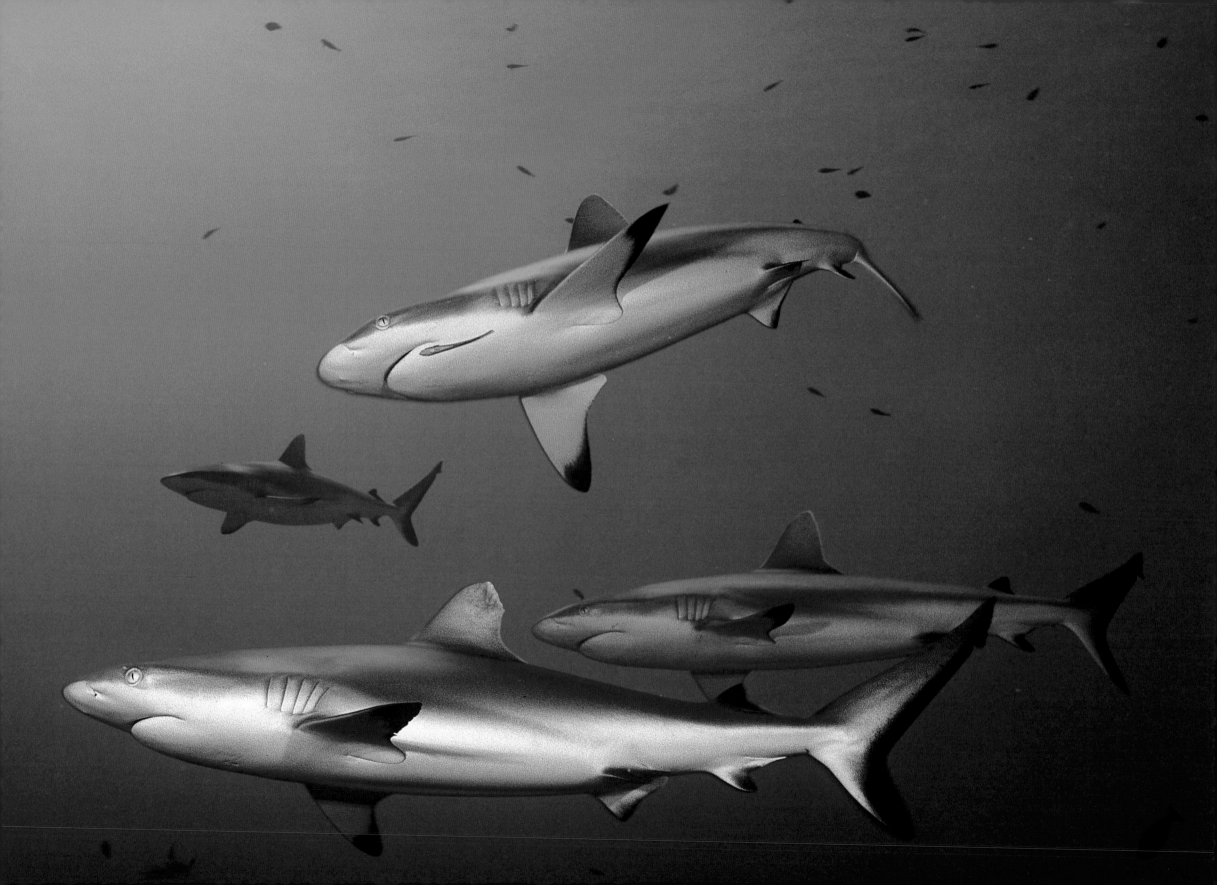

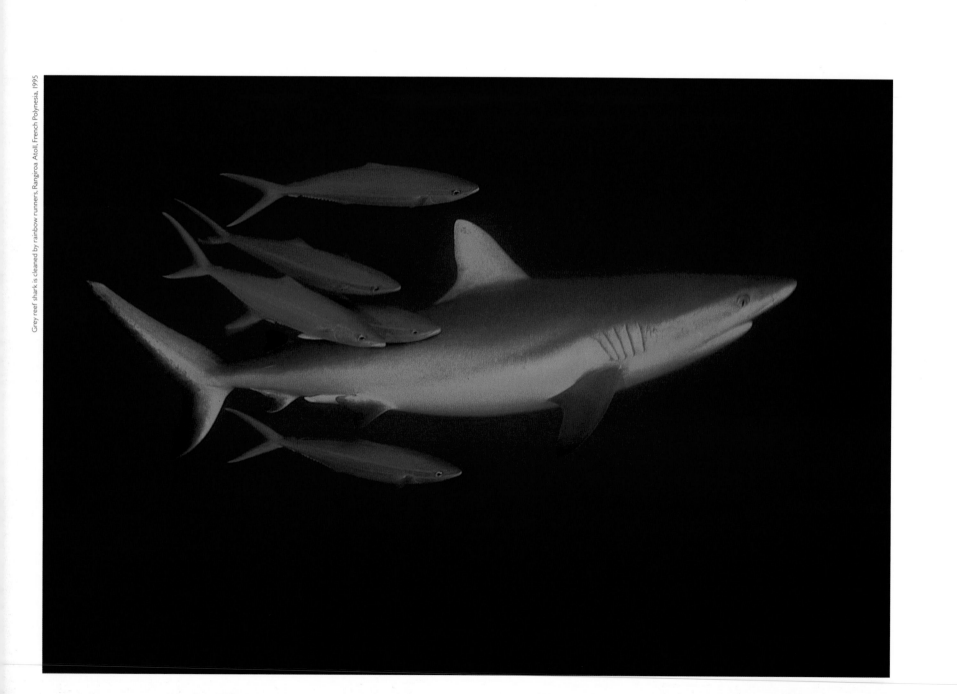

Grey reef shark is cleaned by rainbow runners, Rangiroa Atoll, French Polynesia, 1995

Silver-tip sharks, Rangiroa Atoll, French Polynesia, 1996

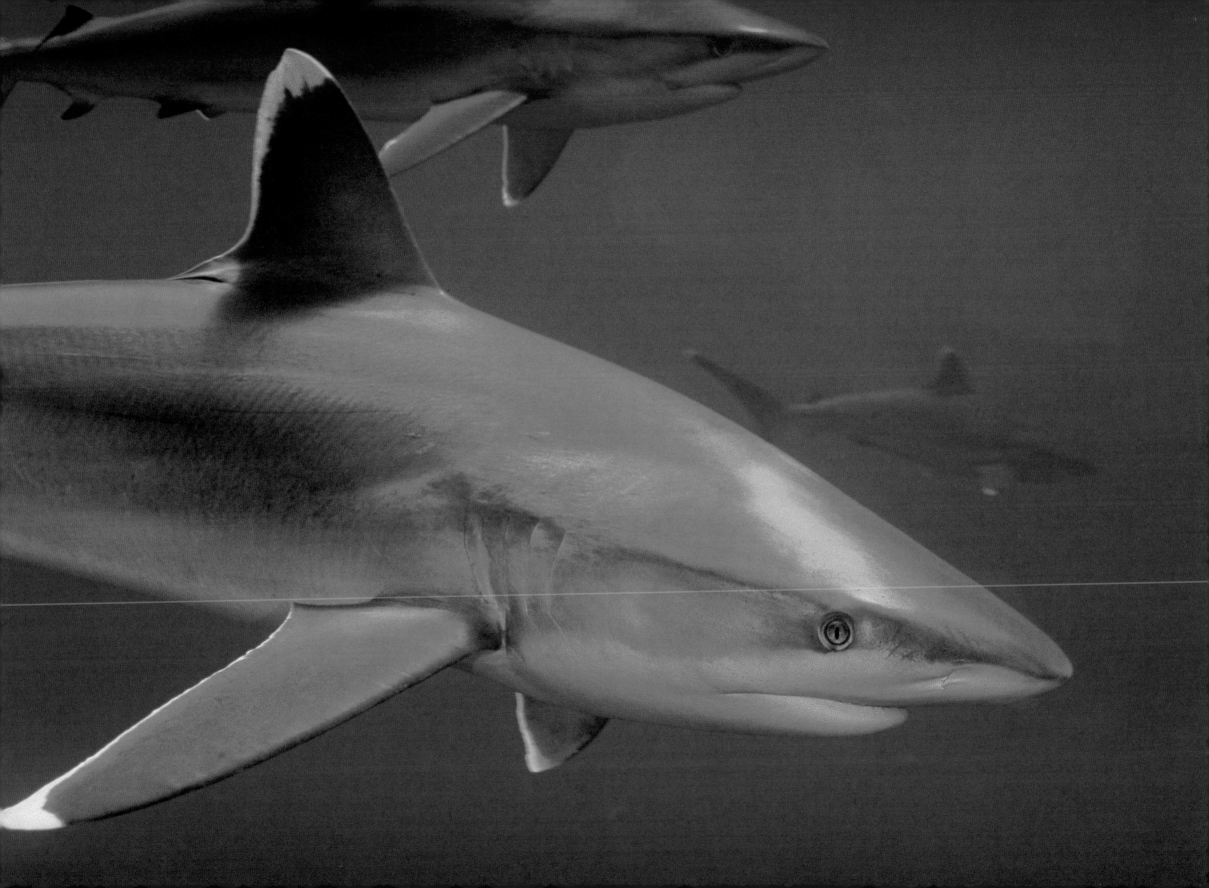

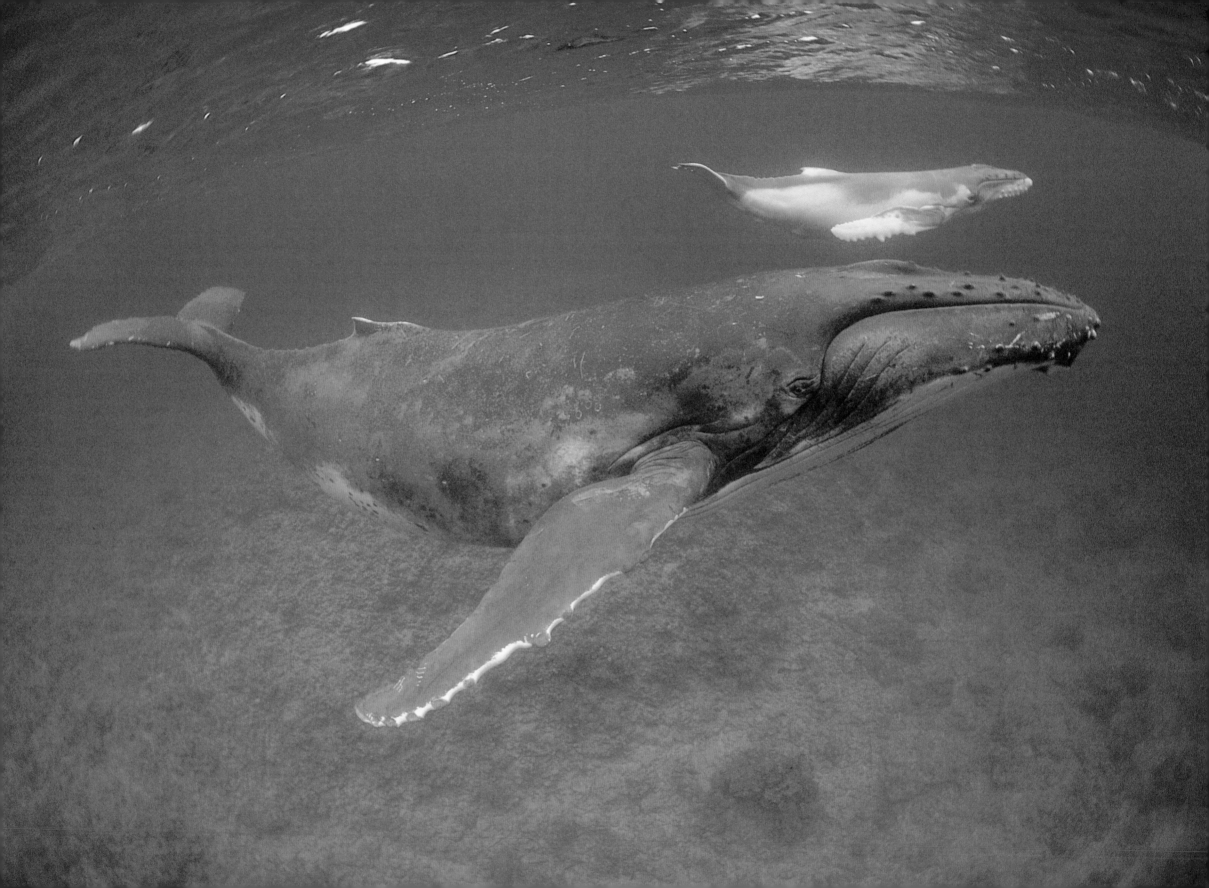

Humpback whale and newborn calf, Austral Islands, French Polynesia, 1998

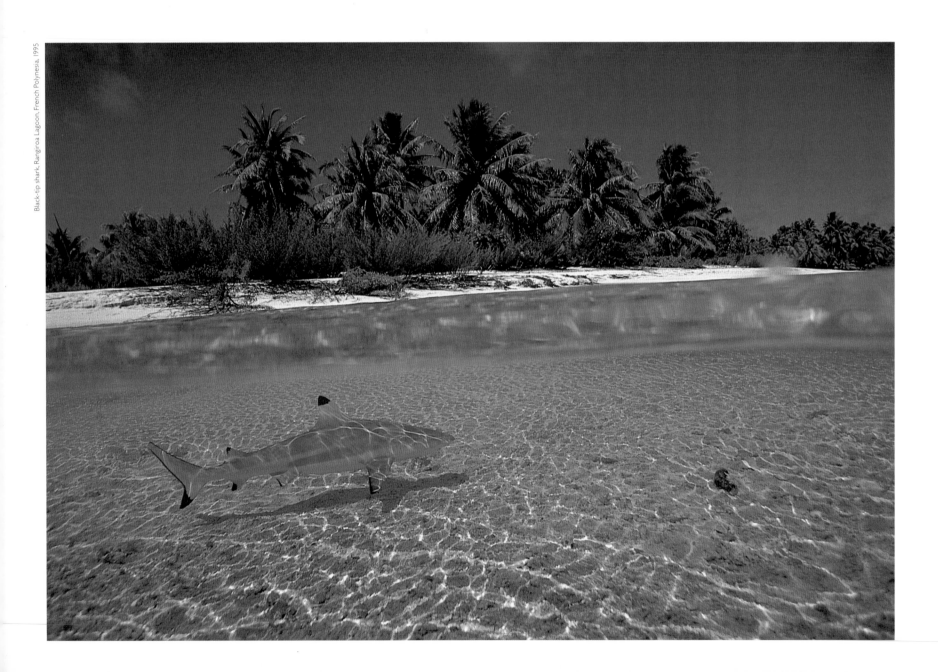

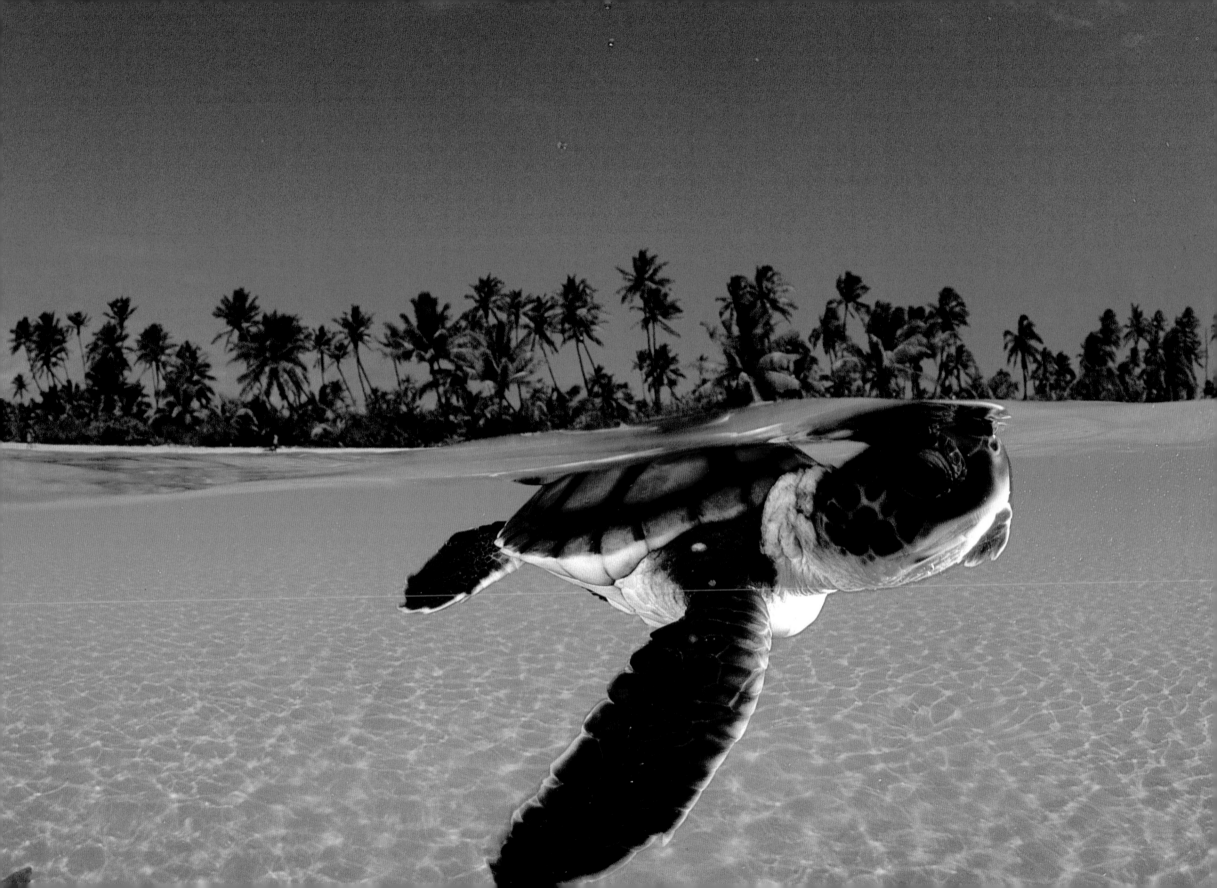

South of Tokyo, the Izu Peninsula sticks out into the Kuroshiro Current (the Gulf Stream of the Pacific) and hooks a little bit of this massive warm-water river in the sea. Izu is dominated at its north-western end by the perfect-looking volcano, Mt Fuji. Very deep water surrounds this thumb-like peninsula. On the ocean side the submarine landscape is made of huge boulders and dark volcanic cliffs that fall steeply away into the deep. One hundred yards from shore, the water is a thousand feet deep.

Pine trees arch over the cliffs of Izu. Pacific Ocean swells boil the shallow water. Deeper, sea fans and soft coral trees cover the dark boulders. The sea looks Japanese, the corals look as if they are arranged. The sea life imitates Kabuki masks – or the reverse is true.

On the western side, the Izu Peninsula forms a protective arm of the vast deep Suruga Bay that lies at the foot of Mt Fuji. This is the deepest water close to land in the world. At one hundred and eighty feet I find a forest of wire coral – a species of black coral that springs from the sea bed like mad electrical wiring. Schools of silver cardinal fish drift through this tangle. They form curtains, backdrops for a beautiful red and white male anthias called a 'cherry blossom'.

It is a soft green world on the deep flanks of Suruga Bay, an alcove of the ocean. I can never escape from its dramatic Kabuki imagery: that of a clear simple stage where actors (fish) parade in resplendent robes: tora-moray eels, cherry blossom anthias, ghost pipefish, dragonettes. All these creatures play in the deep-sea drama of Japan.

Japanese theatre

Silver cardinal fish and cherry blossom anthias, Suruga Bay, Japan, 1989

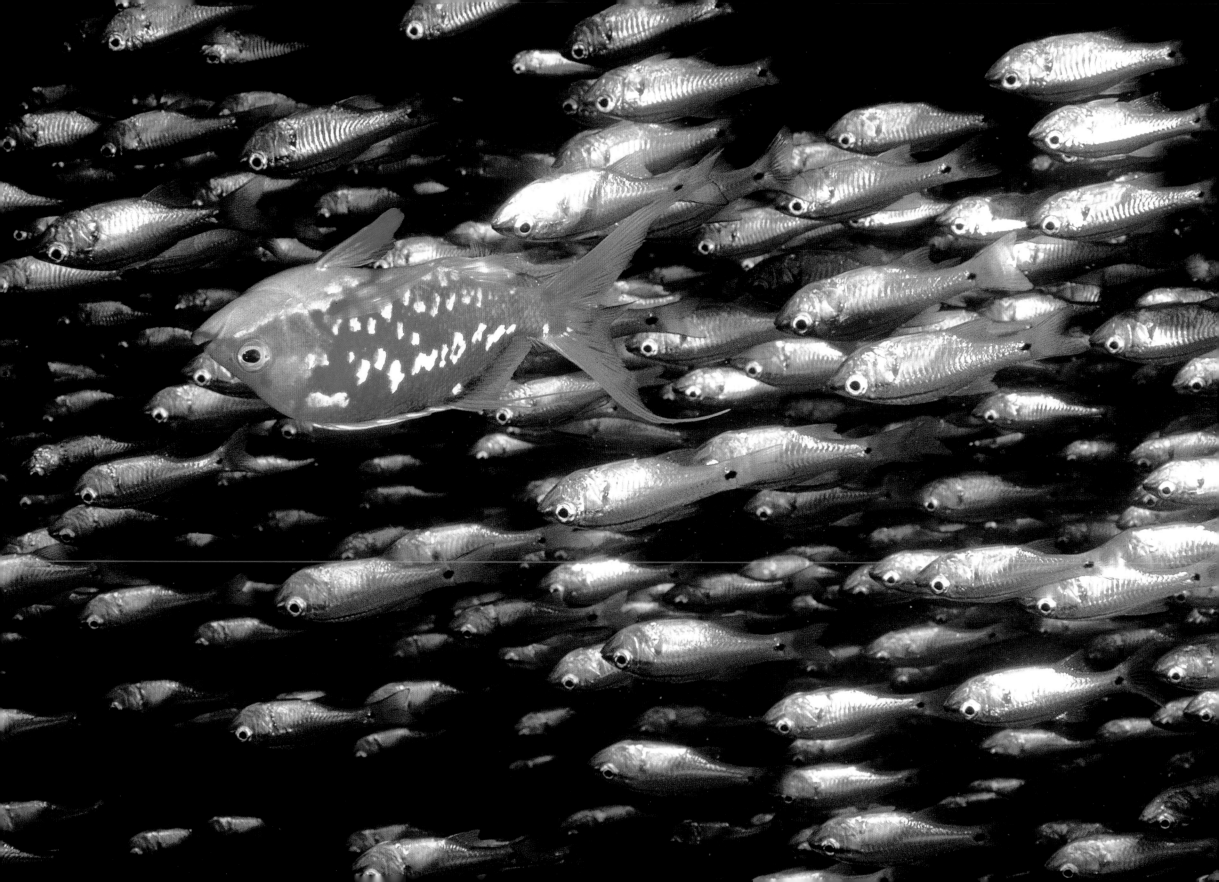

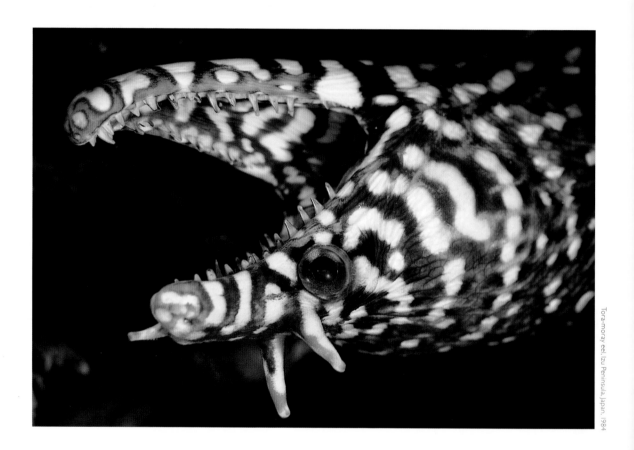

Japanese moray eel in orange coral, Izu Peninsula, Japan, 1984

Tora-moray eel, Izu Peninsula, Japan, 1984

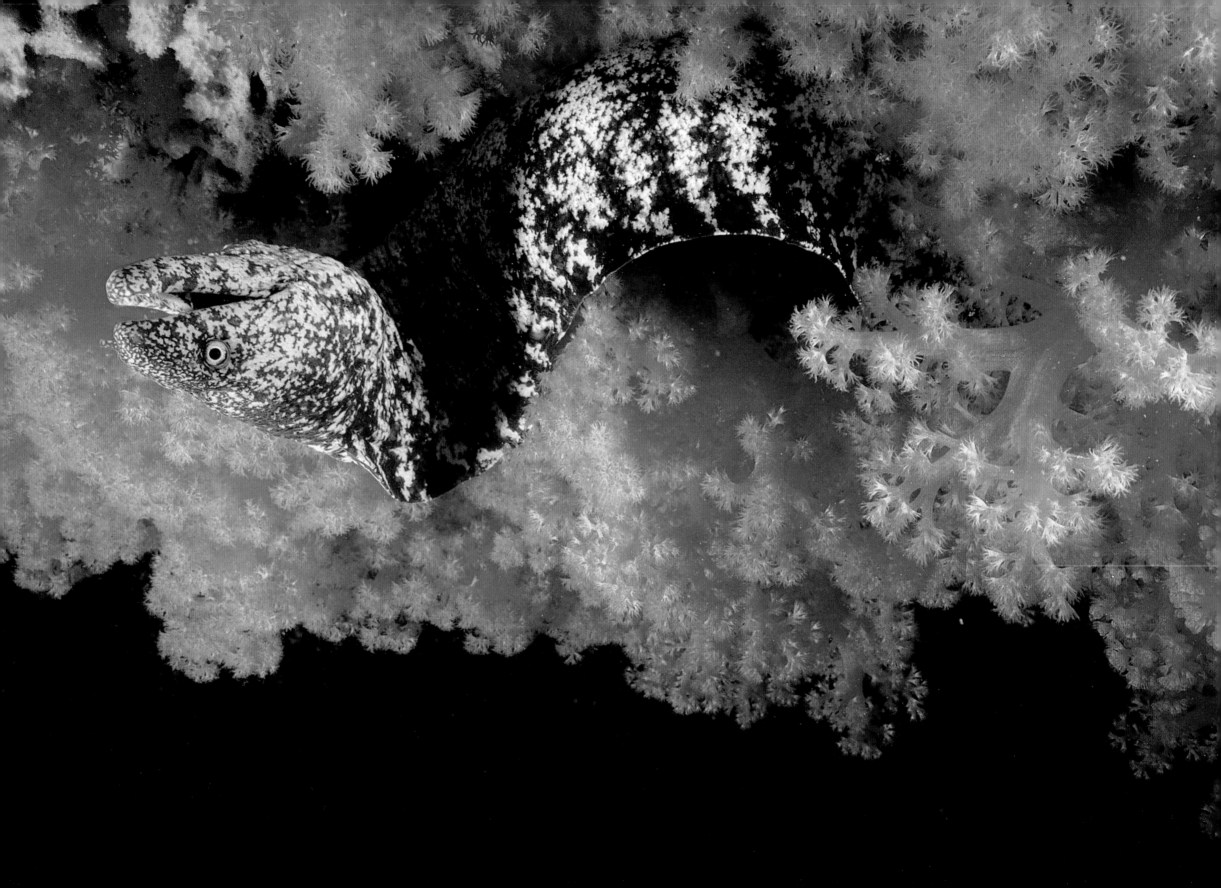

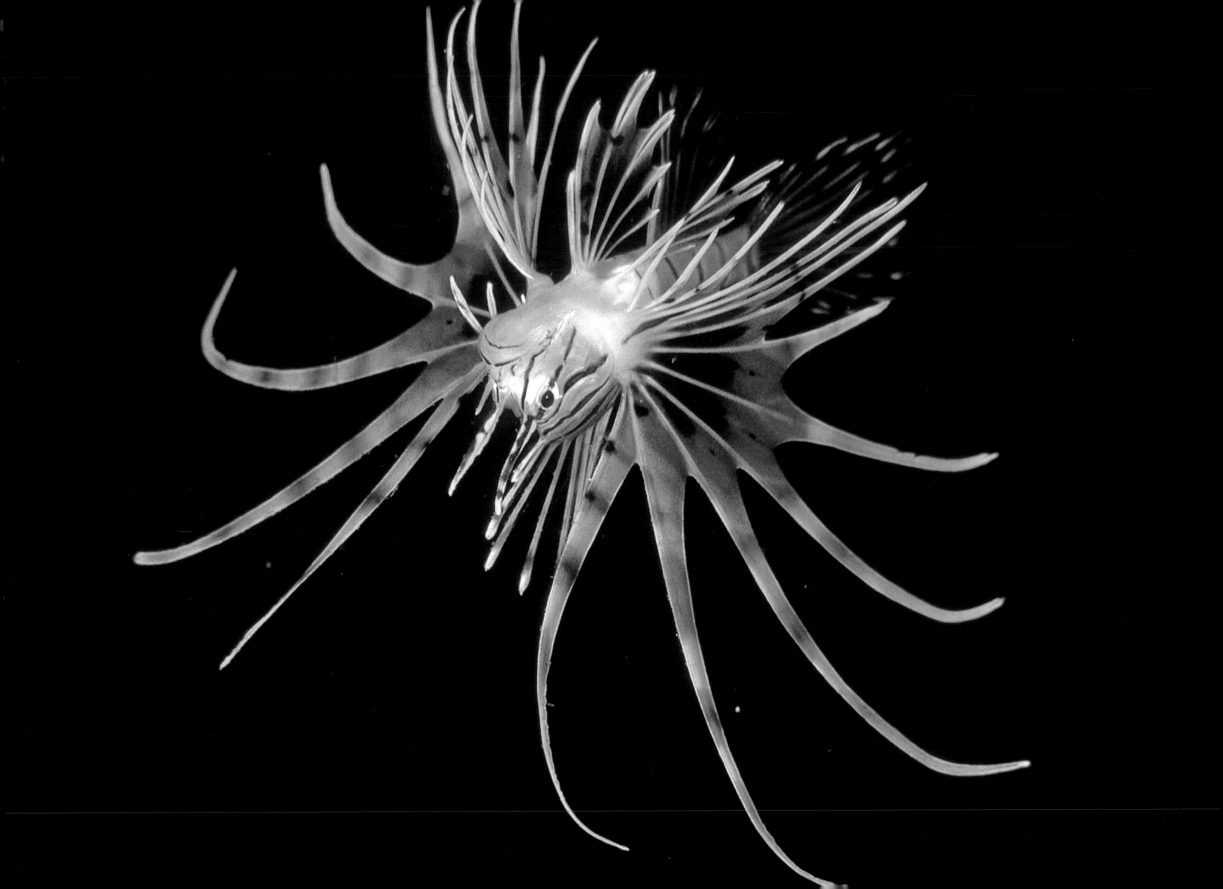

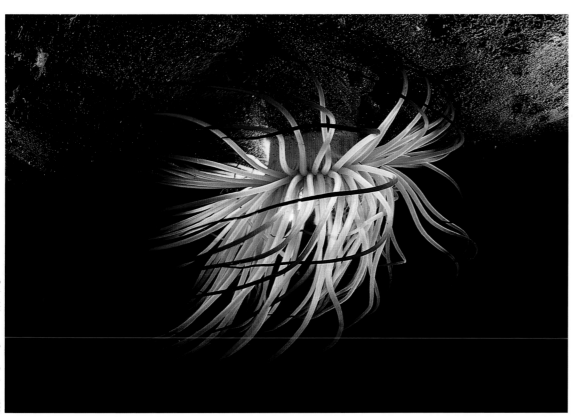

Cerianthid anemone, Suruga Bay, Japan, 1989

Waves, shadow, light and mullet, Izu Peninsula, Japan, 1984

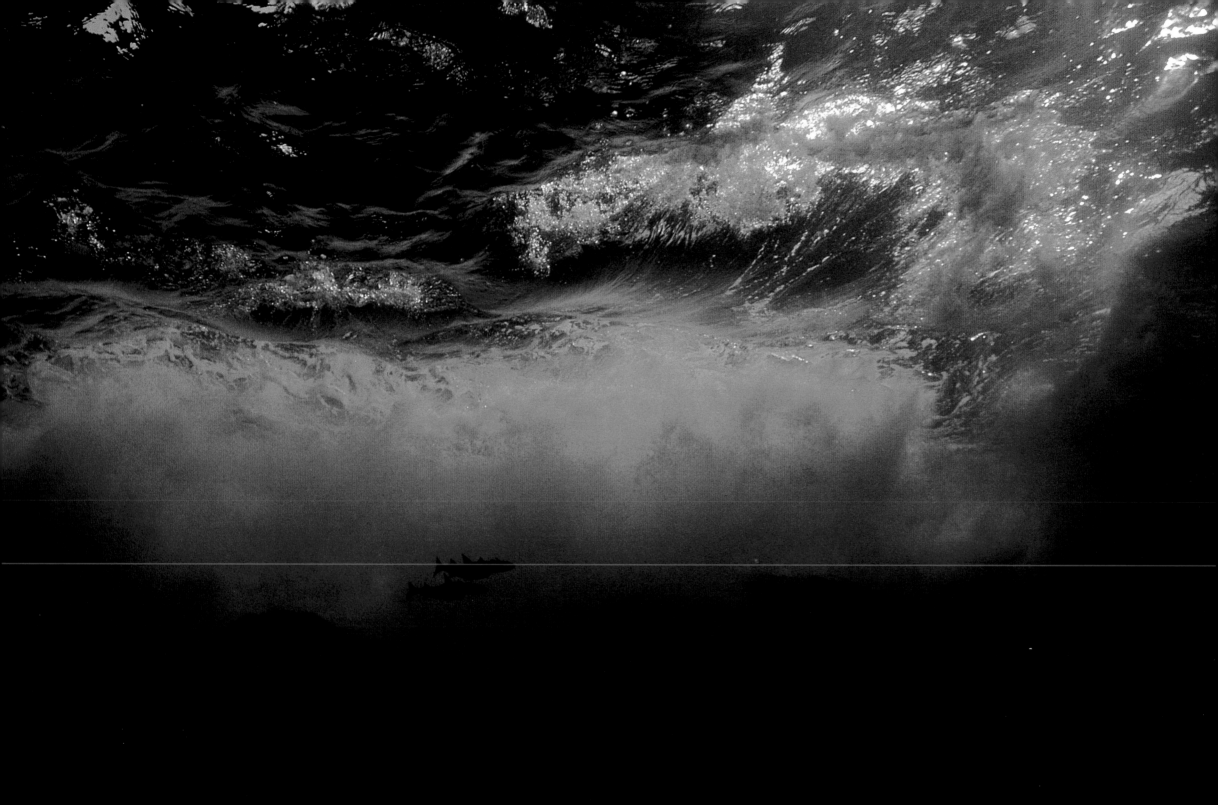

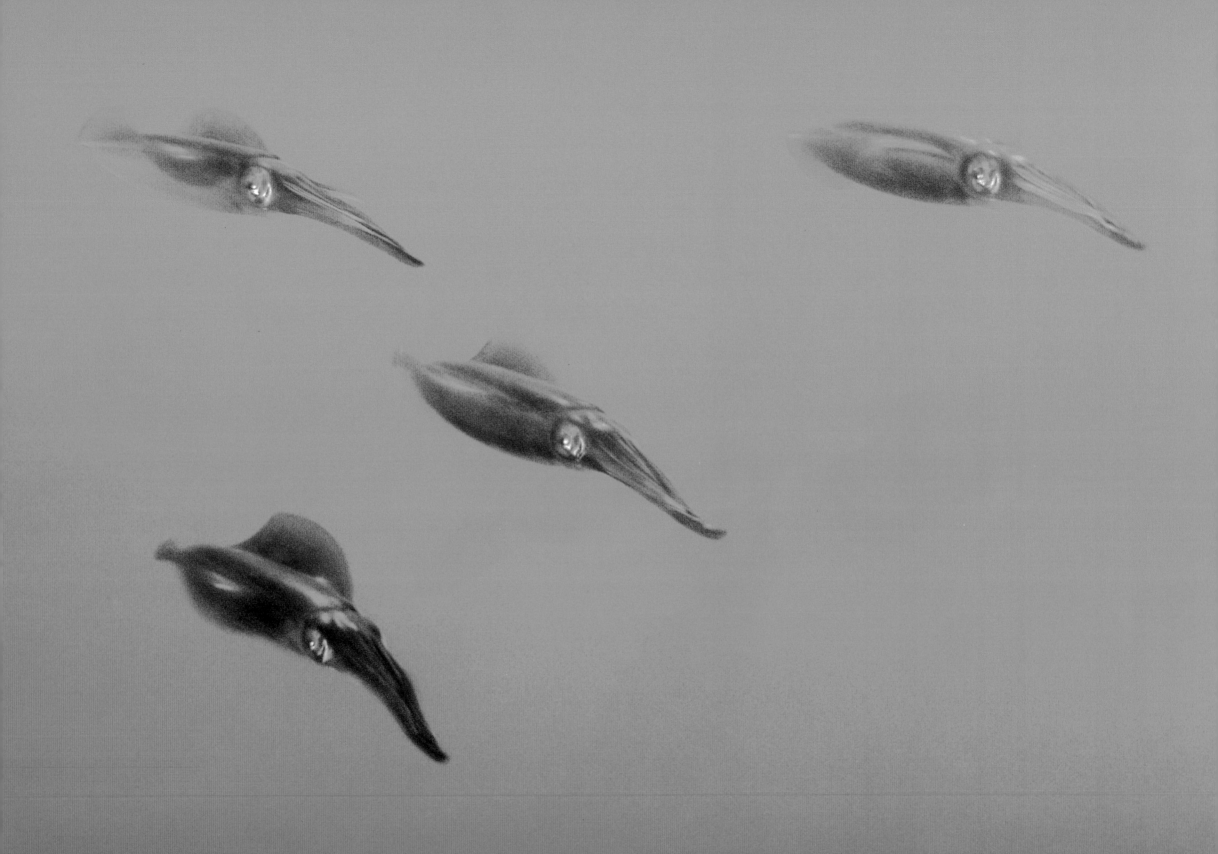

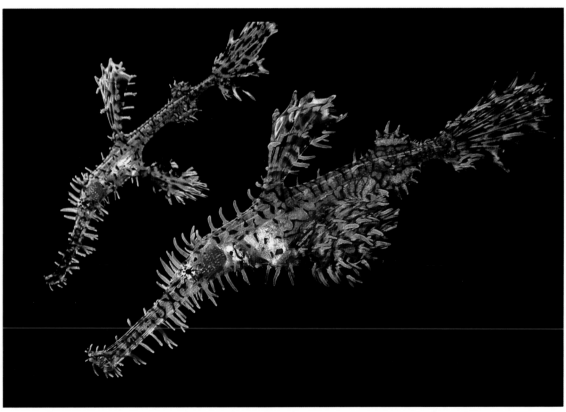

Ghost pipefish (male with larger female), Suruga Bay, Japan, 1989

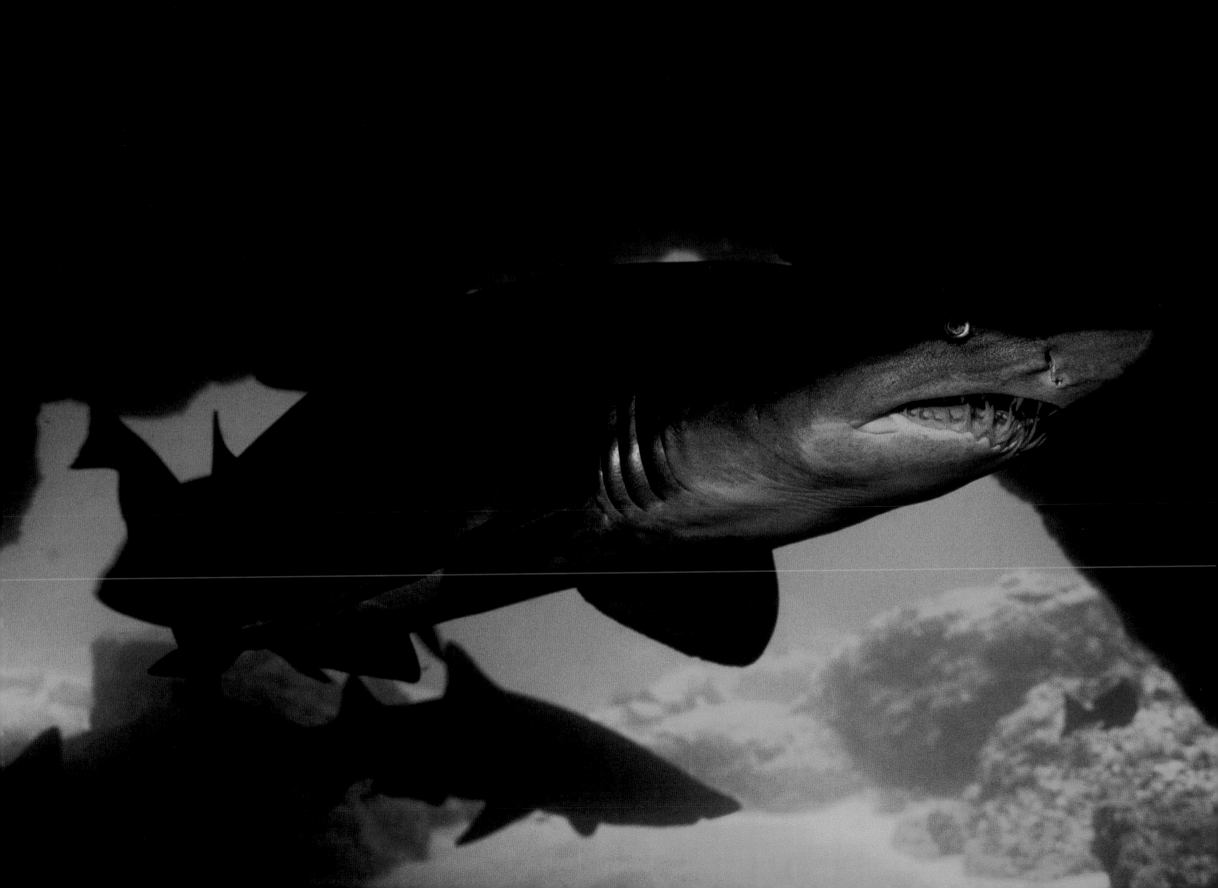

Coral eden

There is a centre, a heart, to the warm coral seas of the world. It lies somewhere within the complicated geography of the central western Pacific Ocean. Between the eastern tip of Papua New Guinea, across the enormous island nation of Indonesia, to the bastions of Malaysia – this is where the coral is the richest.

These equatorial seas are a labyrinth of volcanos and deep basins that survived the Ice Ages. This resulted in an astounding increase of species diversification. As an example: there are 67 coral species in the Caribbean but 450 in Indonesia. The difference between the Caribbean and this coral eden is the difference between an English garden and an African jungle.

It is a visual feast where the most outrageous form follows the most outrageous function. I watched as a Rhinopias scorpionfish opened its mouth to inhale prey, a school of giant 200-pound bumphead parrotfish grazed on coral like buffalos and a clownfish flew over a field of lavender sea-anemone tentacles. I spent my life swimming around this eden as if I were avoiding a dream. In reality, these underwater countries were beyond dreams.

I dived along the black sand slopes of north-eastern Bali where blue-ribbon eels come out of the dark bottom and mantis shrimp with the most complex eyes in the world build their burrows. In Banggai Island off Sulawesi I found extraordinary silver, gold and black cardinal fish living in the spines of sea urchins. These fish are found nowhere else in the world.

There is a dark side to these seas of dreams. The huge expanding human populations confront a delicate sea. A reef can support a village of one hundred but the same village is now one thousand and the economy has shifted from subsistence to cash. There is massive overfishing, blast fishing and cyanide fishing. These reefs are new visions for humans, they are the richest visual environments in the world. We humans have been in the sea, truly in the sea, for only 50 years. In the heart of the ocean, we are in a race between discovery and destruction.

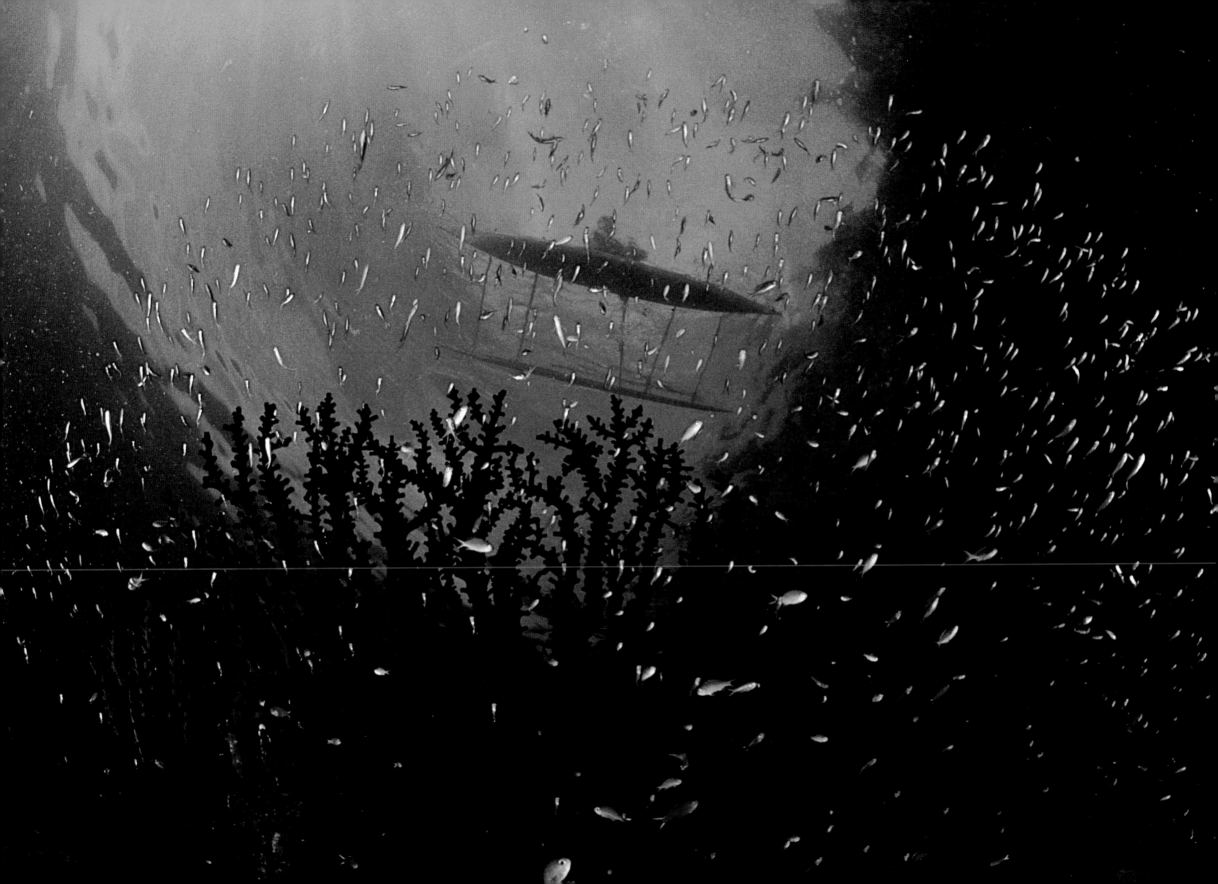

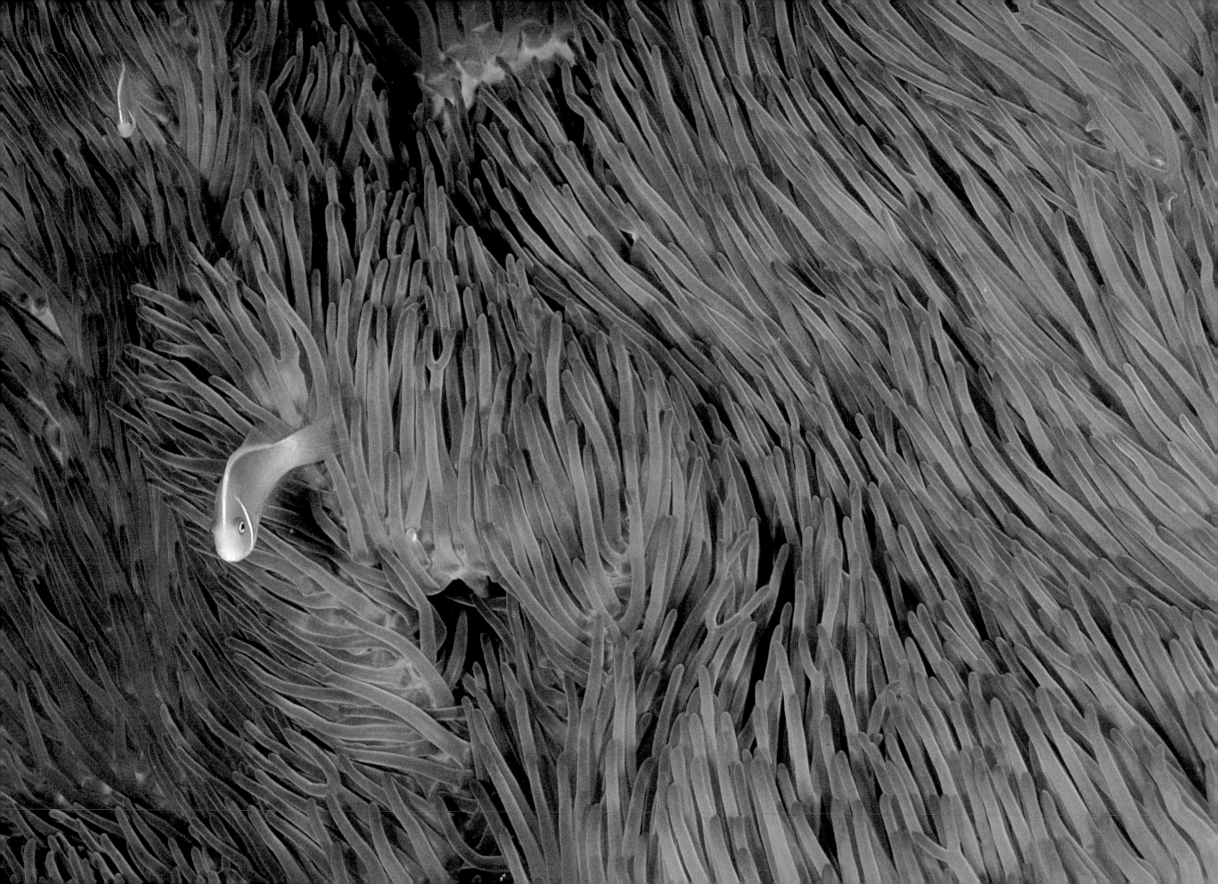

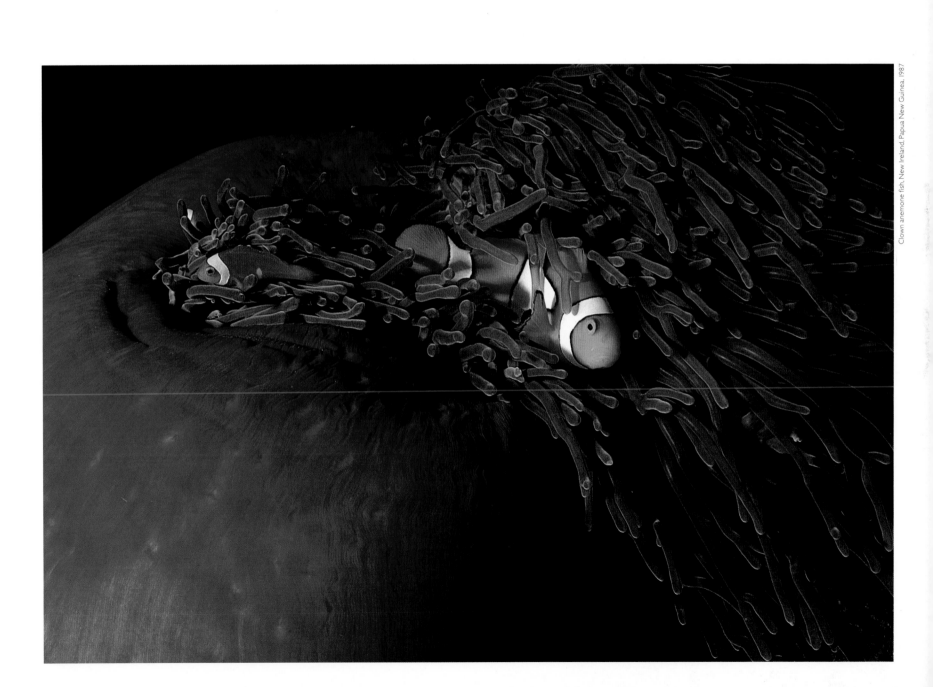

Purple-tipped anemone and orange anemone fish, Bali, Indonesia, 1996

Clown anemone fish, New Ireland, Papua New Guinea, 1987

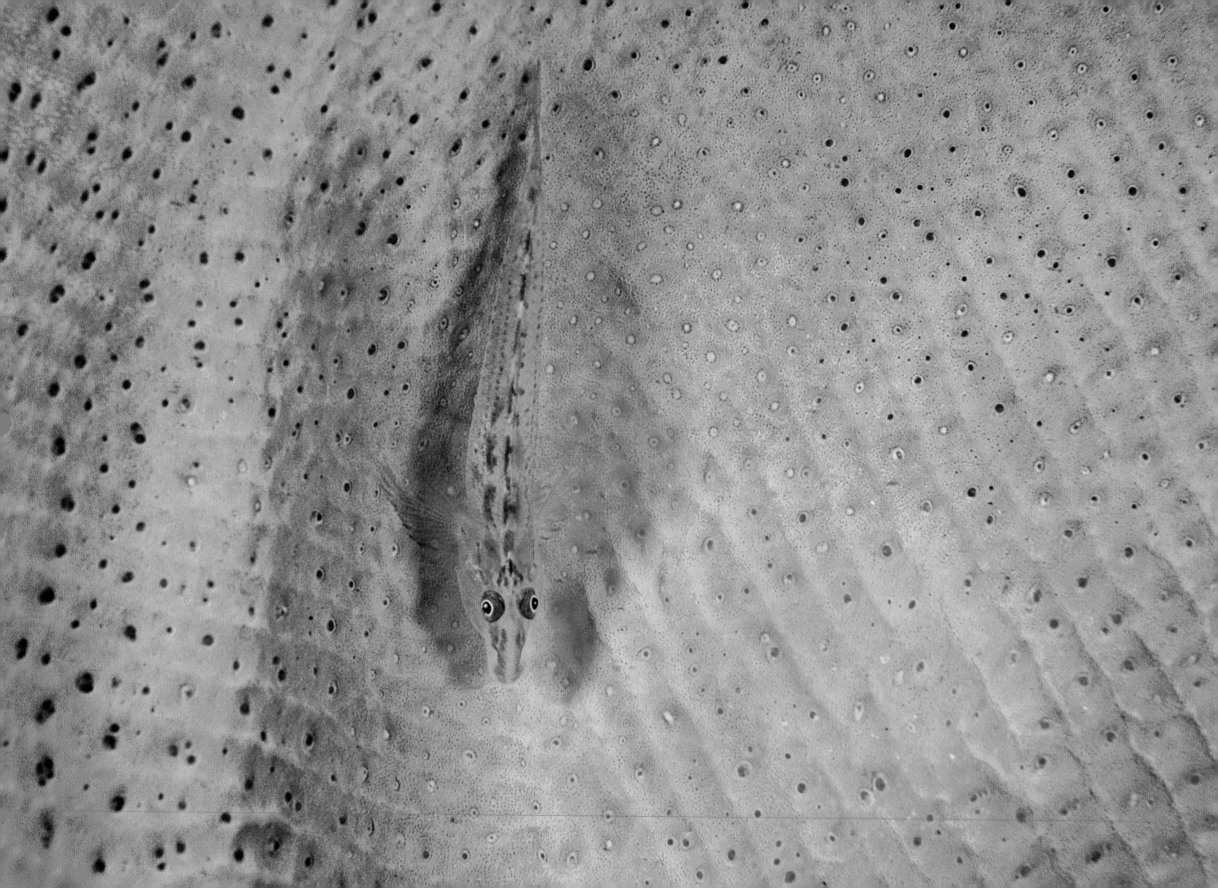

Fairy crab on barrel sponge, Bali, Indonesia, 1996

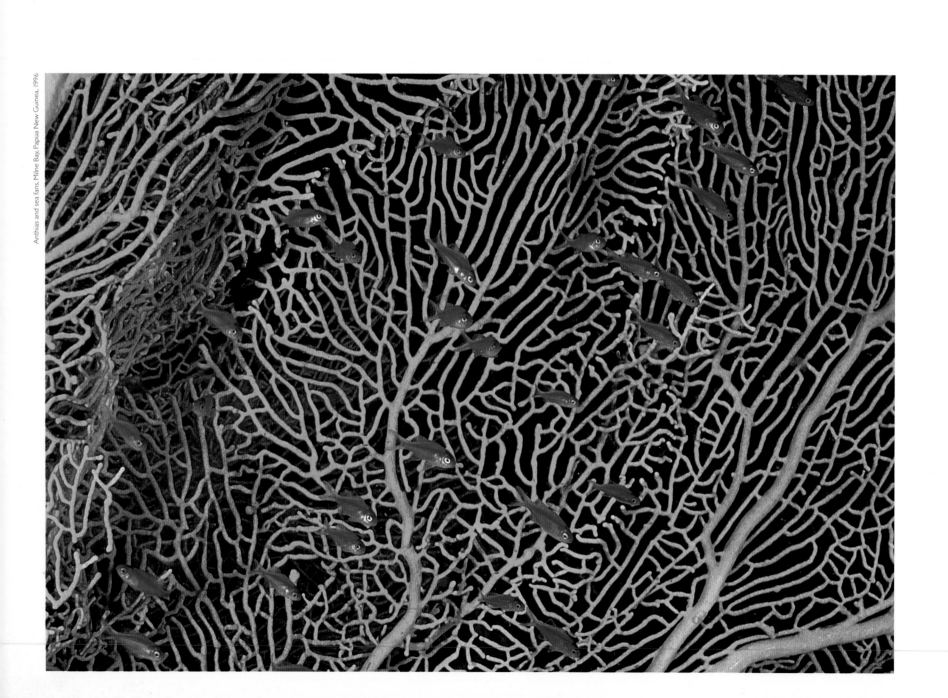

Anthias and sea fans, Milne Bay, Papua New Guinea, 1996

Anthias and chalice coral, Milne Bay, Papua New Guinea, 1986

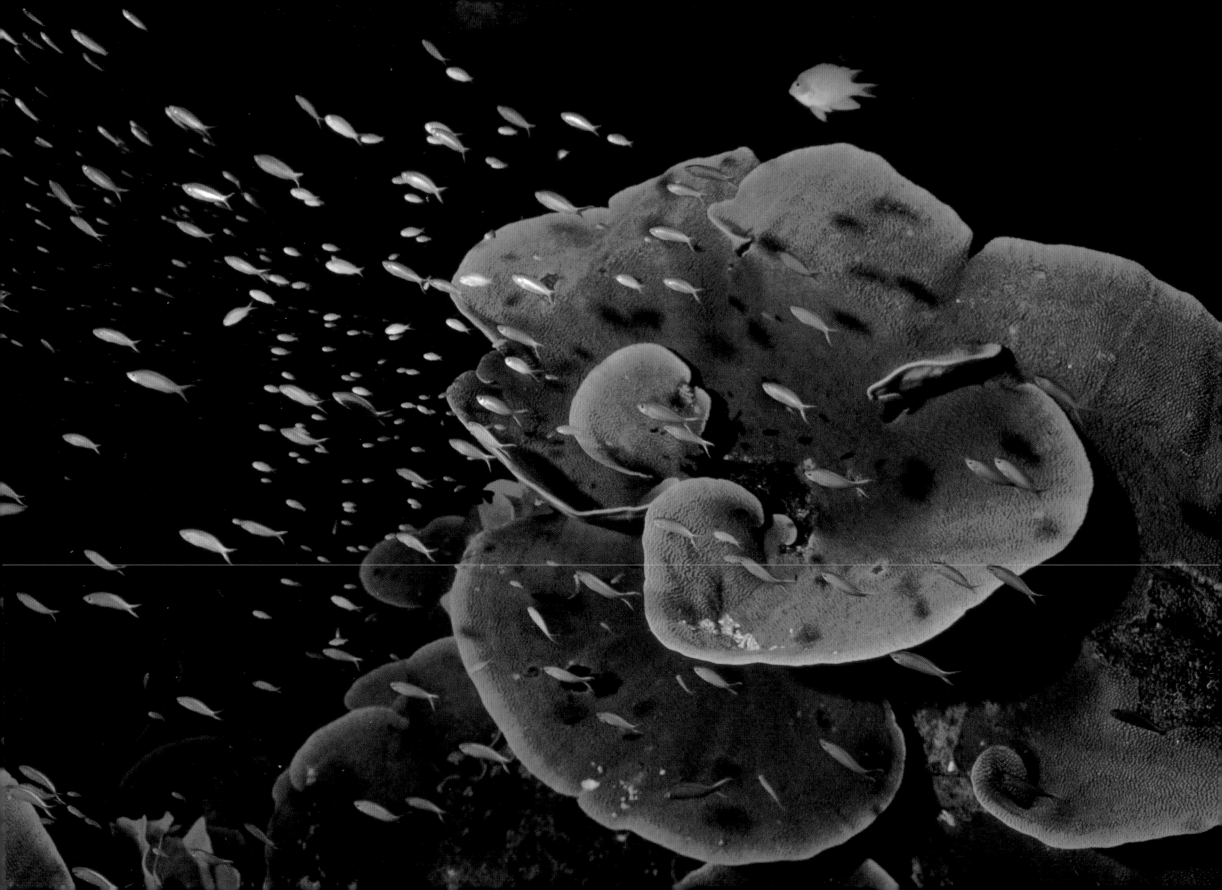

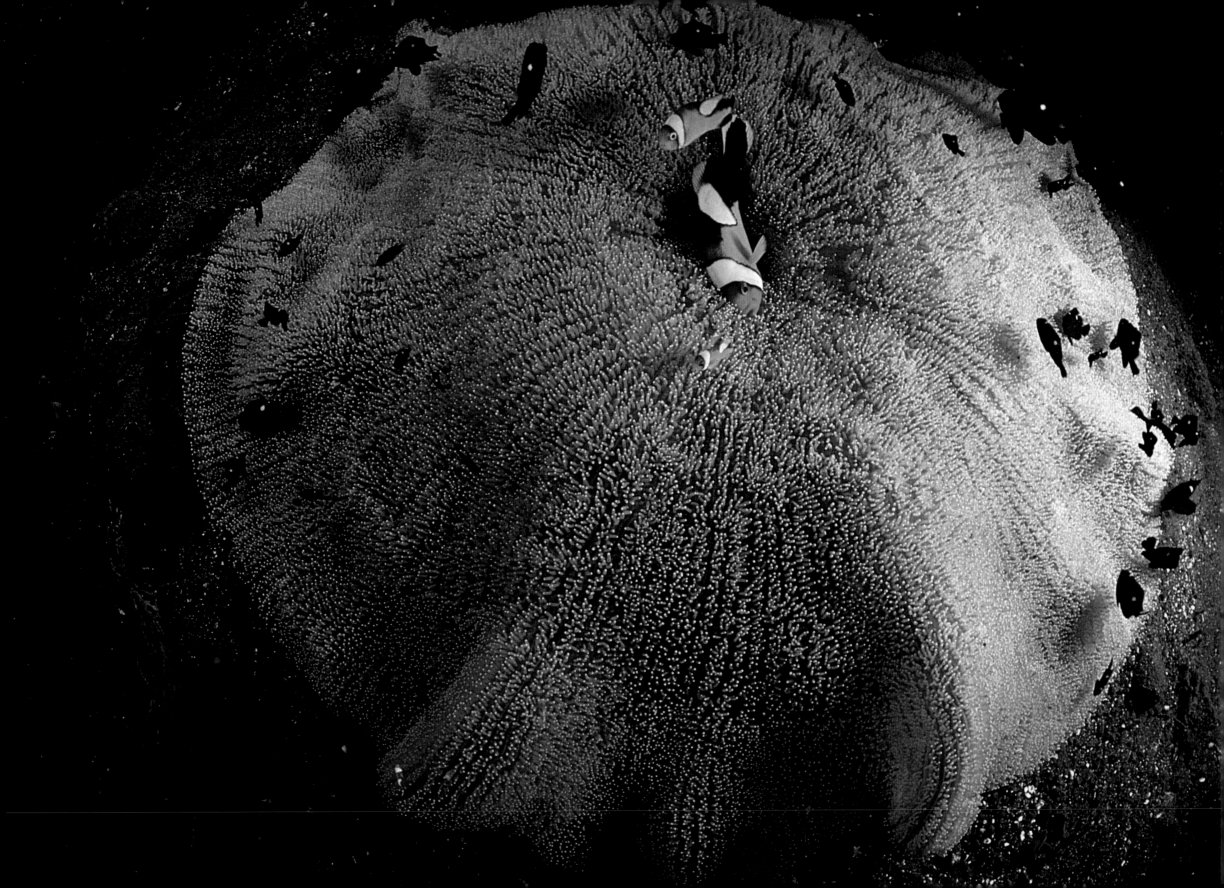

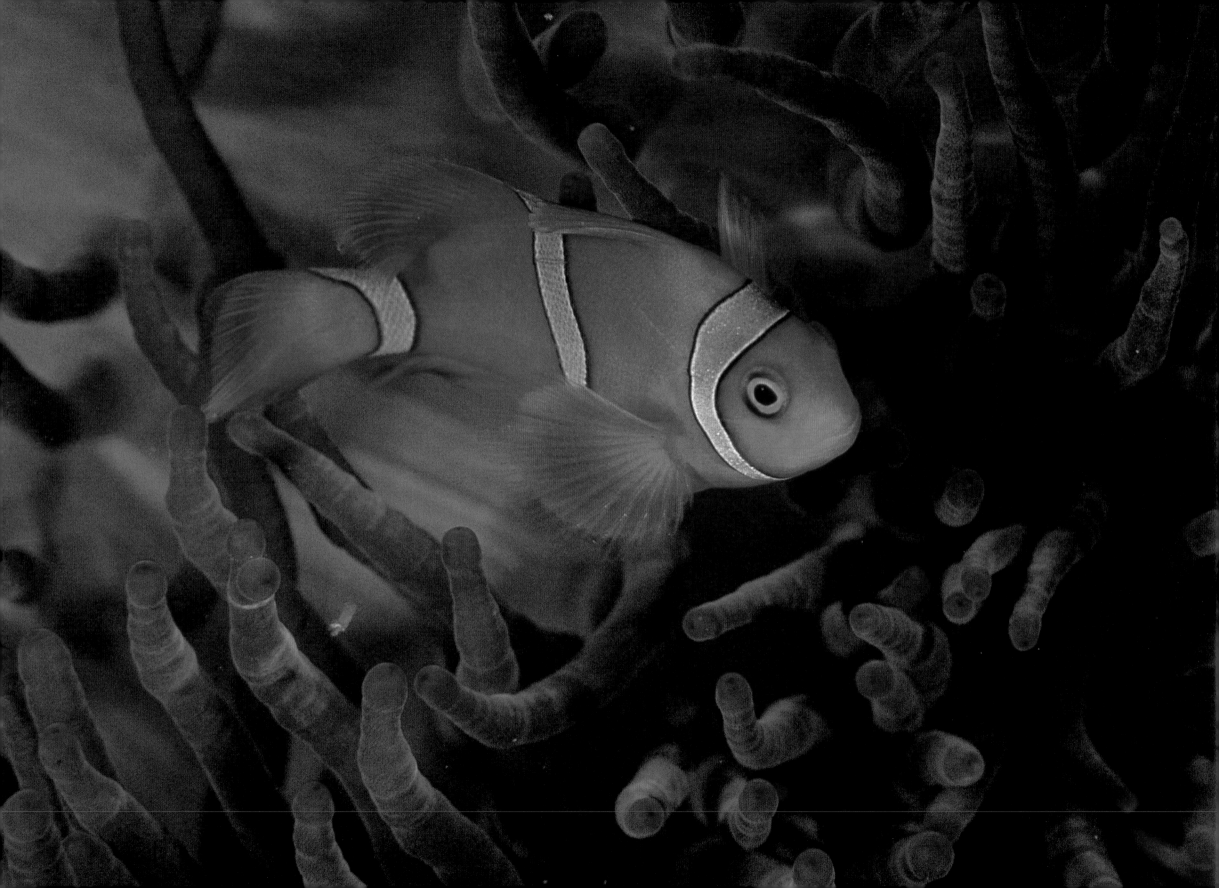

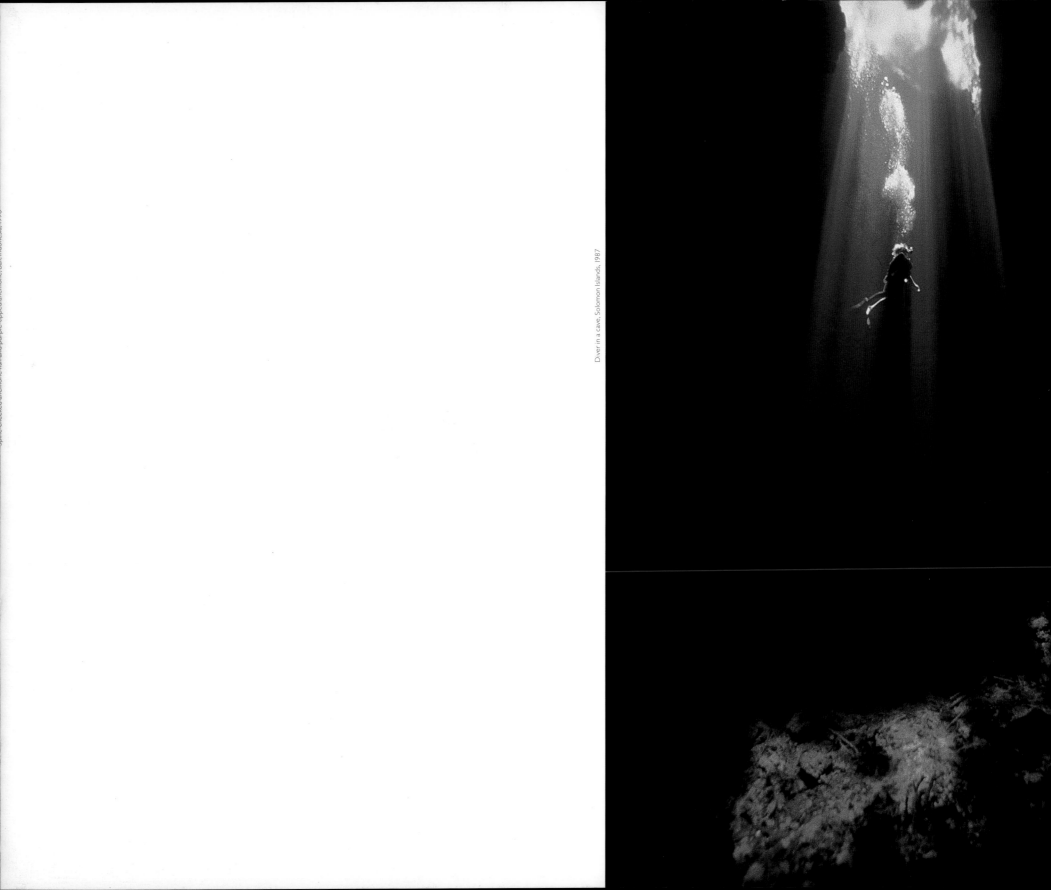

Diver in a cave, Solomon Islands, 1987

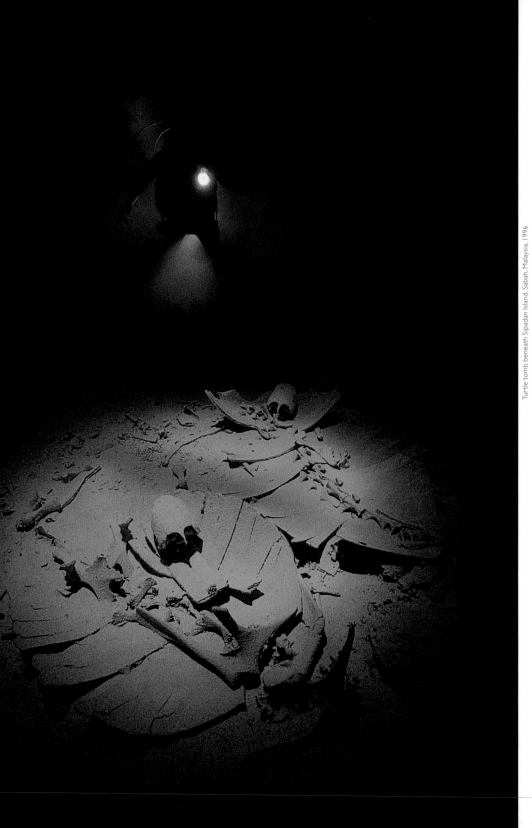

Turtle tomb beneath Sipadan Island, Sabah, Malaysia, 1996

Mating green turtles, Sipadan Island, Sabah, Malaysia, 1996

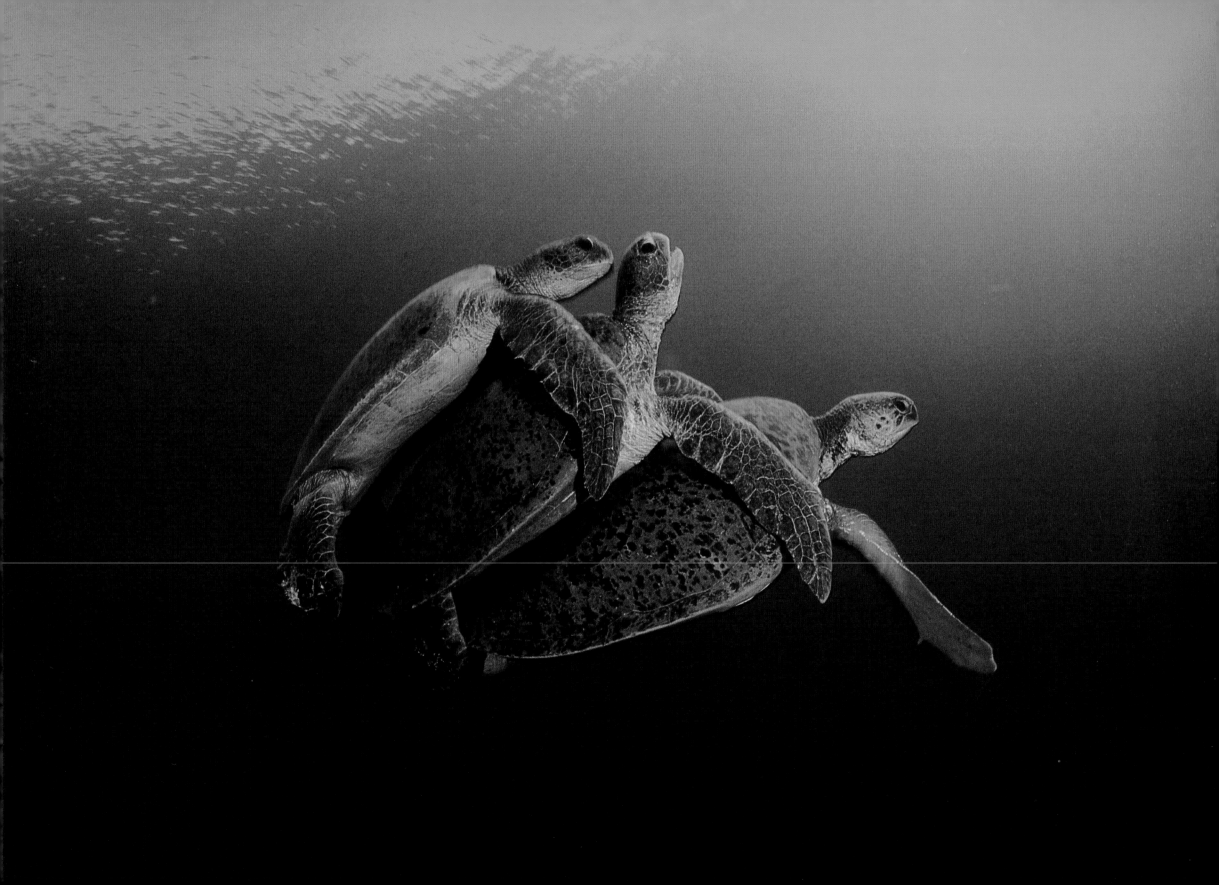

Shrimpfish, Milne Bay, Papua New Guinea, 1994

Moonfish, Milne Bay, Papua New Guinea, 1994

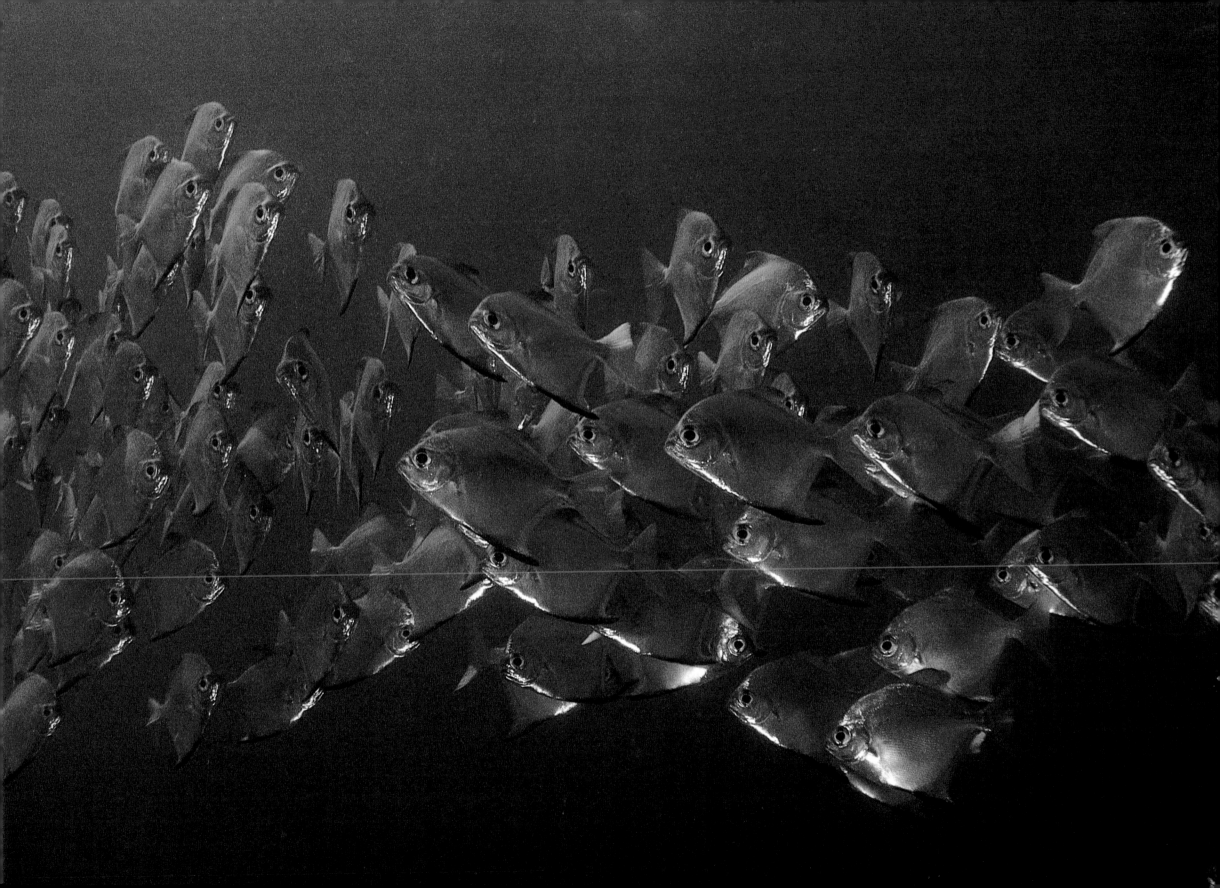

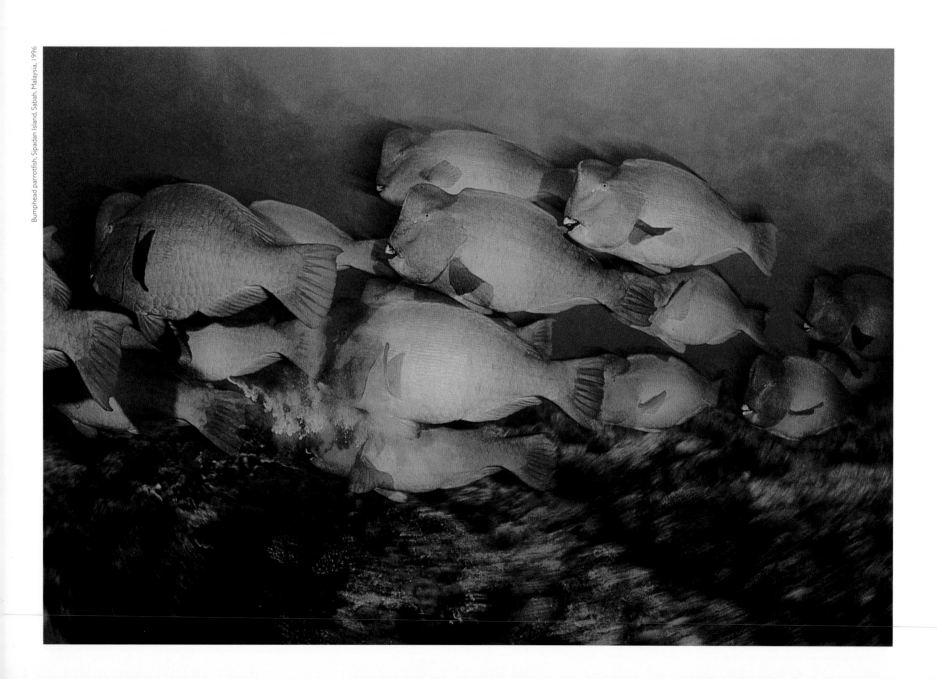

Bumphead parrotfish, Sipadan Island, Sabah, Malaysia, 1996

Pegasus fish, Flores, Indonesia, 1996

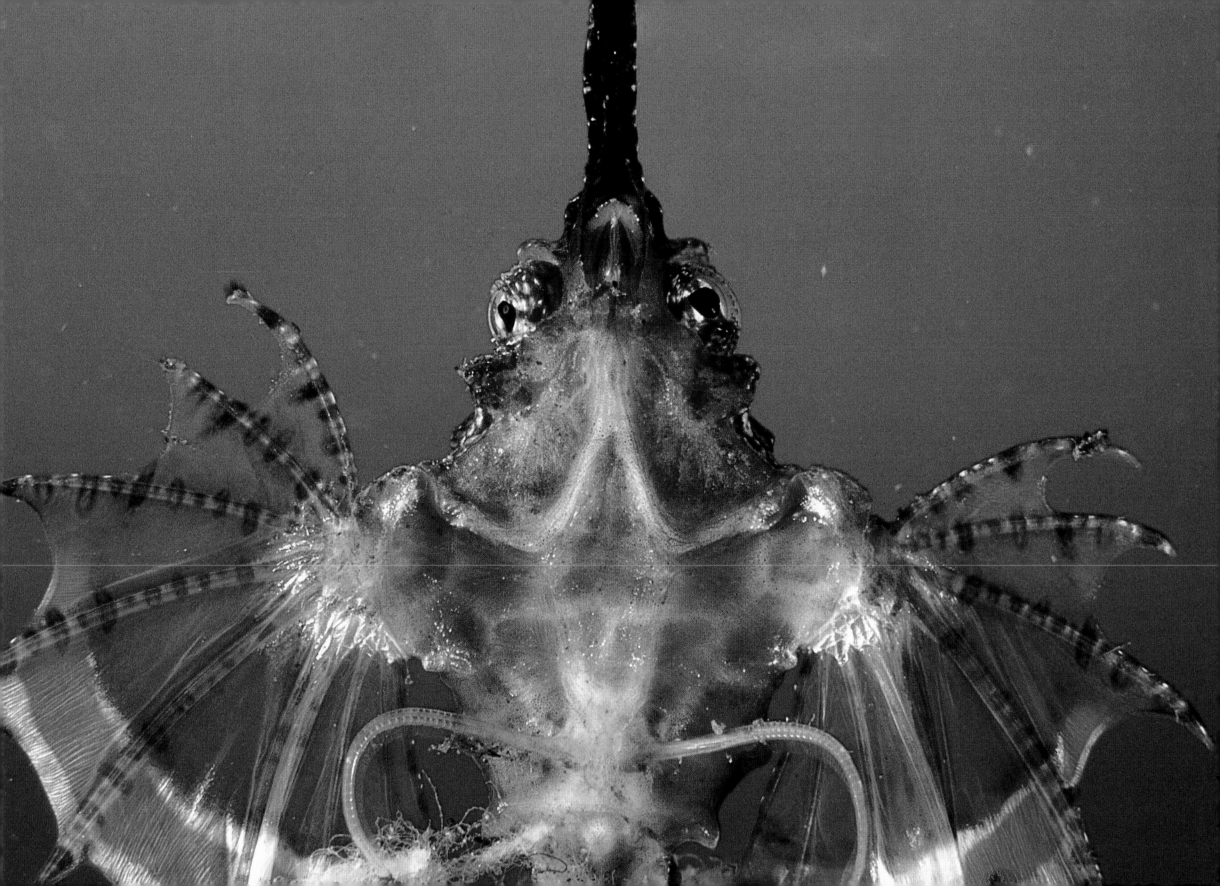

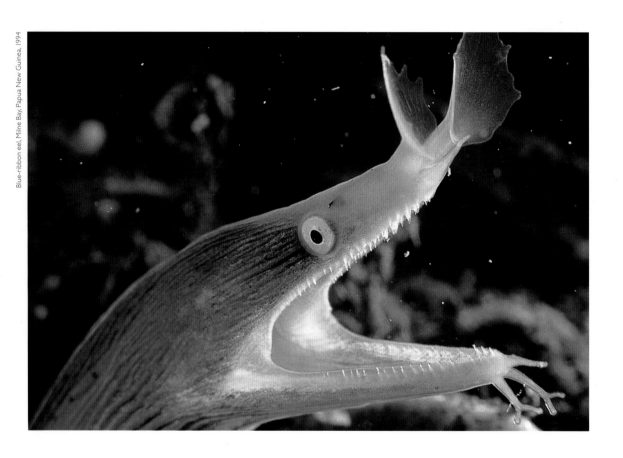

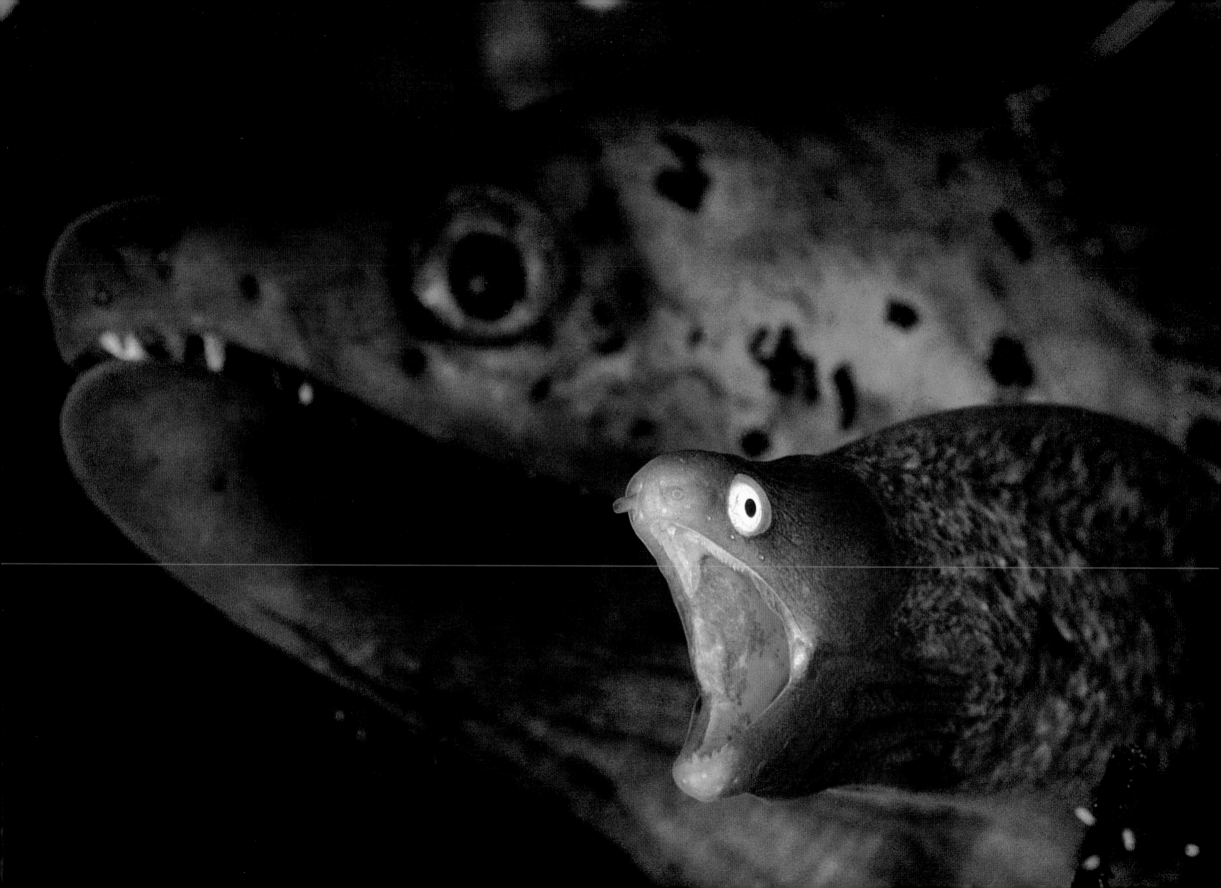

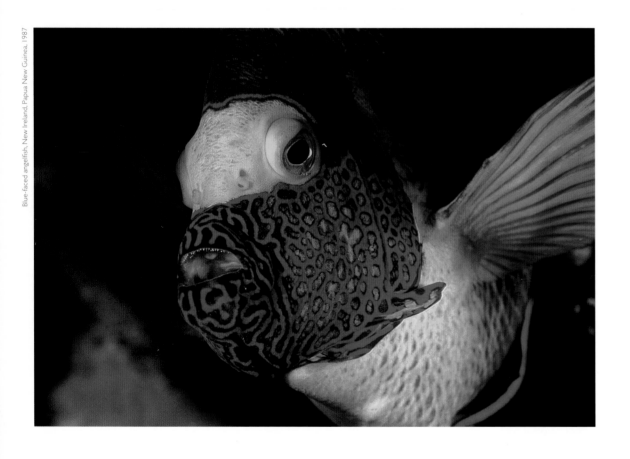

Blue-faced angelfish, New Ireland, Papua New Guinea, 1987

Banggai cardinal fish, Sulawesi, Indonesia, 1995

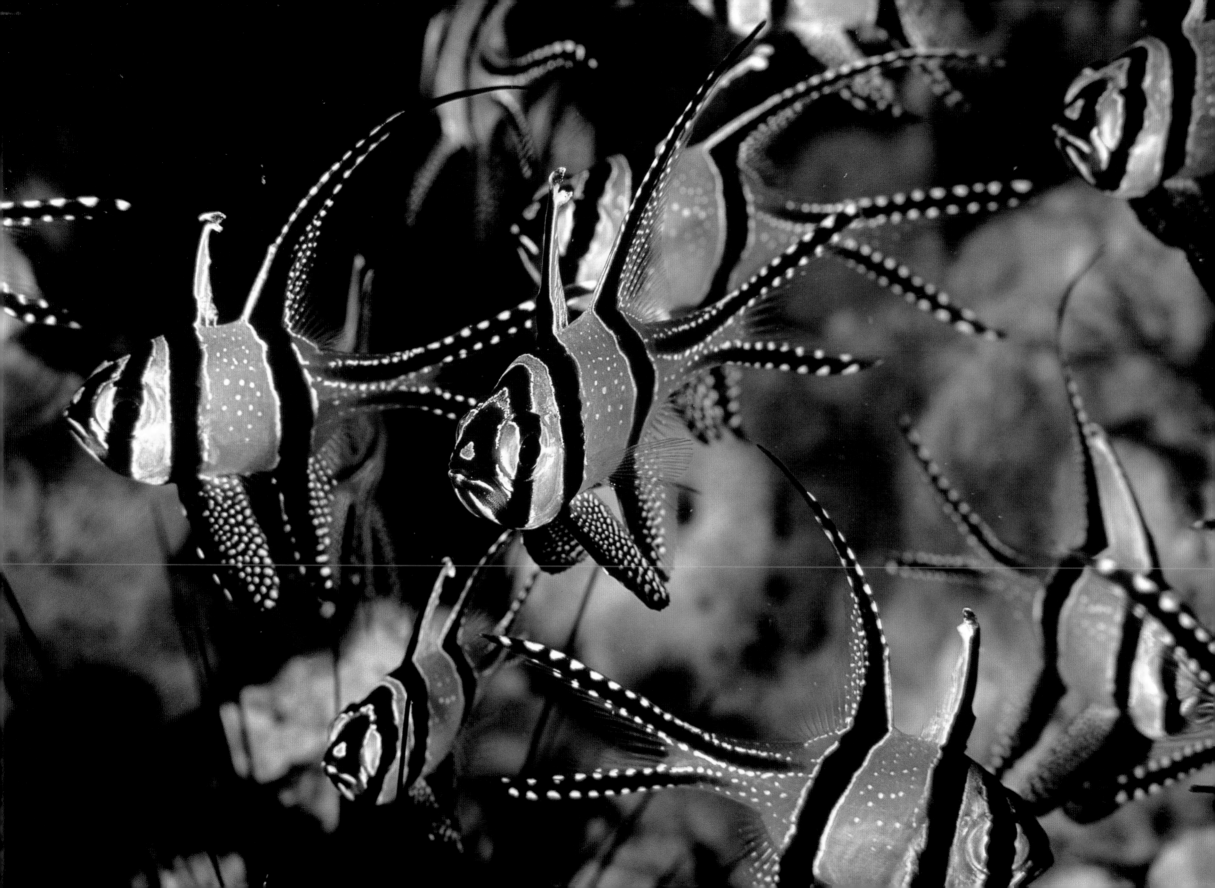

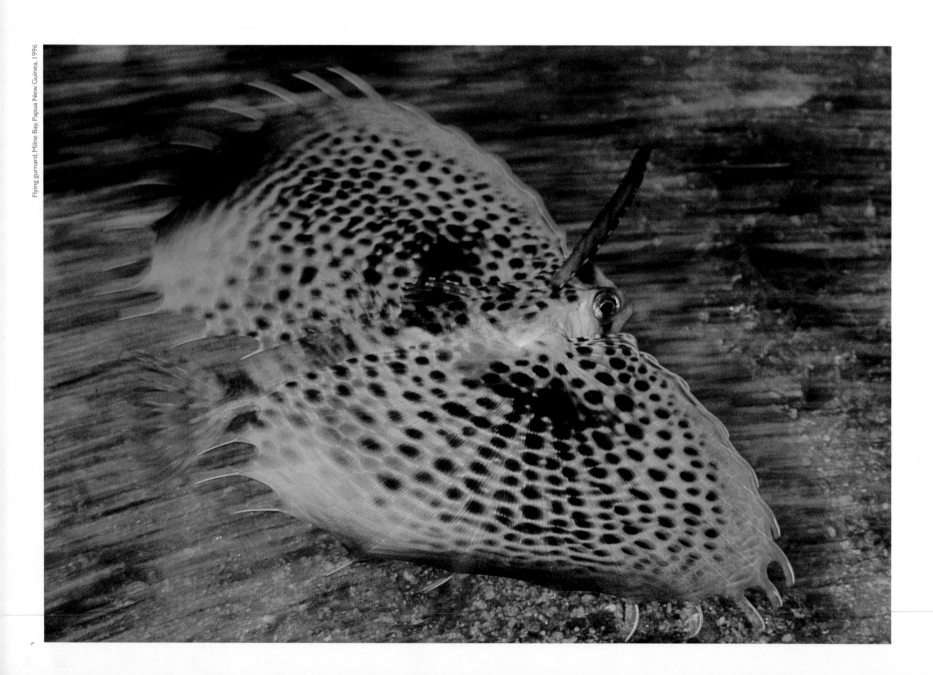

Flying gurnard, Milne Bay, Papua New Guinea, 1996

Yawning Rhinopias, Milne Bay, Papua New Guinea, 1996

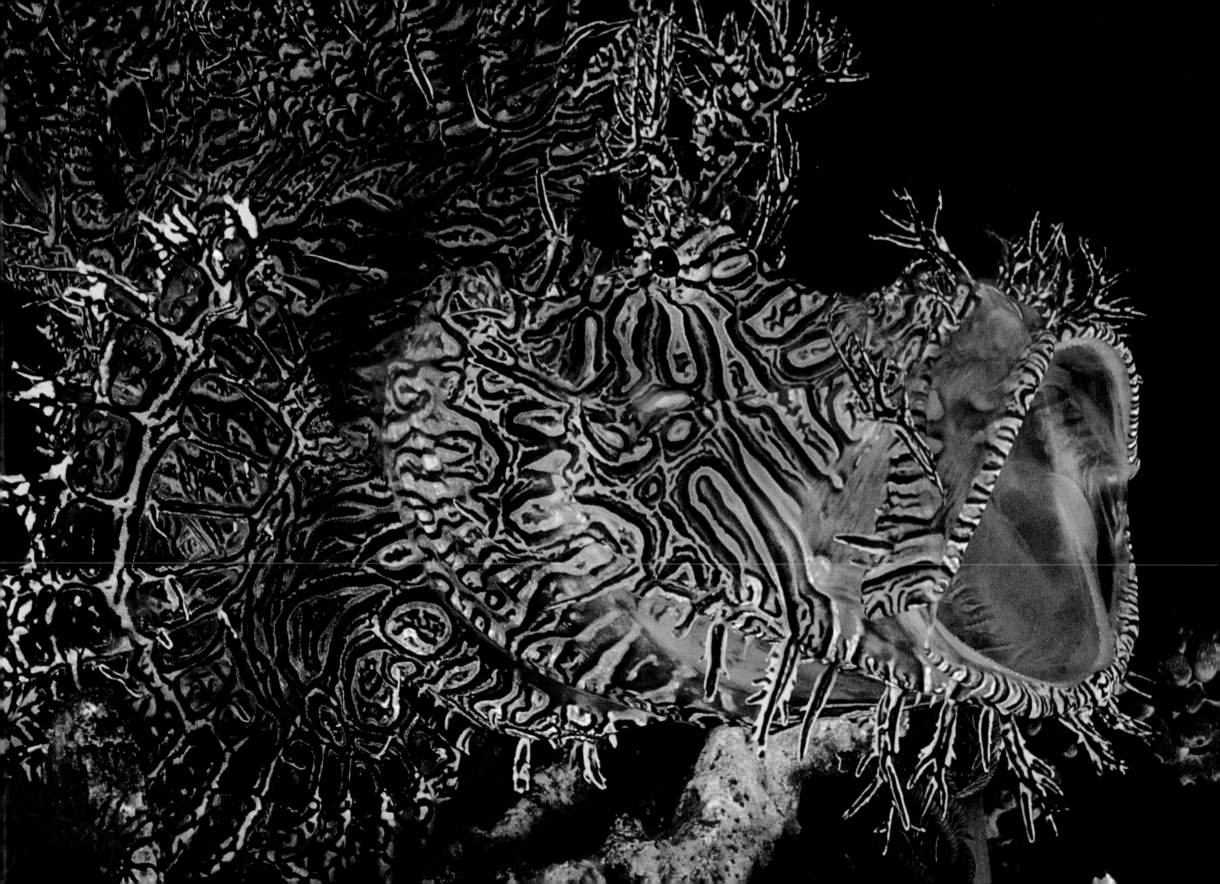

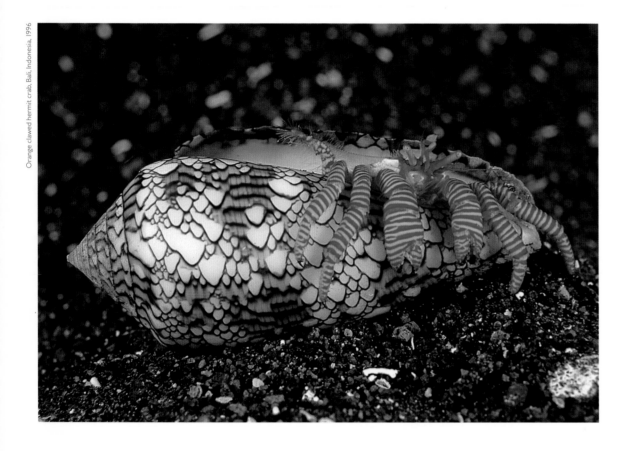

Orange clawed hermit crab, Bali, Indonesia, 1996

Colemani shrimp on fire urchin, Milne Bay, Papua New Guinea, 1996

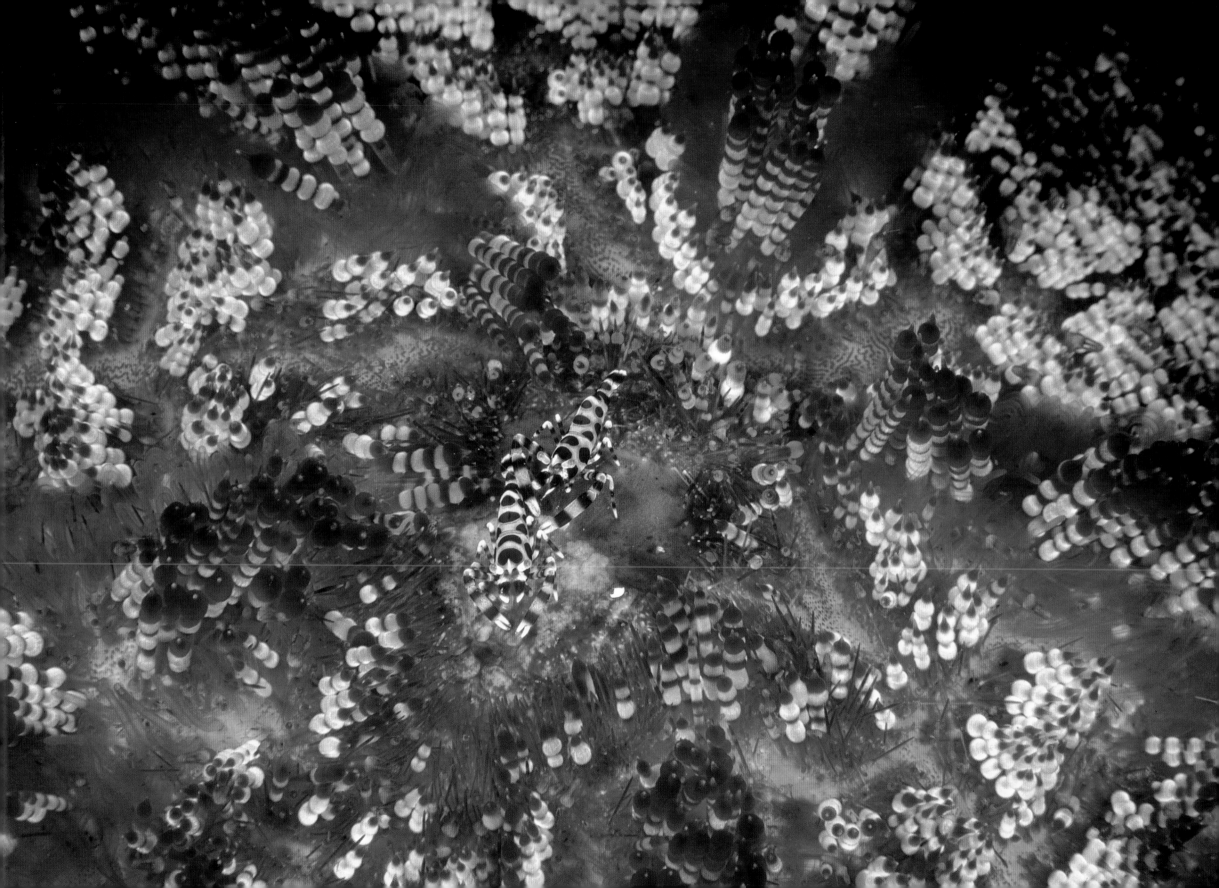

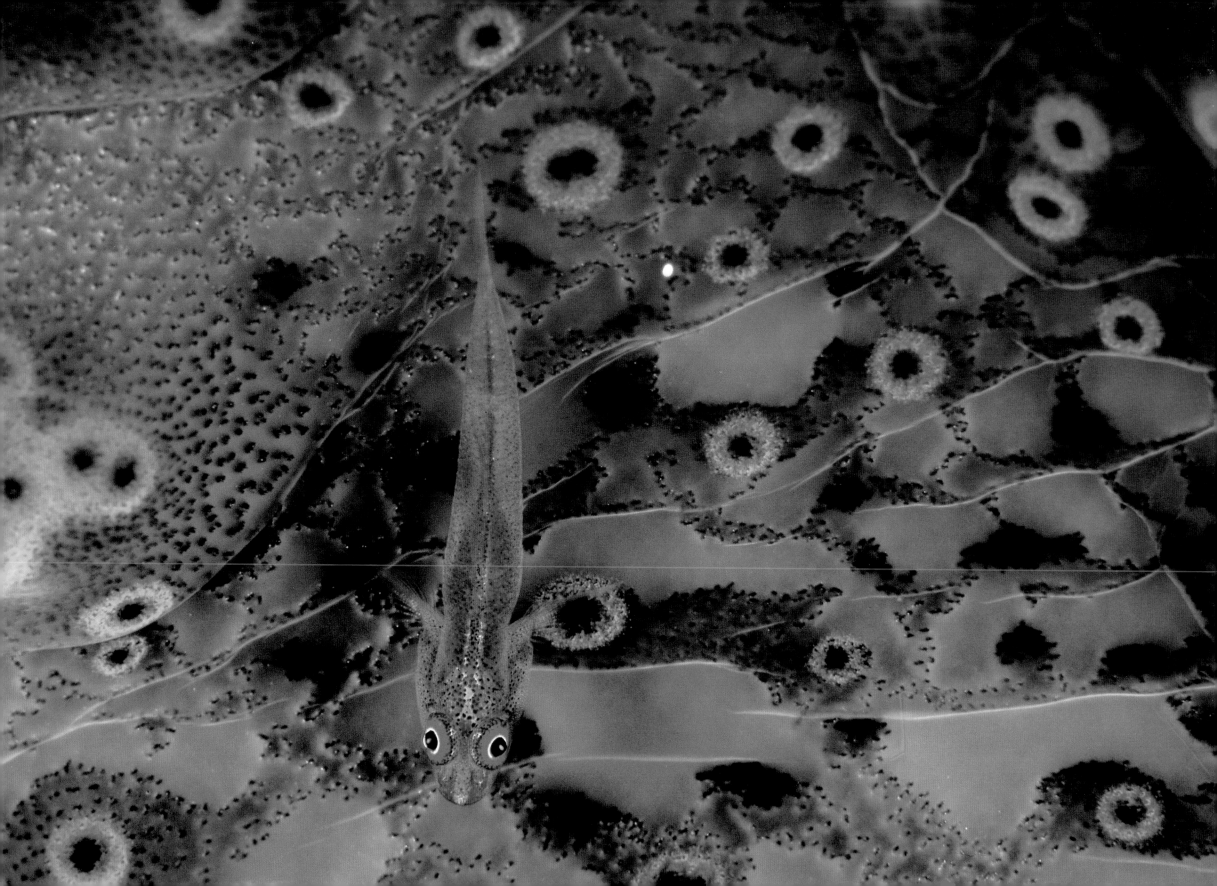

Thanks

Equipment

The most important element in photography is friendship and I would like to thank: the immortal Gary Bell, Maurcio Handler, Asher Gal, Nicky Konstantinou, Burt Yates, Koji Nakamura, Rodney Fox, Howard Rosenstein, Dr Yehuda Melamed, Dinah and Bob Halstead, Jim Watt, Jim and Julie Robinson, Jay Ireland, Randy Davis, Ron Holland, Gary Myors, Jeff and Kevin Deacon, Sue Steere, Penny Pritchard, Tom Campbell, Peter Benchley and Richard Ellis. For guidance and real science, Dr Eugenie Clark, Dr William Hammner, Peggy Hammner, David Fridman (who is the king of the Red Sea) and Karen Gowlett Holmes. At *National Geographic*: Kathy Moran, Bill Allen, Bob Poole, David Jeffries, Kenj Yamaguchi, Connie Phelps, Kent Kobersteen, Al Royce, John Fahey, Robert Gilka, Tom Kennedy, Rick Clarkson, David Arnold and Bill Garrett. Special thanks to Jennifer S. Hayes.

This book is dedicated to my family: my wife Anne, my daughter Emily, my sister Jane Doubilet Kramer and my niece Rain Doubilet Kramer. And in loving memory of my sister Ann and my mother Bobby Doubilet.

Underwater photography is an intensely equipment oriented business. Good pictures are the result of good equipment and the people who maintain it, such as my friend Joe Stancampiano – a genius who dreams in reality.

My first pictures were made with twin lens Rollieflex cameras in Rolleimarin housings originally developed by Hans Hass.

Later, the breakthrough was the ocean eye housing for the Nikon F developed by Gomer McNeill and *National Geographic* photographer, Bates Littlehales. By 1984 I had begun to use the Aquavision Aquatica 3 housing for the Nikon F3. This was followed by the Nikon F4 in an Aquatica 4 housing. I also use the smaller, lighter Nexus F4 housing as well as their housing for a Nikon N90 camera.

Lenses range from 13mm Nikkor to 200mm micro-Nikkor. The basic lenses are the 16mm fisheye, the 60mm micro-Nikkor and the 105mm micro-Nikkor.

For strobes I use Sea + Sea YS300, YS200, YS150, YS120. They are superb lights. Also I use small sonic research SR-2000 strobes and slave lights. Other supplementary lighting is done with Giddings Pace HMI 1200-watt movie lights. I used these lights to illuminate caves, for shipwrecks, for back light and, with ultra-violet filters, for the florescent coral story.

Now film. In the beginning Kodachrome 64 was the basis. I now use Fuji Velvia 50 ASA, Provia 100 ASA and 400 ASA and Kodachrome 200.

Phaidon Press Limited
Regent's Wharf
All Saints Street
London N1 9PA

Phaidon Press Inc.
180 Varick Street
New York
NY 10014

www.phaidon.com

First published 1999
Reprinted 2000, 2001
© 1999 Phaidon Press Limited
Photographs and photographer's text
© 1999 David Doubilet

A CIP catalogue record for this book is available from the British Library.

ISBN 0 7148 3828 4

Jacket: Stingray, Grand Cayman, West Indies, 1990
Back: Circle of barracuda, Papua New Guinea, 1987

Printed in Hong Kong